SONIC ETHNOGRAPHY

Manchester University Press

ANTHROPOLOGY, CREATIVE PRACTICE AND ETHNOGRAPHY (ACE)

SERIES EDITORS: FAYE GINSBURG, PAUL HENLEY, ANDREW IRVING
AND SARAH PINK

Anthropology, Creative Practice and Ethnography provides a forum for authors and practitioners from across the digital humanities and social sciences to explore the rapidly developing opportunities offered by visual, acoustic and textual media for generating ethnographic understandings of social, cultural and political life. It addresses both established and experimental fields of visual anthropology, including film, photography, sensory and acoustic ethnography, ethnomusicology, graphic anthropology, digital media and other creative modes of representation. The series features works that engage in the theoretical and practical interrogation of the possibilities and constraints of audiovisual media in ethnographic research, while simultaneously offering a critical analysis of the cultural, political and historical contexts.

Previously published

Paul Henley, *Beyond observation: A history of authorship in ethnographic film*
David MacDougall, *The looking machine: Essays on cinema, anthropology and documentary filmmaking*
Christian Suhr, *Descending with angels: Islamic exorcism and psychiatry – A film monograph*

In association with the Granada Centre for Visual Anthropology

SONIC ETHNOGRAPHY

Identity, heritage and creative research practice
in Basilicata, southern Italy

Lorenzo Ferrarini and Nicola Scaldaferri

Manchester University Press

Published by Manchester University Press
Altrincham Street, Manchester M1 7JA

www.manchesteruniversitypress.co.uk

British Library Cataloguing-in-Publication Data
A catalogue record for this book is available from the British Library

ISBN 978 1 5261 5200 8 paperback

First published 2020

This publication was supported by a contribution by the LEAV at the Department of Cultural Heritage and Environment, University of Milan.

Typeset
by doubledagger.co.uk

Printed in Poland
by Opolgraf SA

CONTENTS

List of audio tracks *page* vii

Acknowledgements ix

Glossary of musical terms xi

Map xii

Introduction 1
Lorenzo Ferrarini and Nicola Scaldaferri

1 **When the trees resound: towards a sonic
 ethnography of the *Maggio* festival in Accettura** 21
 Lorenzo Ferrarini and Nicola Scaldaferri
 Photographs – Lorenzo Ferrarini

2 **Soundmasks in resounding places: listening to the
 Campanaccio of San Mauro Forte** 53
 Nicola Scaldaferri
 Photographs – Stefano Vaja

3 **Sonic devotion and sonic control: struggles for
 power over a festival soundscape** 85
 Lorenzo Ferrarini

4 **Sounds and images of nostalgia: the revival of
 Lucanian wheat festivals** 105
 Lorenzo Ferrarini

5 **Voices across the ocean: recorded memories
 and diasporic identity in the archive of
 Giuseppe Chiaffitella** 129
 Nicola Scaldaferri

6 **Doing research in sound: music-making as creative
 intervention** 153
 Nicola Scaldaferri

7 Photographing as an anthropologist: notes on developing a photo-ethnographic practice in Basilicata 169
Lorenzo Ferrarini

Afterword 187
Steven Feld

Listening guide 191
Nicola Scaldaferri

References 199

Index 217

AUDIO TRACKS

The audio files can be found at
http://www.manchesteropenhive.com/sonic-ethnography/sound

- **Soundscape composition – Accettura 2005 – Tuesday (17 May)**
 Steven Feld

Sound-chapters:

Nicola Scaldaferri

1 **The saint and the tree**
2 **Rhythms in the dark**
3 **'We came a long way...'**
4 **Dancing with wheat**
5 **Memories from a loyal companion**
6 **A musical journey with my *zampogna***

'Engaging a project like this one typically proceeds from reading to viewing, and then to listening. Do try it the other way around: listening first, and then either sequentially or simultaneously viewing, and then reading. Perhaps you'll experience a similar sensation to the one that struck me: a sense that no media controls primal authority either when it comes to memorability or to explanation.'

(Steven Feld, Afterword)

ACKNOWLEDGEMENTS

This book and the research behind it were made possible by the collaboration and support of a number of people, to whom we are deeply grateful. In particular, Don Giuseppe Filardi, Biagio Labbate, Franco Volpe, Alfonso Vespe and Antonio Trivigno were of great help in every step of the work on Accettura. We thank Mimì Deufemia, Francesco Diluca, Rocco Giammetta, Francesco Laguardia and Lorenzo Scaldaferri for their collaboration on the research on the *Campanaccio*. We are grateful to Don Serafino La Sala and Don Antonio Lo Gatto for their opinions on the religious festivals in the Pollino area, and to Umberto Costantini, Enza De Salvo, Vincenzo Di Sanzo and Davide Leone for their help. The chapter on wheat festivals was made possible by the collaboration of Mimì Barone, Vincenzo Blumetti, Biagio Chiacchio, Franca Delia, Andrea Miraglia, Andrea Mobilio, Leonardo Osnato, Salvatore Palazzo, Enzo Peluso, Pietro Ragone and Mosè Antonio Troiano, in addition to the city council and public library of San Paolo Albanese. Heartfelt thanks go to Stella Scutari, whose willingness to give us access to the family archives made possible the ongoing research on Giuseppe Chiaffitella, which also relies on help from the late Maria Scutari, and from Rosalba and Rosita Scaldaferri. Teresa Magnocavallo Romano, and Marianne, Megan and Michael Grahlfs were crucial to reconstructing the American part of Chiaffitella's biography. Alessandra Bellusci, papàs Antonio Bellusci, Susanna Blumetti, Domenico Chiaffitella, Rosetta and Vincenzo Carbone, Attilio Carrera, Anna D'Amato and Pasquale Scaldaferri provided further archival materials and accounts from their memories of Chiaffitella. Cecilia Gnudi, Lorenzo Pisanello and Anastasia Semenova worked on digitising Chiaffitella's archive at the LEAV – University of Milan. Finally, Lorenzo Ferrarini would like to extend his gratitude to the Scaldaferri family in San Costantino Albanese, for providing friendship and hospitality throughout the years.

A number of colleagues provided comments and reflections on the themes of our research, adding depth to our understanding of the ideas presented in the book. Our gratitude goes to Nina Baratti, Stephen Blum, Francesca Cassio, Giovanni Cestino, Alessandra Ciucci, Angela Danzi, Filippo De Laura, Barbara Faedda, Eugenio Imbriani, Marco Lutzu, Peter McMurray, Ferdinando Mirizzi, Stanislao Pugliese, Amy and Louis Trotta, and Quirino Valvano. At the University of Manchester Jenna Ashton, Rupert Cox, José Luis Fajardo Escoffie, Paul Henley, Andrew Irving, Jérémie Voirol and Peter Wade provided useful comments. We also owe thanks to the editors of the series Anthropology, Creative Practice and Ethnography, to our commissioning editor Thomas Dark and to the Manchester University Press staff, for the way they supported the book's specific needs in terms of design and audiovisual media. They provided us with the space to develop an ethnography as sound recording and as photographic images, in addition to text. Publication was generously supported by the Open Access fund of the University of Manchester Library and by a contribution by the LEAV at the Department of Cultural Heritage and Environment, University of Milan.

Some portions of chapter 5 have appeared in the article 'Voice, Body, Technologies: Tales from an Arbëresh Village' in *Trans – Revista Transcultural de Música* 18 (Scaldaferri 2014b), and we are grateful to the publisher for allowing us to reproduce a revised version. Stefano Vaja has collaborated with us on a number of occasions, and we are particularly grateful for his permission to include a sequence of his photographs from the *Campanaccio* in San Mauro Forte as part of chapter 2. Finally, we wish to thank Steven Feld, not simply because he gave us feedback on the book project from its inception, collaborated on the research whose outcome is presented in chapters 1 and 2, and contributed a soundscape composition track and a closing text to the book. He also provided constant inspiration by developing theoretical concepts, examples of creative research practice and publication formats in a lifetime of work in and about sound.

GLOSSARY OF MUSICAL TERMS

Ciaramella: a type of shawm, a double-reed woodwind instrument, mostly used together with a *zampogna* to play solo parts.

Organetto: a diatonic button accordion, often used as a substitute for a *zampogna*.

Tamburello: a frame drum, made out of a goat skin on a wooden frame, with small cymbals.

Tarantella: a folk dance typical of central and southern Italy, characterised by a fast tempo. In Basilicata it is often played on a *zampogna* or *organetto*, and is usually accompanied by a *tamburello*.

Zampogna: a type of central and southern Italian bagpipe. In Basilicata it has two chanters and two drones, with double reeds. Measured in palms, its most common sizes are 3 and 4 palms. The Lucanian variant is called '*a chiave*' (keyed) because of the presence of a metal key that allows the last hole of the lower chanter to be reached.

BASILICATA

Map of the places mentioned in the book

CAMPANIA

N

TYRRHENIAN SEA

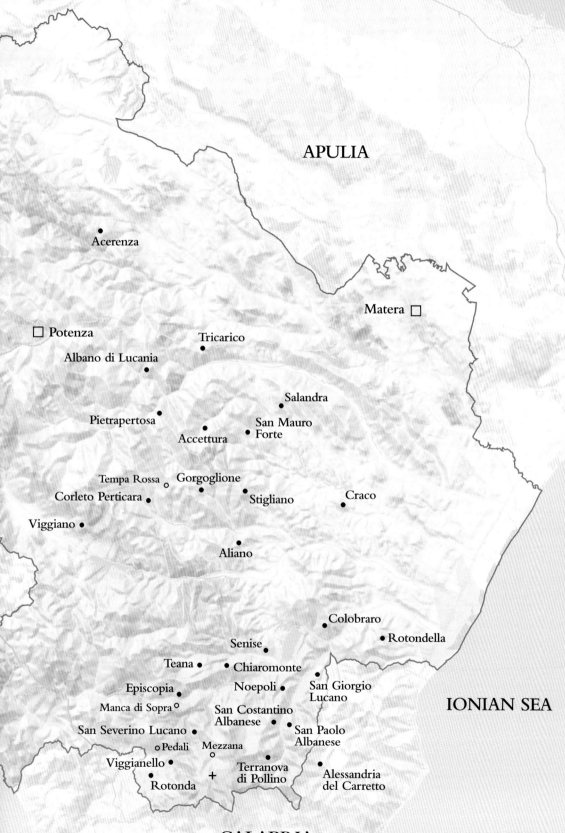

APULIA

• Acerenza

Matera ▢

▢ Potenza

• Tricarico

Albano di Lucania •

Salandra
•

Pietrapertosa •

San Mauro
Forte
Accettura •

Tempa Rossa ○ Gorgoglione
•
Corleto Perticara •

Stigliano
•

Craco
•

Viggiano •

Aliano
•

Colobraro
•

Rotondella
•

Senise
•
Teana • Chiaromonte
•

San Giorgio
Lucano
•

Episcopia •

Noepoli
•

Manca di Sopra ○

San Costantino
Albanese
•

San Paolo
Albanese
•

San Severino Lucano •

○ Pedali Mezzana
○

Viggianello •

Terranova
di Pollino
•

Alessandria
del Carretto
•

Rotonda •

✝

IONIAN SEA

CALABRIA

INTRODUCTION

Lorenzo Ferrarini and Nicola Scaldaferri

In this work, we focus our attention on the role of sound in the formation of local identities in the southern Italian region of Basilicata. Through a combination of text, photographs and sound recordings, we will concentrate on soundful cultural performances, including religious festivals and collective events meant to promote cultural heritage, as well as more informal musical performances. Throughout the book we will listen to tree rituals, carnivals, pilgrimages and archival sound recordings, to understand how in the acoustic dimension people mark space, organise action, take control of festivals or reaffirm local identities. Our approach, which we term 'sonic ethnography' and describe in chapter 1, is based on thirty years of fieldwork by a researcher native to the region (Scaldaferri), and on research combined with a work of photographic interpretation which has developed over two decades (by Ferrarini). It reveals how during such sound events tradition is made and disrupted, power struggles take place, and communities are momentarily brought together in shared temporality and space.

Our more general objective is to demonstrate how such an attention to sound and listening can reveal mechanisms and patterns that have been missed by earlier approaches. Going beyond a traditional attention to music as the main form of culturally organised sound, our sonic ethnography reveals the emergence of temporary communities around practices of listening and sound-making, whose workings are often deeply affective and embodied. Identities, ideologies and power do not simply resonate within these practices but are transformed by them – for example when certain sounds are used as markers of authenticity or to contest authority. Our work answers interdisciplinary calls to engage sound seriously, or even for an aural turn in the social sciences, by employing listening and sound-making both as research subjects and methods. On the one hand, we aim to provide rich ethnographies that demonstrate how by making, restricting, recording or playing back sound, people act in the world. Each of

our chapters based on ethnographic research (1–5) centre around a function performed by sound – coordinating ritual action (chapters 1 and 2), expressing devotion and embodied involvement with the sacred (chapter 3), denoting a relationship with the past (chapter 4) or strengthening ties to a distant community (chapter 5). On the other hand, we also engage sound as a medium in which to conduct research and recording as an interpretive form of ethnographic representation. Thus, one of the two methodological chapters details Scaldaferri's long-term practice of sound-making as a research strategy (chapter 6). Finally, to each of these six texts corresponds a 'sound-chapter', a composition of sound recordings that provides a complementary narrative in the acoustic medium itself.

While building on recent perspectives in the anthropology of sound and sound studies, we integrate them with an awareness of the ways the historical legacies of past research, whose afterlives keep surfacing throughout the book, have dominated most existing studies on the region. Tellingly, the diffusion and recontextualisation of this earlier research have often privileged ocularcentric interpretations and visual representations, and shifting the emphasis onto sound allows us to bring back in the frame the role of materiality and sensory experience. One of the transversal themes of this work is the transformation of the outcomes of this past research into resources upon which actors in the local politics of heritage can draw. The diffused awareness by some of the participants of the anthropological significance of the events we examine blurs the distinction between cultural performances – institutionalised and explicit representations – and performing culture – the enactment of aspects of social life (Schechner 1985). In this book we mostly examine the sonic components of events classifiable as cultural performances (chapters 1–4), which we privilege over an ethnography of the everyday because of their aspect of 'aesthetic practices' that 'situate actors in time and space, structuring individual groups and identities' (Kapchan 1995: 479). Rather than approaching cultural performances as distillations of culture, in the manner of Milton Singer (1972), we see them as *culture in performance*, that is, moments in which social and political matters are decided, fought over and made manifest in unpredictable ways. These performances share a strong element of self-representation, in which authenticity and tradition are renegotiated and innovations are made; therefore, we do not privilege them in order to look at static survivals or cultural fossils. Rather, we are interested in these performances as 'time out of time' in which people break with the ordinary (Falassi 1987), as 'society in its subjunctive mood,' as Turner wrote of the carnival (1986: 123), in which sound contributes to the creation of specific configurations of space and time. This also means that the communities we will be considering are

sometimes limited spatially and temporarily to the performance, that is, they are acoustic communities (Truax 1984: 65–66) or communities of (sonic) practice that come together around a given event and might separate after its conclusion.

In this introduction we unpack how we interpret the connection between sound and the formation of local identities, starting with some clarifications on these two key terms. Subsequently, we trace the main steps in the entanglements of ethnographic research, creative practice and cultural heritage in Basilicata, providing important context for an outline of our own representational strategies in the book.

Sound and local identities

In this work we understand *sound* as the perception of acoustic phenomena through listening and the material resonance of vibrations that create relationships with an environment. In our approach we build on a tradition of scholarship that underlined the importance of treating a sonic setting as an acoustic environment (Schafer 1977), or in other words we go beyond a more traditional attention to music as a sonic equivalent of culture. In what we would call an *ecological* approach, we are interested in the relational and experiential aspects of sound that cut across dichotomies between nature and culture, non-musical sound and music. The term 'ecological' as we use it here does not refer to Schafer's concept of acoustic ecology and its concern for noise pollution and lo-fi soundscapes, but rather to the capacity of sound to enact relationships between species, places and meanings (Feld 1996). In order to represent the acoustic environments that we encountered in their most complex form, we expanded our focus in this research beyond formal performances to include also the sounds of bells, tools, humans and animals at work. We were especially concerned with the way in which these sounds interact with multiple musical performances that are emplaced, recorded, amplified and understood in specific ways (Clarke 2005), creating 'an acoustic environment in which listeners are active social participants' (Samuels et al. 2010: 335).

Sound, in this ecological perspective, becomes a tool to mark ritual space and organise action, as in the cases analysed in chapters 1, 2 and 3. It can also serve as a marker of local identities, as in the case of the sounds of a rural world of the past described in chapter 4, or the recordings of the sounds of the home village made for the migrant communities in the USA (chapter 5). The concept of soundmark, coined by Schafer to refer to 'a community sound which is unique or possesses qualities which make it specially regarded or noticed by the people in that community' (1977: 10), can be usefully expanded and applied to all these examples. Interestingly, in recent years definitions

of intangible cultural heritage have started to include sounds of every-day life, thus giving an institutional – and in some cases financial – support to the connection between sound and local identities (Kytö et al. 2012; Yelmi 2016).

We approach the term 'identities' with a series of precautions. While we share on a general level the constructivist approach to identities that emerged from the 1970s, underlining their processual, fluid and contextual nature, we are also aware of the ways the analytical function of the term has been overestimated and overstretched (Brubaker and Cooper 2000). As a category of practice, however, we found the term to be a sensible way to describe how local communities 'make sense of themselves, of their activities, of what they share with, and how they differ from, others' (Brubaker and Cooper 2000: 4). Another concern has to do with the way the influence of postmodern theory, and in particular semiology, led to the characterisation of identities as a matter of expression, representation, or signification of belonging or difference (for example in Cohen 1985). This historical preference for a semiosis of identity, we argue, has often led to a neglect of the embodied and experiential dimensions of identity and community formation. By contrast, in analysing a locally produced video that re-enacts wheat harvest as it would have taken place at the end of the 1950s in the village of Acerenza, Marano (2001) underlines how the participants, from different age groups, recognised themselves in sensory experiences that created an aesthetic community in the original sense of the term *aesthesis*, that is, as a group sharing common experiences of perception (see also Cox 2002; MacDougall 1999; Meyer 2009), and performing similar evaluations and appreciations of them. Stokes has remarked how '[a] sense of identity can be put into place through music by performing it, dancing to it, listening to it or even thinking about it' (1994: 24). We suggest that this observation can be equally well applied to sonic environments in which musical performances may be only one element or indeed may not be present at all. In this book, we discuss the emergence of aesthetic communities in the case of the communal work that forms part of the complex ritual labour for the *Maggio* festival in Accettura (chapter 1), the sonic appropriation of space by the bell carriers of San Mauro Forte (chapter 2), the 'sonic devotees' of the Madonna del Pollino (chapter 3) and the manual reaping competition in Terranova di Pollino (chapter 4). In all these situations, sound plays a crucial role in the sensory experience of the event, along with other modalities of perception and bodily participation.

These experiences are often characterised by a nostalgic element, an orientation to the past that complements the embodied concreteness of aesthetic communities with the attached meanings of imagined communities. Discourses of tradition and authenticity,

intertwined with the legacy of classic anthropological studies in the area, permeate most aspects of the situations we describe in this book, but are especially evident in the institutional politics surrounding the events themselves, given the current availability of regional funds to support cultural initiatives rooted in the past and classifiable as intangible heritage. To further complicate this frame, a warning should be made on the term 'local', since the often festive events we describe see the yearly return of emigrants who temporarily rejoin their communities of origin. Their presence and participation inject supposedly 'local' identities with a diasporic element that adds further layers to the local imaginaries concerning the traditional and the authentic. Some of the processes of reification and fixation of tradition were in fact started, for entirely different reasons, by emigrants such as Giuseppe Chiaffitella (chapter 5), who recorded the sounds of his natal village of San Costantino Albanese for his fellow migrants in the New York area (Scaldaferri 2014b). As is well known, for diasporic communities music can also create a strong sense of 'local' identity abroad (see for example Shelemay 2011). In other words, when we refer to 'local' communities or identities, it must be kept in mind that these phenomena are entangled in geographically extensive networks in which people, ideas and rituals have circulated for a long time. Such convergences of experiences and imaginaries in the sonic events that we analyse could be considered examples of what Kun has called an 'audiotopia', that is, 'small, momentary, lived utopias built, imagined, and sustained through sound, noise, and music' (2005: 21).

With this book we want to underline that an attention to sound-making, recording and listening practices can bring innovative contributions to the ethnography of an area that has already been the setting for a number of researches from different eras and approaches. From the anthropology of sound we draw the fundamental premise that in a soundscape both resonate and are shaped social practices, ideologies and politics. We are not so much primarily interested, however, in the way sounds are interpreted as symbols or representations of society, in the manner of the first ethnographies of sound in rainforest societies (Feld [1982] 2012; Roseman 1991; Seeger 1987). Our focus, in quite a few of the examples described, is rather on what sound does, and on what it allows people to do. The first three chapters, all in different ways, highlight ways in which sound allows the control of ritual spaces – at times used by the institutional powers to maintain their positions of privilege or by participants to subvert the established order. It is a perspective that draws on studies on the relationship between control of sound and power, or more generally between sound structure and social structure (Attali 1977; Feld 1984).

In the interest of going beyond the label of 'anthropology of sound' that he coined in the 1970s, Steven Feld proposed 'acoustemology' to put a stress on the relationality of sonic ways of knowing and on 'situated listening in engagements with place and space-time' (2015a: 15). This shift towards listening as a relational process is evident in a number of studies on histories of listening in and beyond anthropology (Hirschkind 2001; Johnson 1995; Nancy 2007; Ochoa Gautier 2014; Szendy 2008) and signals a renewed attention to processes of perception. With Feld, we want to suggest that listening to the sounds of the events and situations that we describe in this book also means attending to histories of listening in which forms of power, ritual space and time, and values of authenticity all sound out simultaneously in layers.

Some of these histories are influenced by the interactions between the representations of Basilicata that circulated from after the end of the Second World War – especially novels, films and photographs – and the legacies of ethnographic research in the region – chiefly those that received institutional recognition. Therefore, we now move to providing context for the setting of our research and its histories of representation.

Basilicata: ethnographic and media imaginaries

Also known by the ancient name of Lucania, Basilicata is a largely mountainous region. At less than 10,000 square kilometres in area, and with little more than half a million inhabitants, it is only sparsely populated. Out of 131 municipalities, only the two provincial capitals, Potenza and Matera, can boast populations of over 60,000. The rest of the region is made up of small villages, which were traditionally based on an economy of small-scale agriculture and herding. With two coastlines, over the centuries a number of different peoples have arrived from afar, leaving traces that can still be detected today, starting with Greek colonists of the Magna Graecia era, followed by runaway monks of the late Byzantine Empire, and then by various medieval conquerors speaking a variety of languages. Centuries later, hardships and rural poverty pushed many Lucanians to migrate to North and South America, especially at the end of the nineteenth century, and after the Second World War towards northern Italy and the rest of Europe. The continuing outflow of young people is still one of the greatest problems of the region, since it results in the progressive abandonment of the countryside and the overall ageing of the population. Over time, these migratory patterns have created various diasporic communities that in some cases have maintained continuous relationships with their communities of origin, and especially in recent years have taken advantage of the internet and social media to rekindle their links.

Despite its touristic potential and the presence of abundant natural resources – including oilfields and waterways – Basilicata is still considered representative of some of the worst features of the Italian South, including political and economic clientelism (Zinn 2019) and rural underdevelopment (DiMaria 2018: chapter 4). Some of this renown is also based on the characterisation of the region's rural and folkloric heritage as steeped in a timeless past, a characterisation that Italian social sciences have played a major part in creating.

In the period immediately following the Second World War, Basilicata was frequently the subject of social research, attracting both Italian and foreign scholars as well as photographers, filmmakers and journalists (Mirizzi 2000). As a result of this research, within the national intellectual debates of the time the region came to represent paradigmatic internal otherness, the home of the backward subaltern peasant. The work of Antonio Gramsci, with its emphasis on the opposition between hegemonic and subaltern classes (see Cirese 1973), inspired a particular strand of politically engaged research in the region, sometimes supported by the trade unions and the Communist Party, which had the aim of contributing to the liberation of oppressed peasants. This ideology, which was not exempt from a certain degree of orientalism (Faeta 2003), provided the framework for a number of ethnographies, journalistic inquiries, and literary and cinematic works.

Basilicata began to feature in the national media at the end of the 1940s, as a result of the coverage of the struggles of peasant groups for agrarian reform and the visits of politicians to the city of Matera. During the post-war reconstruction effort this city – which in the 1990s would become a UNESCO World Heritage site on account of its neighbourhoods carved in the rocky walls of a canyon – was described by Alcide De Gasperi, then prime minister, as a 'national infamy' and by Palmiro Togliatti, leader of the Communist Party, as 'Italy's shame' due to the living conditions and extreme poverty of its inhabitants. But the factor that most triggered the interest of Italian intellectuals in the region was the publication of a novel by the painter and writer Carlo Levi. Exiled by the fascist regime in 1935–36 from his native Turin to the Lucanian village of Aliano, Levi drew on this experience in the novel, first published in 1945, *Cristo si è fermato a Eboli* (*Christ Stopped at Eboli*). In this work, the agrarian world of the southern peasants is characterised as marginal and archaic, but at the same time it is presented in a much more intimate and humanised way than had been the case in previous scholarly publications on the demography and economics of southern Italy. Read by many as an ethnographic account thanks to its lively detail, Levi's novel became a must-read 'political-emotional manual for all those who … cared about the fate of *the other Italy*' (Carpitella in Agamennone 1989: 18).

One of the many readers of Carlo Levi's book was Ernesto De Martino, a key figure in the process of 'discovery' of Basilicata (Zinn 2015). He specifically discussed episodes and characters from *Cristo si è fermato a Eboli* in one of his essays (De Martino 1949; see Gallini 1995). A historian of religion and considered to be among the founders of modern anthropology in Italy, De Martino conducted a series of brief but important periods of fieldwork in Basilicata during the 1950s, focussing especially on magic and mortuary lamentations (De Martino 1958, [1959] 2015; Gallini and Faeta 1999). De Martino worked with an interdisciplinary team, variously composed of his assistant Vittoria De Palma, a photographer, a filmmaker, the ethnomusicologist Diego Carpitella and at times even a psychologist and a medical doctor. His methods often used song and music as a way into the lifeworlds of the peasants, since he had noticed the presence of music in their every-day and ritual life (Carpitella 1992: 28). In this regard he was greatly aided by the musicological expertise of Carpitella as well as by the support that he received from audio technicians of the national radio and the first Italian ethnomusicological archive, the CNSMP (Adamo and Giannattasio 2013; Ferretti 1993). This research centre later promoted further field research in Basilicata and beyond, including that of Alan Lomax who, in 1954–55, toured the country with Carpitella in order to record songs (Lomax 1956, 2008; Lomax and Carpitella 1957a, 1957b).

Other foreign researchers also became interested in the region around this period: among the best known are the sociologists Frederick G. Friedmann and George Peck, and the anthropologist Edward G. Banfield. In later years, they were followed by Nevill Colclough, Dorothy L. Zinn and Steven Feld. The latter worked in collaboration with local scholars on the sonic aspects of some important festivals during the early 2000s, and part of the outcome of this research is published in chapters 1 and 2 here (see Scaldaferri 2005; Scaldaferri and Feld 2019).

The research produced by De Martino and his school not only inspired subsequent scholars, but also, largely on account of his use of audiovisual media, played a major role in the construction of an imaginary that had a significant influence far beyond the specialised world of academic social research, reaching out into the documentary arts and cinema. The first photographer to collaborate with De Martino was Arturo Zavattini, son of Cesare, one of the principal figures of Italian neorealist cinema in the post-war period. Through evocative black and white images, Arturo Zavattini's work depicted life in the poorest neighbourhood of the village of Tricarico. These images have subsequently become part of the canonical iconography of the region. Ando Gilardi followed in Zavattini's footsteps, collaborating with De Martino mostly while he was conducting research into magic. For

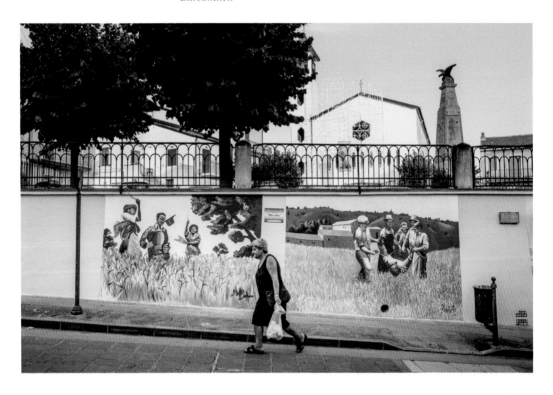

0.1 San Giorgio Lucano, August 2018. Mural paintings based on Franco Pinna's photographs of the game of the sickle, by painters Mattia Damiano (left) and Vincenzo Blumetti (right).

his part, Franco Pinna produced some of the most iconic images of the Demartinian corpus during field trips investigating funeral lamentations and the 'game of the sickle' in Basilicata (see image 0.1) and during De Martino's particularly renowned research on Tarantism in neighbouring Apulia. All three photographers spent a brief but important part of their careers collaborating with De Martino, moving to photojournalism and set photography for Federico Fellini (in the case of Pinna), history and critique of photography (Gilardi) and direction of cinematography (Zavattini).

De Martino's inquiries into 'subaltern lifeworlds', magic, and local forms of religion and superstition as existential countermeasures to the hardships of peasant life, amplified by the images by the photographers who worked with him, also spread beyond academic circles thanks to photographic essays published in mass circulation magazines and to his radio broadcasts (De Martino 2002). His work also influenced an important group of filmmakers, whose work focussed on the same themes and which would later come to be known as 'Demartinian cinema' (Marano 2007: 29–67). In 1949, a law was passed to support documentary filmmaking that required cinemas to set aside a short slot for nonfiction films to be shown before the screening of the main feature and also assigned 3 per cent

of the box office proceeds to these productions (Rizzo 2010: chapter 4). This encouraged filmmakers with backgrounds in experimental and art film to create a cross-fertilisation that generated new documentary forms, with the result that a broader general public was exposed to this imagery than ever before.

The directors of these short films were not specifically interested in ethnographic documentation or visual anthropology as such, but rather saw their films as creative and poetic enterprises, and they were not afraid to engage in experimentation. The first work of this kind is generally considered to be the short film on Lucanian funeral lamentation directed by Michele Gandin, *Lamento funebre* (1954), on which De Martino acted as an adviser and which featured field recordings by Carpitella. Later works by directors such as Lino Del Fra, Cecilia Mangini and Gianfranco Mingozzi mixed documentary and fiction in approaching themes previously dealt with by De Martino across various different regions of southern Italy. However, the most important Demartinian director is widely considered to be Luigi Di Gianni, who, although also well known for his work in fiction and for his adaptations of Kafka, made a number of films in Basilicata, often incorporating explicit references to De Martino. The screenwriters who worked on these films included Pier Paolo Pasolini and Salvatore Quasimodo, a winner of the Nobel Prize in literature, while the soundtracks were often composed by electronic music experimentalists such as Egisto Macchi and Domenico Guaccero (Cosci 2015).

The imaginaries surrounding Basilicata also reached mass audiences through cinema masterpieces such as Luchino Visconti's *Rocco e i suoi fratelli* (*Rocco and His Brothers*) (1960), where 'Lucania' is evoked as the land of origin of the protagonists, who leave behind its misery, superstition and hardships to move to the northern city of Milan, at the time undergoing an economic boom. The 'lunar' landscapes of inner Basilicata (image 0.2), first described by Levi and also appearing in Gandin's short film, appear again in Pasolini's *Il vangelo secondo Matteo* (*The Gospel According to St Matthew*) (1964), partly filmed on location in the Sassi area of Matera. The canyons and cave settlements of Matera would soon become a favourite Hollywood backdrop, still in use in more recent productions such as *The Passion of the Christ* by Mel Gibson (2004) and *Ben-Hur* by Timur Bekmambetov (2016) to name but two, which in turn generated film-related tourism and urban development (Ferrari 2016).

In sum, it is interesting to point out that the overlap between anthropological themes and creative practice was a feature of the best-known body of research on the area as far back as the 1950s (Schäuble 2019). The role of audiovisual media – especially photography, documentary or neorealist fiction films, and field recordings – was and

is fundamental in amplifying and propagating those ideas, which still reverberate in the discourse of local and institutional actors.

Cultural and heritage policies

The discourses developed in and around the research work of De Martino and his students in the 1950s and 1960s, along with the associated iconography, featured centrally in the imaginaries constructed about the region and consolidated over subsequent decades. Together with studies by other scholars, this work has had a lasting impact on an important branch of Italian academic anthropology and is widely considered foundational for Italian ethnomusicology. It has also been instrumental in shaping public policies regarding 'demoethnoanthropological' heritage, a term that began to circulate from 1975 in the domain of museums, public administration and university curricula. It has also reverberated in local identity discourses within the region itself, providing a vocabulary and a starting point for local cultural initiatives, many of which are aimed at promoting tourism.

Sound recordings, photographs and film footage taken in the areas where De Martino did research are commonly used in festivals, exhibitions and publications, and have become integral to local forms of

0.2 Craco, August 2005. View from the old town, over the hills of central Basilicata.

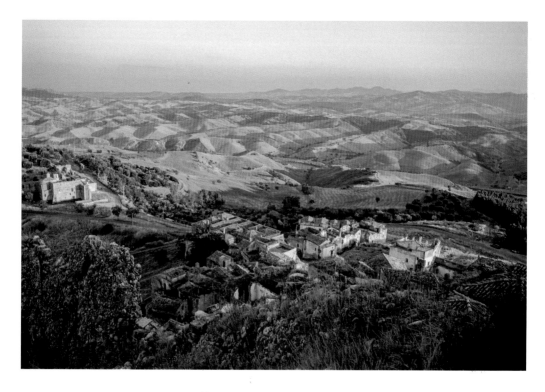

touristic promotion. An emblematic example of the afterlife of anthropological research is represented by the work of Giovanni Battista Bronzini, which partly overlapped with the timeline of De Martino's research, and provided what to this day is one of the dominant interpretations of the *Maggio* festival in Accettura (see chapter 1).

Interestingly, this has even happened in relation to practices and rituals that had originally been framed in a negative light, for example superstition and magic. With the passage of time and the consequent severing of the association of these practices with social marginalisation, they have been recontextualised through a discourse often pervaded instead by nostalgia. A remarkable instance concerns the village of Colobraro, whose reputation as the home of witches and bad luck was once so sinister that people in the region refrained from mentioning it by name, referring to it simply as '*quel paese*' (that village). This reputation was immortalised and amplified by De Martino's writing and Pinna's images in *Magic: A Theory from the South* ([1959] 2015). Among the best-known pages of the entire body of De Martino's Lucanian ethnography is the description of a troubled trip to Colobraro to record a well-known *zampogna* player, only for him to be found dead upon the researchers' arrival. Equally famous are Pinna's images of a local 'enchantress', who today continues to appear frequently as an icon of Basilicata in a surprising variety of local contexts (see chapter 7).

More than fifty years on, in Colobraro these practices have been absorbed as an identity marker and are enacted in a theatrical form during open-air shows that take tourists around the narrow alleyways of the village. Twice a week during the month of August, a group of local people, coordinated by a theatre director, take part in a performance that makes use of De Martino's terminology and is opened by an exhibition of Pinna's images.[1] This initiative, started in 2011, has now become one of the main cultural tourism attractions in the region, drawing three thousand visitors on a single evening in 2018, a figure which represents more than twice the number of permanent residents in the village (image 0.3). A similar festival was started in 2012 in Albano di Lucania, another key destination of De Martino's expeditions. This is explicitly entitled *The Nights of Magic – a Journey in the Footsteps of De Martino*.

Since the early years of the twenty-first century, processes of 'heritagisation' of tradition (Harrison 2013; Walsh 1992), and in particular of its documentary traces in the form of audiovisual media, have become ever more frequent and visible in Basilicata. The old rural world is becoming increasingly obsolete due to changes in lifestyle and economy, and is shifting its significance for the younger generations, who now mainly identify with it on an emotional level. But at the same

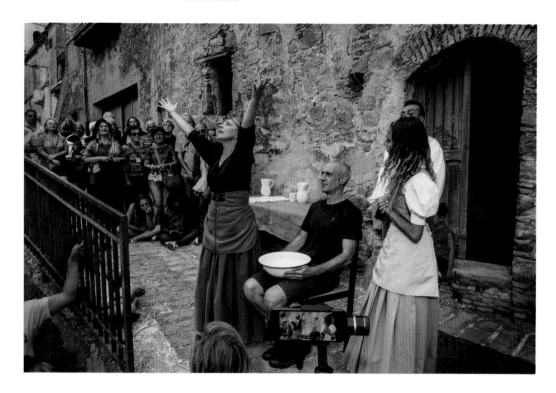

time, local institutions are increasingly committed to 'rediscovering' traditions, which are then often enshrined in museum collections and archives. Scholars of European heritage have underlined how these processes often privilege festivals as public moments when tradition is perpetuated and local identities are performed for the community itself and for the benefit of tourists (Boissevain 2008; Fournier 2013; Hafstein 2018; Kockel et al. 2019). These processes of 'festivalisation' (Richards 2007) also affect the heritage of Basilicata, and are part of more general trends of institutionalisation of culture in Europe (Macdonald 2013; Peckham 2003; Smith 2006).

0.3 Colobraro, August 2018. Theatre performance in the streets. Treating a member of the audience for *affascino* (binding) (compare De Martino [1959] 2015, chapter 1).

Lucanian festivals, museums and other initiatives are often directly or indirectly funded by the European Union, via the creation of registers of intangible heritage in which the safeguard of cultural heritage overlaps with the creation of tourism packages. In 2014, for example, the regional government of Basilicata created a list of items of intangible cultural heritage (DGR 1198/2014) that was intended to 'adopt future policies … funded by EU, state and regional resources … and to promote public cultural heritage for the benefit of tourism'.[2] This list was established on the basis of a self-assessment carried out by each municipality and soon became a way for them to present a local identity to the outside world.

Based on this list, each municipality now receives a yearly financial contribution that is managed by local cultural associations charged with promoting events, exhibitions or performances such as that of Colobraro. A quick look at the list reveals the abundance of references to the jargon of anthropology and to sixty years of ethnographic research in Basilicata: among the themes are magic, carnivals, religious processions, tree rituals and wheat festivals, often with explicit references to De Martino's visits – as in the case of the game of the sickle in San Giorgio Lucano.[3]

Another strategy to attract funding is the creation of networks of related events (Di Méo 2005), often making use of anthropological jargon in a number of different guises. In Tricarico, for example, the local tradition of carnival masks is the starting point for a festival called *Raduno delle maschere antropologiche* (Gathering of Anthropological Masks) (image 0.4). The festival centres around a parade of masks from various Italian and international contexts. The adjective 'anthropological' – note the social media hashtag #antropologico2018 – here, as elsewhere, has shifted its original meaning from a term designating academic research to one that identifies a particular event as culturally exotic and therefore appropriate for touristic promotion.

Doing research in Basilicata today means not simply being aware of past scholarship, but also to consider the new lives and uses to which this scholarship is now being put in this region. Here, perhaps more markedly than in regions that have had a similar history of research – for example in Apulia with the research on Tarantism (Lüdtke 2009) – anthropological knowledge has been re-packaged

0.4 Programme for the 'Gathering of Anthropological Masks' 2018, 7th year, in Tricarico.

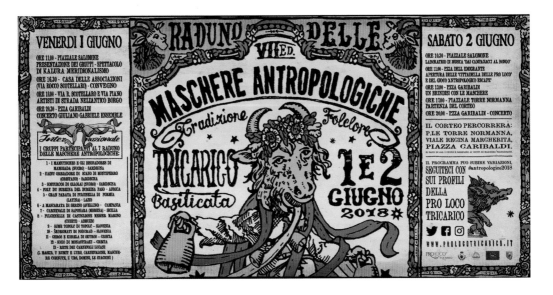

and institutionalised, becoming fundamental to the assigning of public funds by local, national and even international agencies. Anthropologists are often asked to write reports that certify the authenticity and significance of festivals and cultural performances, though concepts are frequently misunderstood and lost in translation in the course of this process. Despite the importance in these discourses of keywords such as 'tradition', 'continuity' and 'authenticity', during the research for this book we often witnessed rapid change and transformation – for example in the case of the flourishing of initiatives and events surrounding wheat festivals during the 2010s (see chapter 4). Nonetheless, this background information is indispensable to understanding the phenomena we examine in this book, given the way in one form or another anthropological scholarship and discourses have become omnipresent in festivals, institutional structures and even everyday local experiences.

Text, photographs and sounds

This is a book that we envisioned, from its inception, as rich in photographic images. The decision to work with a combination of printed images and texts was in part inspired by the region's tradition of ethnographic research and its association with extensive photographic documentation, as mentioned above and examined in more detail by Ferrarini in chapter 7. The format of the printed book has also allowed us to experiment with various different forms of relationship between text and image, and to explore their distinctive possibilities. The formats that we have employed are essentially of three different kinds, though all of them could be considered different interpretations of the photo essay genre (Sutherland 2016b). The first format is used in chapters 1 and 2, in relation respectively to the *Maggio* festival in Accettura and the carnival bells of San Mauro Forte. Here, the essays and the photographic sequences are developed as separate narratives that maximise the distinctive characteristics of each medium. This approach is embodied in the very layout of these chapters, since images and texts occupy separate sections. The photographic sequences encourage interpretations based on their internal narrative arcs, which are constructed around visually suggestive or rhythmic relationships between adjacent images. These sequences are not meant to act merely as illustrations of the text, and although they can sometimes be employed in that way by the reader, this is not what we would consider to be their primary function. Rather, we intend their relationship to the written text to be one of complementarity, where the text is given the task of putting forward arguments, of analysing and providing context. The images, on the other hand, put forward a

different kind of argument, one that is based on sensory evocation and on oriented description, more personal to the photographer's interpretation and to his experience of the events. We use this strategy to approach situations in which we want to highlight, through the perspectives of sensory anthropology, experiential aspects that have been neglected in previous studies. Although the photographic sequences appear after the essays, we encourage the reader to experiment and skip to the images, then read the text, and perhaps come back to the images with new eyes.

The second format that we have employed is exemplified by chapters 3 and 5, in which the photographs are embedded within the text. Despite their positioning, the role of the photographs within these chapters is again not primarily illustrative. Rather, we think of them as being in dialogue with the text and suggest that they can be viewed as short visual essays in their own right. By contrast, in this introduction and in the two methodological chapters 6 and 7, none of which is based on ethnographic research, the images have the straightforward role of providing supporting documentation.

The third form of relationship between text and photographs, exemplified in chapter 4, consists of a photo essay about wheat festivals. Here, after a short textual introduction, groups of images alternate with text, in the manner of the classic magazine photographic essay. Although here too there is a co-presence of images and text, as in the second format described above, in this case the photographs dictate the pace. The dominating narrative is the visual one, and the text follows, adding depth of information or telling the backstory to the images. The selection of images and their ordering, however, was also made with the textual content in mind, so that this format represents a middle way between the previous two. Here the reader can simply look at the photographic sequence and then read the text, or experience everything in the order it is presented.

Sound constitutes the third component of this book, not a secondary or subordinated one but a narrative in its own right, able in each instance to match, oppose or be independent from the textual and photographic narratives. This autonomy of the sound narrative is a function of the intrinsic specificities of a sonic event and of the temporal flow in which it takes place, as opposed to the static nature of texts and photographs. A further contrast inheres in the fact that listening constitutes a distinctive way of knowing, a phenomenon that has received much attention in recent years, most particularly in Feld's work on acoustemology (1996, 2015a).

The first example of a 'sound-book', described as including 'visual and auditory illustrations linked with the text', appears to have been *Hunting by Ear*, a short book on fox-hunting which featured both

drawings and a 45rpm record (Koch and Broch 1937: 5). Later formats used cassettes or CDs, and recently web pages. In some cases, sound recordings serve merely as acoustic illustrations of situations described in the text, reproducing a textualist perspective that we tried to avoid in this book as much as possible. At the same time, the solution we wanted to pursue here was not simply to create sound documentation of ethnographic value following a creative approach, but to give the audio tracks analytical import by structuring them around key concepts, capable of dialoguing with the arguments of the texts and the perspectives of the photographs. We partly took inspiration from recent ethnographic 'sound-books' that give their audio component a primary role alongside text and photographs (e.g. Cox and Carlyle 2012; Feld et al. 2019).

Our solution has been to create sound-chapters, which complete the textual and photographic component of each chapter. With the exception of Steven Feld's soundscape composition track, which is taken from a previously published work (Scaldaferri and Feld 2019), each sound-chapter was edited by Scaldaferri as an autonomous sound narrative to be listened to in parallel to reading the text and viewing the photographs, but also before or afterwards. The guiding principle of each sound-chapter is strictly connected to the argument of each text, for example control of space through sound and music (chapter 3), or creative interactions during fieldwork (chapter 6). At the end of the book a listening guide details the contents of each track.

Each sound-chapter comprises diverse kinds of recordings, deriving from more than thirty years of listening–research–interaction in the field (Scaldaferri 1994). These range from musical performances recorded during ethnomusicological research to ambiences and soundwalks, but also include archival materials. Their editing is not based on respecting a temporal or spatial coherence, but on the meaning that they can assume in the context of a montage. There are two editing principles at work: creating descriptive sequences of sounds (as in sound-chapters 1, 3, 4 and 6) or overlapping them in evocative and creative compositions (chapters 2 and 5). These representational choices derive from a historical path of convergence between the creative processes of electronic music, especially as represented by Luc Ferrari's work, and those of soundscape composition, including Westerkamp and Truax in addition to some of Feld's own work. The relationships and overlaps between the technical processes and creative approaches of these two strands are well documented and can be said to form a 'continuum' (see also Drever 2002; Rennie 2014).

The recordings may be used by the reader-listener to explore a variety of relationships. For example, those mainly centred on musical performances allow appreciation of the skills of single or groups

of musicians, the personae they enact in performance, their interaction with the surrounding context, and the competences and skills that enable them to dominate a sonic environment more effectively than with sheer decibels (see chapter 3). These recordings also reveal the innovative and creative nature of their interaction with more established traditional practices (see chapter 6). On the other hand, an attention to soundscapes and the various interactions contained within them allows the listener to grasp gestures and dynamics that synchronically reveal the complex and stratified power relationships between actors (see chapters 2, 3 and 4). Finally, a third type of recording emerges from archives that were not created for reasons of research but in order to connect migrants or assuage nostalgia (chapter 5). The relevance of these recordings lies in the cultural meanings that they evoke both for later generations and for researchers.

What is to be gained from putting photographs not only side by side with text, but also with a montage of sound recordings? Unlike the pairing of images and sounds in documentary films with a synchronous soundtrack, our approach in this book allows the reader-listener to switch off the images, as it were, and concentrate on sound only. As remarked by Henley (2007), the realist tradition of ethnographic documentary has long treated sounds other than the spoken word and music as merely an accessory to the visual, especially directly after the advent of easily portable cameras capable of synchronous sound. We feel that our approach to audiovisual representation steers away from this tradition towards a direction shown by ethnographic films inspired by more experimental filmmaking styles, such as those produced in recent years at Harvard's Sensory Ethnography Lab or Manchester's Granada Centre for Visual Anthropology. We never searched for a close correspondence between sound and photographic accounts, preferring instead to develop independent paths for each medium. When these narratives are experienced in juxtaposition, the evocative effect generated by the gaps left by the 'asynchronous' (Heuson and Allen 2014) lack of direct correspondence between sonic and photographic accounts can evoke sensations that go beyond the visual and acoustic, including, for example, a sense of the tactile qualities of the phenomena represented. In this way, we would argue, the representation of the two media in combination may be more akin to the fragmentary and multisensory nature of experience.

On the one hand, we use our approach to the juxtaposition of images and sounds to enrich the project with the perspectives of sensory anthropology (Cox et al. 2016). On the other, we recognise and pay tribute to the genealogy of artistic inflections in the history of social research in the region. We were also influenced by past experiences with similar book formats, especially a previous collaboration

between Scaldaferri and Vaja (2006) and other collaborations between Scaldaferri, Vaja, Ferrarini and Feld (Scaldaferri 2005; Scaldaferri and Feld 2019) – all based on fieldwork in Basilicata. In Greece, Feld participated in two projects that used a similar formula and were very influential for us (Blau et al. 2010; Keil et al. 2002).

Finally, we would very much encourage the reader-listener to play and experiment with the juxtaposition of photographs, sounds and text that are presented in this book. In this way, we might, in effect, be giving up some of our authorial control over the work. But our hope is that by this means the reader-listener will be empowered to discover new pathways through the sensory experience of the sonic environments that we evoke as well as new interpretations of their significance.

Notes

1 www.basilicataturistica.it/attrattore/sogno–di–una–notte–a–quel–paese–colobraro (accessed 31 March 2020).
2 https://patrimonioculturale.regione.basilicata.it/ (accessed 31 March 2020).
3 https://patrimonioculturale.regione.basilicata.it/rbc/form.jsp?bene=541&sec=5 (accessed 31 March 2020).

WHEN THE TREES RESOUND: TOWARDS A SONIC ETHNOGRAPHY OF THE *MAGGIO* FESTIVAL IN ACCETTURA

Lorenzo Ferrarini and Nicola Scaldaferri

In the village of Accettura, a settlement of less than two thousand residents in central Basilicata, every year around Pentecost the festival of St Julian culminates in the raising of a massive tree in the main square by means of a system of manually operated winches. The process of carrying large oak trees from the nearby woods – with ox-teams – and a holly tree – borne on the shoulders of teams of men – as well as the mass participation of the village population, have resulted in the festival achieving widespread renown as the most impressive and spectacular such event in Italy.

Over many years, scholars, photographers and filmmakers have provided a number of perspectives on the festival. However, in this chapter, which is based on long-term team research led by Scaldaferri since 2002 (Scaldaferri and Feld 2019), we argue that the sonic aspect of the festival has often been overlooked – perhaps precisely because of its striking visual characteristics. A sonic ethnography, on the other hand, allows the detection of mechanisms at work during the festival that were previously unnoticed. Importantly, it also highlights the experiential dimension for the participants, which has been neglected because of the way an abstract symbolic interpretation has become officially institutionalised as a result of processes of heritagisation. The intersection between sound and the experiential dimension of the festival, we argue, remains the central aspect for the participants despite the increasing relevance of cultural tourism and heritage politics.

By 'sonic ethnography' we refer to an approach to ethnographic fieldwork that puts sound at its centre, beyond its definition as 'the sounded representation of ethnographic data' (Gershon 2013: 259; see also Borbach 2017: 85; Gershon 2012: 5). This is only one component of a threefold methodology that starts with taking sound seriously and listening critically. It requires re-balancing the ocularcentric bias identified by the early anthropology of sound and treating hearing as a cultural process (Feld [1982] 2012; Roseman 1991; Stoller 1984),

21

which in turn allows sound to be conceived of as a way of knowing (Feld 2015a; Rice 2003). This sensibility opens up listening to, among other things, senses of place (Feld and Basso 1996; Gell 1995), technologies and ideologies of mediation (Katz 2004; Sterne 2003) and histories of class and power (Fox 2004; Ochoa Gautier 2006). Sound is here treated not so much as a natural-cultural given, as in the classic notion of soundscape, but as the emerging aural outcome of acts of listening that are embodied, mediated and inscribed in historical and ideological contexts.

The second aspect of this methodology concerns the different positionalities of the listeners. This entails doing research *in* and *through* sound, involving research collaborators in processes of elicitation, feedback and dialogic editing over sound recordings (Feld 1987), but also performing sound collaboratively as a research practice (Wilson 2017). This answers calls to adopt ethnographic methods that put sound at the centre, for an 'anthropology in sound' (Feld and Brenneis 2004) or a 'sounded anthropology' (Samuels et al. 2010).

The third methodological component of sonic ethnography is the representational one, which for us includes framing sound recordings as more than illustrative material, developing arguments in sound through strategies of editing borrowed from electroacoustic music (Drever 2002; Scaldaferri 2018; Truax 2008). The post-production of sonic ethnographies is a powerful analytical device that allows detection in the recordings of unexpected relationships and structures that the ethnographer might otherwise have missed (Feld and Scaldaferri 2019: 82–84). However, finally it is important to stress that a sound-centric approach to ethnography is not meant to replace other, more established ways of working, but can be useful to complete the frame and build on existing scholarship as we do here.

The *Maggio* festival

The raising of the tree is only part of a ritual cycle that involves extensive preparations and a number of side events including processions of statues of the patron saint, St Julian, and of a painting of St John and St Paul. The part of the festival taking place around Pentecost is called *Maggio*, a term meaning 'maypole' that is also used to refer to the tree raised in the village and to its lower component, a massive oak with its branches removed, which is joined to a leafy holly (called *cima* (top)). After being chosen by a group of forestry officials (since the trees are taken from regional forest parks), loggers and members of the festival committee, a number of oak trees are felled on Ascension Thursday. These are the *maggio* itself and the supporting posts for the winches that will raise it. On Pentecost Saturday, nine days later, the oak trees

are dragged by ox-teams towards the village, and on the following day, Pentecost Sunday, the holly *cima* is also felled in a forest at the opposite end of Accettura's territory. On the same day, the parish priest holds a mass for each group and in the evening the oak trees and the holly reach the village. All along there is a festive atmosphere, with plenty of food and wine, music and singing.

Monday begins with a procession of the painting of St John and St Paul, while most of the day is dedicated to preparing the square for the raising of the *maggio* on the following day. This is not a simple endeavour, since the tree is so heavy that the winch used to raise it is large enough to require another winch to put it in place. In the evening of the Monday a procession with a small statue of St Julian takes place. On the Tuesday morning, with the aid of large wooden dowels, the *cima* and the *maggio* are joined while still on the ground, and some metal tags are tied to the branches (formerly cheese, cured meat and even live animals). After a mass is celebrated a larger statue of St Julian is carried in a procession, stopping in the main square where the *maggio* is finally fully raised, often totalling more than thirty-five metres. Women dance balancing votive offerings of candles on their heads, and towards the evening some young men climb the tree and perform acrobatic feats. Until a few years ago, men would shoot at the tags with shotguns. This is the climax of the festival, which usually also includes a concert and fireworks display, as on other similar occasions. The *maggio* remains in the square until Corpus Domini Sunday, when it is publicly auctioned and taken down.

This is the rough timeline of the festival as we witnessed it in 2004 and 2005, and at various points over the following years. Although small changes are common, the available historical sources suggest the relative stability of the festival cycle since the turn of the nineteenth century, when the cult of St Julian first became associated with the festival. Colclough interprets this period as crucial to the history of the festival, when it acquired new significance and an egalitarian character in the face of increasing concentration of land ownership and loss of communal rights (2001). Until the 1970s, in fact, the committee organising the festival was still representative of the main categories of peasants and artisans who would also contribute to its practical unfolding with their specialised knowledge of forestry, carpentry and ox-driving, and excluded the landowning gentry. Although many phases of the festival are in fact displays of masculine strength and prowess, women also fulfil essential organisational functions behind the scenes. Their appearances in the public phases of the ritual, however, are limited to singing during processions and dancing with votive offerings. It is hard to overestimate the importance of the *Maggio* for the community of Accettura, which includes the hundreds of emigrants who return to

their village of origin for the duration of the festival. Not only is the *Maggio* crucial in identity terms, being the pride of the community and a main selling point for cultural tourism, but it is also the object of considerable local investments in the form of grassroots funding or acts of devotion such as caring all year round for teams of oxen that only work during the festival. Since the 1960s, this local relevance of the *Maggio* has acquired a specific tint that derives from the interplays between anthropological scholarship and heritage politics.

The *Maggio* as ancestral symbol

Whether its origins lie in an episode of Langobard history, are inspired by revolutionary liberty trees or derive from even earlier pre-Christian cults (Filardi 2001), the *Maggio* festival is clearly distinctive on account of its deliberate anachronism evident, for example, in the procedures used to raise the tree or in the way its components are transported to the village. The uniting of two (gendered) trees at springtime has led a number of scholars to suggest that the *Maggio* represents a powerful atavistic rite of natural renewal. These interpretations often distinguish between a primordial layer, consisting of the pagan ritual of the marriage of the trees, and a much more recent addition in the form of the Christian cult of St Julian. The best known example of this type of approach to the festival is that of Giovanni Battista Bronzini, who attended the *Maggio* at the end of the 1960s and published a number of essays that were later gathered in a monograph (1979). Ferdinando Mirizzi (2019) underlines how Bronzini, although claiming to favour an approach close to the experience of the protagonists, based his analysis on Tylor's notion of cultural survivals, framing the coupling of the trees as an ancient pre-Christian ritual of tree worship by reference to Frazer – who in actual fact had not described anything comparable to what happens in Accettura. Seeing the Christian component as a later addition, Bronzini proposed the label – now commonly used – of *Maggio di San Giuliano* (*Maggio* of St Julian) for what was otherwise simply referred to locally as the festival of the patron saint. Shortly afterwards, Bronzini's colleague Lanternari also insisted on the syncretic character of the festival (1977), though he acknowledged that the marriage of trees had no direct connection with the lifeworlds of the participants, underlining instead the function of the *Maggio* as an expression of local identity.

In parallel to the writings of these scholars – often problematically dubbed the 'discovery' of the festival in the Italian literature – the national media started taking an interest in the *Maggio*. The first documentary was an 8mm film by Giosuè Musca produced for the University of Bari (1969), while shortly after the national television

company (RAI) aired the short *Il matrimonio degli alberi* (*The Marriage of the Trees*) directed by Carlo Alberto Pinelli (1971). The former film had a commentary written by Bronzini, and the latter by Lanternari. Both expository voiceovers proclaimed that the *Maggio* was an archaic ritual of renewal of the natural world, an interpretation which then began to spread to tourist guide booklets and to the protagonists of the festival themselves – to eventually end up in the *New York Times* in recent years (Silverman 2018). Colclough, though aware of the influence of 'post-war south Italian folklorists' (2001: 384), speculates that these survivalist interpretations could date back to the pre-Unification period, a time when itinerant Neapolitan missionaries were seeking to get rid of pagan elements among local Christians.

In actual fact, the expression 'marriage of trees' appears to derive from the description of the festival that Nicola Scarano, a poet and primary school teacher in Accettura, sent to Bronzini in 1961 after he had asked his students to do research on the festival as a class activity. Both Bronzini and Lanternari took up that idea, but the evidence of its presence among the protagonists of the festival is weak. In the transcripts of the interviews conducted by Bronzini all the respondents stress the importance of the cult of St Julian, and the equal importance of the roles of the saint and of the tree. Significantly, the only mention of a marriage as such is in response to a leading question by Bronzini, which prompts the interviewee to compare the *maggio* and *cima* 'more or less' to husband and wife (Bronzini 1979: 43; in Mirizzi 2019: 34). Vincenzo Spera, who was Bronzini's student at the University of Bari, reports a conversation that he had in 1971 with some key figures in the organisation of the festival, who commented to him that the idea of the marriage was something that 'the professor from Bari told us' (Spera 2014: 125).

Regardless of the details of this debate, what is interesting for our purposes is that the idea of the ancestral fertility ritual based on the marriage of the trees has taken root in the community of Accettura, particularly since the festival has started to attract tourists and its media coverage has increased. People in Accettura have begun producing their own representations of the festival in order to promote it with tourists and local institutions – and inevitably to think about it as heritage and as something that they partly perform for an outside audience. Official publications about the *Maggio* by the city council or the *Pro Loco* (tourist office), self-produced videos or online portals[1] echo the interpretations provided by these scholars, who lend an aura of authenticity to the tradition by connecting it with the past. As a result of these processes, it is now common to hear festival participants provide interpretations that follow the framework provided by Bronzini.

The institutionalisation of Bronzini's interpretation of the *Maggio* festival came close to reaching an international stage with the

preparation of a candidacy for the UNESCO register of Intangible Heritage in 2007. A possible inclusion in the register, with its attached value of international recognition, is a prospect that is raised time and again in local political discourse. The dossier, which was never actually completed, was heavily reliant on a reading of the festival as an ancient pagan rite and quoted Bronzini in claiming that the ritual was unique in Europe. However, at the time that he first wrote on Accettura, Bronzini was not aware of a number of similar tree rituals in the area surrounding Accettura and in the Pollino mountains further south. Scaldaferri documented seventeen such festivals over these two areas, taking place between April and September and invariably connected to a figure of the Christian calendar (2019b: 13–16), while Spera relates Accettura's *Maggio* to the tradition of raising trees of Cockaigne (greasy poles) in the kingdom of Naples since at least the seventeenth century (2014: 130–31). In the context of these examples, the case of Accettura has come to appear much less unique. Partly as a result of this new ethnographic data, the strategies of heritagisation have evolved towards creating a network of tree rituals in the region, in which Accettura heads nine municipalities, with the aim of promoting the rituals as intangible heritage and a form of 'territorial marketing'.[2] The village now also hosts a museum dedicated to these festivals, which gathers literature, photographs and videos from the region and beyond.

While the reading of the festival as a survival of a pagan fertility ritual is currently under increasing scrutiny in the light of historical and ethnographic data, it is striking how it has nevertheless taken on a life of its own, even beyond the intentions of its original proponents. Its use in websites, documentaries and in the captions of the vast numbers of photographs of the event published every year testifies to the desire for a mark of authenticity by professional experts, and it has now become a favourite interpretation even for the festival's own protagonists. Its original scholarly origins have been forgotten and it has become instead part of the tradition. At the same time, the festival is losing its connections with the everyday practices of its protagonists and also the rebellious character that it is reported to have had since the eighteenth century (Colclough 2001; Spera 2014). Instead, the *Maggio* is increasingly becoming more and more a representation addressed to outside audiences, a performance of local identity influenced by processes of heritagisation in which local institutions play a major part.

Another striking aspect of these contemporary debates about the meaning of the *Maggio* festival is that they have remained within the domain of the symbolic level, with scholars arguing over whether it *represents* the generative power of the natural world, or rather *stands for* the community of Accettura united in common labour or divided along class lines. The overwhelmingly sensuous character of the celebration,

with its sometimes brutal and dangerous phases that leave the carriers of the *cima* ragged and exhausted or the drivers of the *maggio* ox-teams covered in mud, is something that we want to bring back to the centre of attention. Our ethnography has demonstrated that the most active participants are not particularly concerned about scholarly interpretations, but rather live the festival as a form of embodied devotion and a performative reassertion of a sense of community.

A sonic ethnography of the *Maggio*

The days around Pentecost, when the central phases of the *Maggio* festival take place, offer what is undoubtedly a remarkable visual spectacle. It is not by chance that generations of photographers including Mario Dondero, Joseph Koudelka, Fausto Giaccone, John Vink and Ivo Saglietti have turned their lenses on the tree. However, the festival is an assault on the full sensorium that includes the strong smells of the forest, of the sweat of men and animals, the taste of the festive food and abundant wine consumed in the woods and around the village, and the very tactile experience of being hit by branches, bumped into by drunken people, or slipping and falling on the muddy paths trodden by crowds. However, we decided to approach the festival in its sonic dimension, which is especially complex and has been left underexamined in most existing studies. In particular, our sonic ethnography has revealed how sound is a major organising principle of the festival.

Many of the early accounts mention the sonic density of the *Maggio*. For example, in 1961 Scarano described 'eardrum-shattering' marches performed by the band. Other scholars simply omit any mention of music or other sounds in their otherwise very evocative descriptions. Too often the sonic component of ritual has been considered an accessory, and as ethnomusicologist Roberto Leydi once put it, from the works of anthropologists and ethnologists there often emerges 'a terrifyingly quiet world, an anachronistic silent film' (1991: 119). But even when sound is mentioned, it is presented as an index of a festive atmosphere, or as a background or surrounding effect without any particular function.

At first listening, the *Maggio* can indeed give the impression of a chaotic clash of noises, shouts, animal calls and diverse forms of music. In order to reach some form of informed understanding, it is useful to start by distinguishing between institutionalised sounds – those that are part of the official ceremonial and are planned during the organisation of the festival – and spontaneous sounds – including improvised, peripheral musical performances and non-organised sounds that are contingent upon certain activities. Spontaneous sounds have the distinctive character of affording active participation in the festival by

people who are otherwise not directly involved in the organisation or transport of the trees.

Among the institutionalised sounds are the religious musical repertoires, especially the devotional songs for St Julian, which happen at strictly defined moments and places. The music of *tarantelle* played on the *organetto* accompanies the dancing of women with votive offerings of candles on their heads, and later on the Tuesday when these offerings are brought in the procession for St Julian. Moreover, it has now become common, as in other village festivals in southern Italy, to schedule a well-known Italian pop music star to give a concert in the main square on the culminating night.

Perhaps the most significant form of institutionalised sound is the music of walking wind bands, of which two kinds are usually heard at the *Maggio*. The large ensembles – symphonic wind bands simply called *banda* in Italian – play a repertoire of marching music and symphonic compositions during the key official moments of the festival, including the arrival of the trees at the village, the processions of the small St Julian statue and of the paintings of St John and St Paul, and the Tuesday procession of the main St Julian statue. One *banda* ensemble is resident in Accettura, and another is usually invited from neighbouring regions. Much more active throughout the more labour-intensive phases of the festival are smaller ensembles called *bassa musica* or *bassa banda* (literally 'low music' or 'low band'), which are composed of a few wind and percussion instruments. There is a clear difference in prestige between the two, and the word 'music', in the parlance of many elders of the area, is still used to refer mostly to symphonic wind bands, the larger ensembles, while 'ending up in *bassa musica*' is a regional idiom to refer to a financial collapse.

Early *bassa musica* ensembles probably originally had the function of making public announcements and were often heard outside of festive circumstances (Scaldaferri and Vaja 2006: 31–32). Their presence at the *Maggio* is documented since at least 1862, and today one often hears ensembles from Apulian towns such as Carbonara or Mola di Bari (piccolo, snare drum, bass drum and cymbals) and Accettura's own ensemble, which performs only during the festival (clarinet, trumpet, saxophone, various percussion instruments). Both *bassa musica* ensembles provide an almost continuous sonic accompaniment for the most physically demanding components of the festival, playing quick marches, *tarantelle* and catchy popular songs, or sometimes particularly fast-paced percussion improvisations called *scasciatammorr* (drum-wreckers). It would be easy to dismiss the *bassa musica* as a marginal phenomenon, derivative of the more prestigious symphonic wind bands and not suitable for the official occasions where institutional figures are present. However, we noticed that during the *Maggio*

its particular function is to provide sonic encouragement to those doing the hard work and entertainment for the more peripheral participants. If the *bassa musica* falls silent, before long one can expect to hear shouts of '*Musica!*', loudly demanding that the music be resumed. In 1961, Scarano even wrote that if the band took a break during a procession, the bearers of the statue would refuse to proceed until they had started playing again. This is not unique in the context of tree rituals in southern Italy. Across the border with Calabria, in the village of Alessandria del Carretto, for example, the selected fir tree called *pita* is dragged by hand by the participants. At the head of the procession is a group of *zampogna* players who lead the way and 'pull' the tree by sound (Scaldaferri and Vaja 2006: 27).

The *bassa musica* also fulfils a crucial role in ensuring the safe realisation of the potentially very dangerous operations of transporting the trees. For example, the *cima* launched at full speed on the shoulders of more than thirty men constitutes an unstoppable force that will sweep over anyone in its path. The characteristic way in which it is carried, with brief accelerations that almost reach running pace, and the fact that most of its carriers cannot see because of the branches, create potential danger for the numerous bystanders. Moreover, in the festive atmosphere massive quantities of wine and beer are consumed. Along the path of the *cima* many of the participants are teenagers, some of whom will be getting drunk for the first time. In this chaotic situation the *bassa musica* ensemble works as a sonic announcement of the moving *cima*, allowing those in front to move away before they can see it. It also works as a magnet, drawing the crowds away from the more dangerous operations: while the intoxicated crowds dance nearby, a few specialists can, for example, 'park' the *cima* suspended on a system of wooden forks that allows preservation of its branches. It is striking to compare the soundful scenario of Accettura with another tree ritual — that of Rotonda, a village of the Pollino area. Here the transport of the tree, called *pitu*, is much quieter and sometimes even silent, thanks to the strict organisation of every aspect of the festival. Music is confined to planned, official moments and is mostly devotional. Yet, despite the almost militaristic organisation, the festival in Rotonda has seen a number of fatal accidents that over the years have been entirely absent in the apparently chaotic Accettura – something that the locals call 'St Julian's miracle'.

Many forms of spontaneous music-making are just as important in involving the numerous participants who do not directly contribute to the labour of transporting, joining and raising the *maggio*. One of the main sources of danger, in fact, is the presence of so many more people than is needed for these operations. Along the path of the trees, and around the main moments of the ritual, a number of musical

'jam sessions' take shape, involving *zampogna*, *organetto*, *tamburello* and improvised musical instruments such as glass bottles struck with keys. In Accettura, many men and a few women excel at a semi-improvised style of singing that is accompanied by a *zampogna* – sometimes replaced by an *organetto* – and their skills attract players from all over the region. While at the time of the research there were no active *zampogna* players left in Accettura, the visiting performers are figures often found in other festivals of the region, especially pilgrimages and processions. These temporary communities of performers are constantly forming and dissolving in succession, sometimes overlapping with each other, following modes that are common in other mass festivals in the region and represent a form of sonic participation (Scaldaferri and Vaja 2006: 21–28).

Not all the sounds relevant to a sonic ethnography of the *Maggio* are musical ones. Many of them emerge from the interaction between humans and materials, and in some cases between humans and animals. For a few days of the year in Accettura one can hear sounds that belong to a way of life that is now all but abandoned, one that is based on former modes of agriculture and forestry: the bellowing of the oxen, the crack of the whips, the chopping of axes and the roar of falling trees deep in the woods. Some of these sounds emerge from engagements with materials requiring skills whose practice is in decline, even though it is occasionally possible to hear chainsaws too. These sounds acquire special significance for those who previously lived through that way of life, and are preserved for the limited duration of the festival by the rigidity of the protocol adopted to transport and raise the trees. They are also dense in meaning for skilled ears, as evident in the crucial moment of the raising of the tree on Pentecost Tuesday. These tense minutes are one of the few moments of relative quiet in the whole festival, when the senior specialists charged with directing the operations are nervously listening for signs of instability. As those operating the massive winch desperately fight the weight of the tree, hisses and shouts of 'Silence!' alternate to the loud creaks of the rope under several hundred kilos of tension. When the *maggio* is finally stabilised in the almost vertical position that it will preserve until the arrival of the statue of St Julian, a collective sigh of relief is marked by a renewed musical explosion by both the *banda* and *bassa musica* ensembles. Around the tree, people sing their joy to the *zampogna* and praise St Julian.

These examples of skilled listening highlight the relevance that sound as a way of knowing still has for some of the participants. Across the whole festival, sound fulfils a denotative function of the changes between the various phases of the ritual, between locations or between different emotional atmospheres. It helps greatly with the coordination

of the transport and raising of the trees, in addition to improving the safety of the participants. Even though some aspects of the *Maggio* festival are clearly developing towards representing the community to an external, growing circuit of heritage tourism, the production of sounds is still very much directed to listeners internal to the community. The meaningfulness of these sounds is perceived in different ways by different categories of participants, in some cases almost unconsciously.

Sonic ethnography as research practice and as mode of representation

The experience of team research carried out at the *Maggio* in 2005 was a fundamental stepping stone to developing the concept for this book and its formulation of sonic ethnography. In particular, there was a first realisation of the potential of sound-making as a way to facilitate research and an exploration of the possibilities afforded by sound recordings as forms of ethnographic representation. While some elements are presented here, the work in its entirety has also been published in the format of a book comprising two CDs, two photographic sequences and some short essays (Scaldaferri and Feld 2012, published in English 2019).

The idea of putting sound at the centre of an ethnography of a well-studied and documented event such as the *Maggio* in Accettura was planned by Scaldaferri during early visits in the role of *zampogna* player. While playing for the Accettura singers, he noticed the emphatically sonorous qualities of the festival, and decided to assemble a research team that could deal with the complexity of the event through different methods and media. One of these modes of research was music-making, and two of the most prominent *zampogna* players of the region – Alberico Larato and Quirino Valvano – joined the team with the aim of eliciting performances by the singers. In the turmoil of the festival, the players were able to attract the singers to favourable positions for the sound recordists. This way of using sound to facilitate research became Scaldaferri's own main mode of engagement, since after his arrival he was requested to play during most of his time in Accettura. The use of this strategy effectively represents an application to research of the same organising principles of sound within the festival that we describe in the previous section. Using *zampogna* players to influence the unfolding of the festival for the benefit of the researchers was for Scaldaferri a first step towards developing his double role of researcher and performer in the direction of a more engaged and experimental creative practice (see chapter 6).

The sonic ethnography of the *Maggio* also resulted in two CDs, each providing a distinct approach and contribution. The first consists

of a seventy minute soundscape composition by Feld, divided into six tracks. Recording through Dimensional Stereo Microphones (see Ferrarini 2017), Feld used his body as an emplaced 'point of listening' (Scaldaferri 2015: 377) to balance the different sound sources within a very wide perspective and portray the sonic unfolding of the festival from the perspective of a participant. In combination with the editing techniques of soundscape composition, Feld achieves a poetic representation of the festival that revolves around points of sonic tension and release. Consistently with the perspective of sonic ethnography, Feld dedicates a large portion of the composition to the Monday, which is usually considered a phase of stasis between the more spectacular days of Sunday – with the transport and arrival of the trees in the village – and Tuesday – with the raising of the *maggio*. Acoustically, on the other hand, Monday is extremely rich in events, from the religious processions to the preparations of the trees, which are meaningful for their religious significance and for the ways sound interacts with the space of the village, despite not being as visually remarkable as the events of the other days. On this day, privileging listening over observation, one notices the layering in space of various musical sounds – religious and profane – with the sounds of work made by chainsaws and hammers, as well as the politics of space evident for example in the procession of St John and St Paul, representing the participation of the outlying rural communities. We include the final track from Feld's soundscape composition as an opener to the sound-chapters of this book.

The second CD creates a complementary perspective, which concentrates instead on a broader documentation of musical repertoires. Part of it was recorded during the 2005 experience by four researchers with training in ethnomusicology – Fabio Calzia, Cristina Ghirardini, Elisa Piria and Guido Raschieri; part derives from Scaldaferri's 2002–7 corpus of recordings of the festival; and part comes from the archives of Don Giuseppe Filardi, the parish priest of Accettura, recorded since 1983 in the village and among communities of emigrants in the USA. This CD gives a deeper diachronic perspective to the musical repertoire present in Feld's composition, especially through the inclusion of archival recordings, and explores the geographical ramifications of the *Maggio* through the voices of the emigrants from the diaspora. Its twenty-five tracks present a narrative that is analytical and wide-ranging, in contrast to the synthetic and personal approach of the first CD. As is the case with the sonic component of this book, both discs are meant to constitute narratives that take the listener on a coherent path of discovery, and were never meant merely to document or support the texts.

One of the advantages of developing a sonic ethnography in the medium of sound was that we could establish a dialogue over the two CDs, which found attentive listeners able to engage critically. This is evident in the conversations with three protagonists of the *Maggio* festival published in the English translation, where they discuss with Scaldaferri their interpretation and reception of the book and of its audio component (see Scaldaferri 2019a). The community has been involved in the project since the beginning, at first helping with accommodation and access, and later supporting financially the publications, which even now they help us promote at a national level. Thus, even though nobody ever tried to condition our way of working or influence our conclusions, we too became part of processes of heritagisation and touristic promotion, and our work – though in different ways from Bronzini's – is used to validate the *Maggio*'s exceptionality, this time to an international public. We consider these to be legitimate appropriations of scholarly work by the community that made it possible, and we are particularly happy that our sound-oriented perspective seems to resonate with many in Accettura. Its value lies in evidencing the critical role of local ways of listening, meant as phenomenologically and socio-historically emergent, and offering to the researchers the possibility of integrating them in their ethnographies.

Notes

1 http://ilmaggiodiaccettura.it/ (accessed 31 March 2020).
2 www.ritiarboreilucani.it/ (accessed 31 March 2020).

Photographs

Maggio di Accettura, 2005

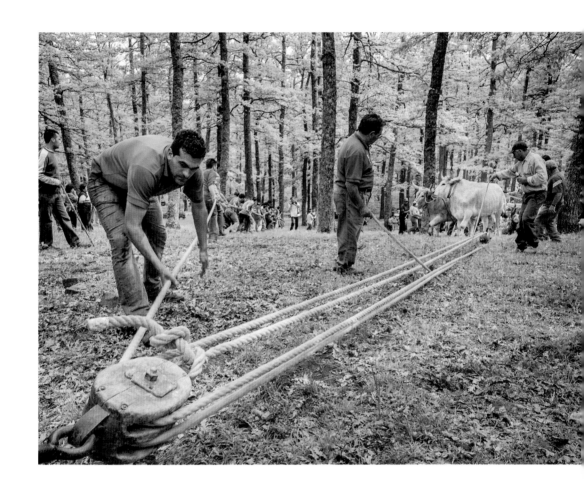

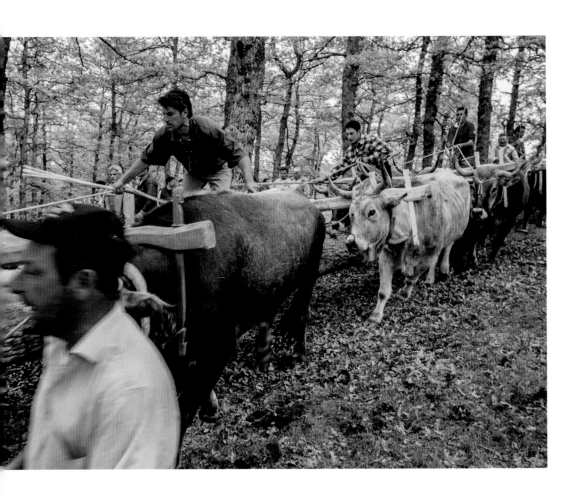

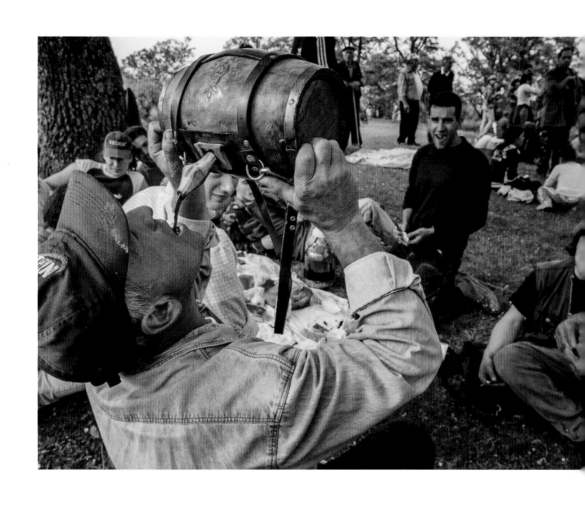

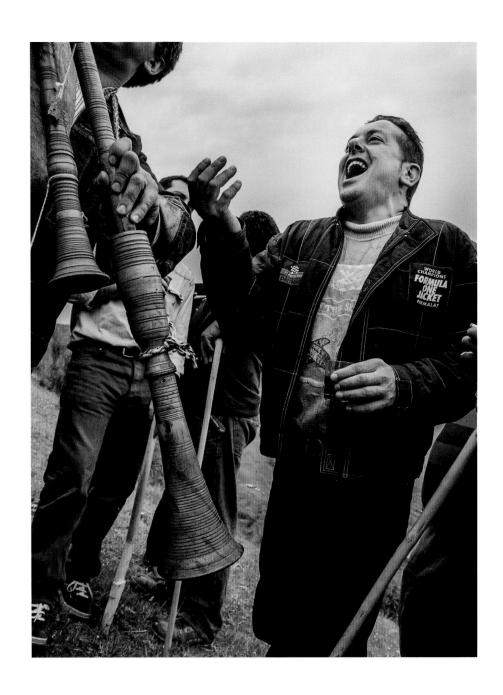

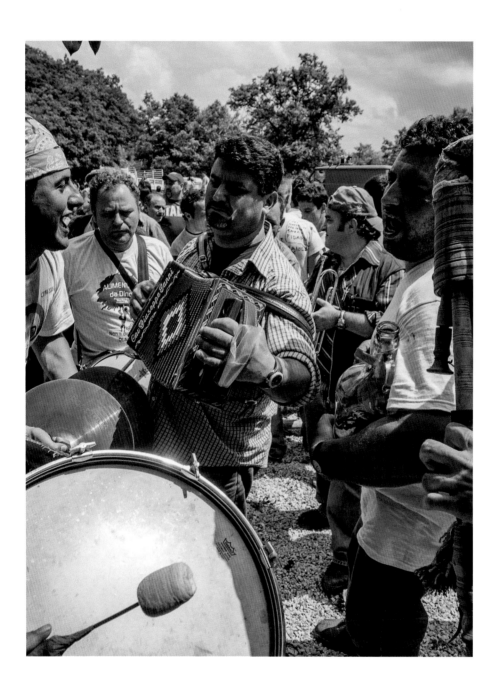

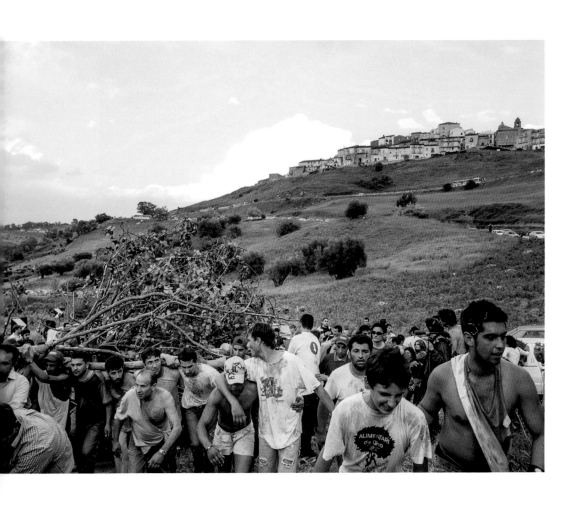

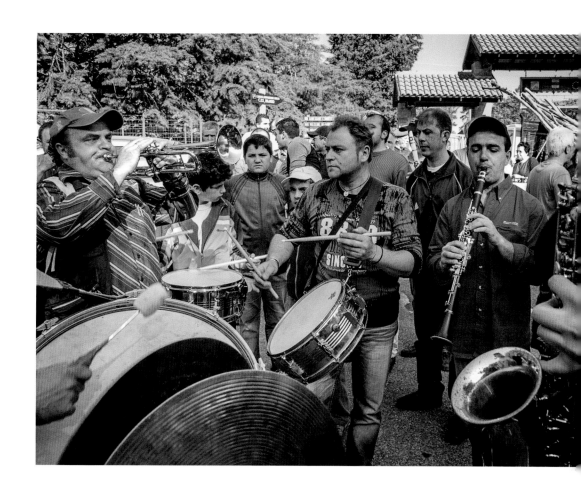

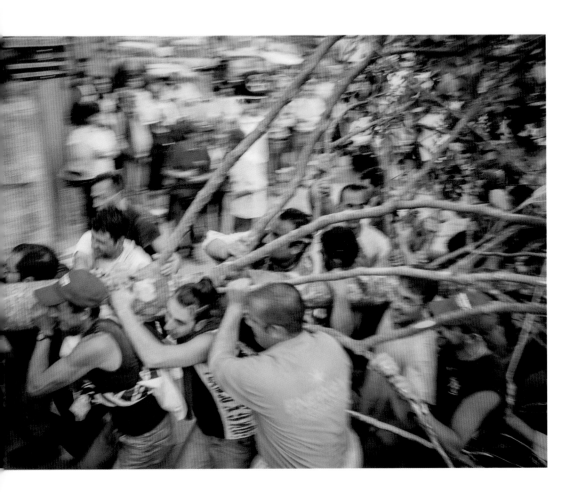

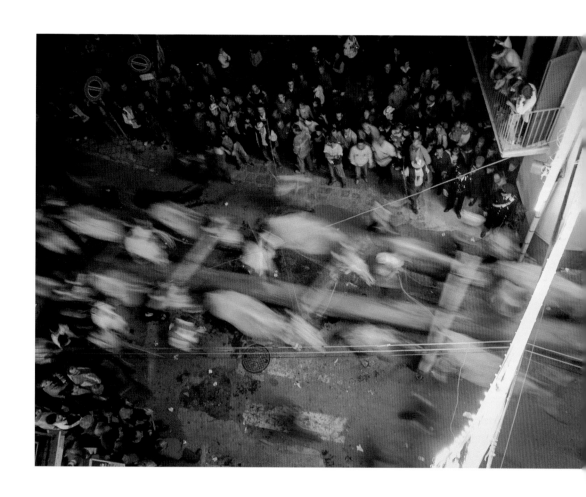

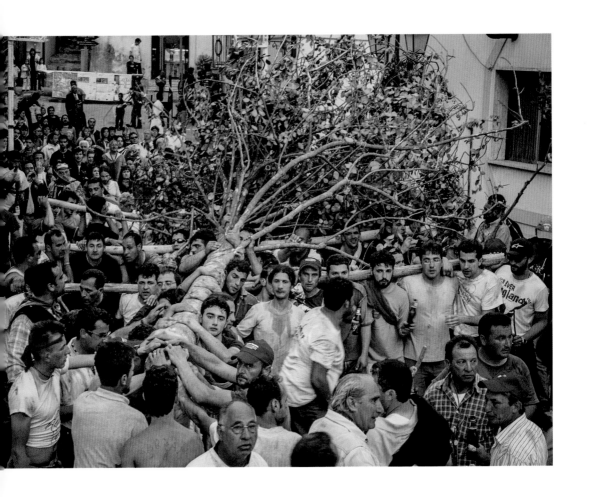

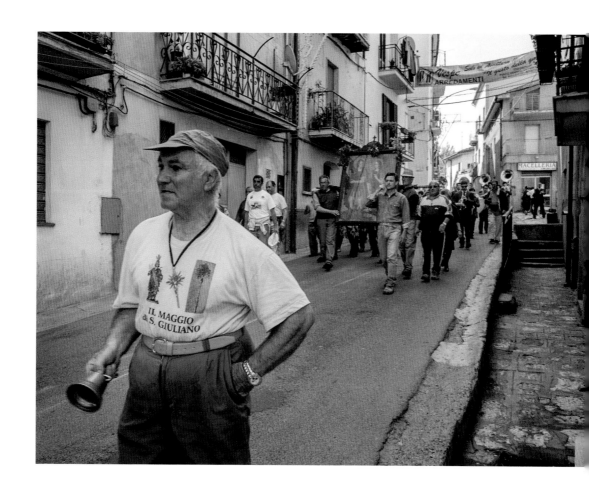

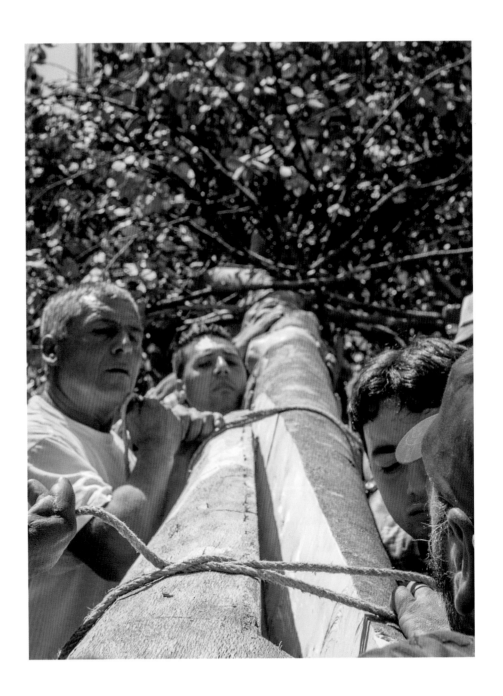

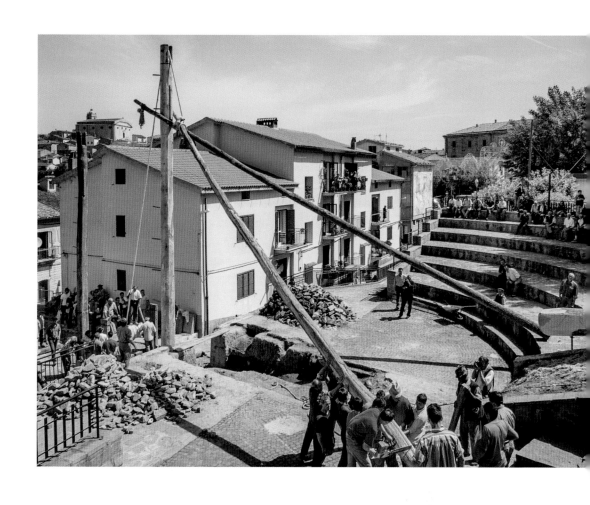

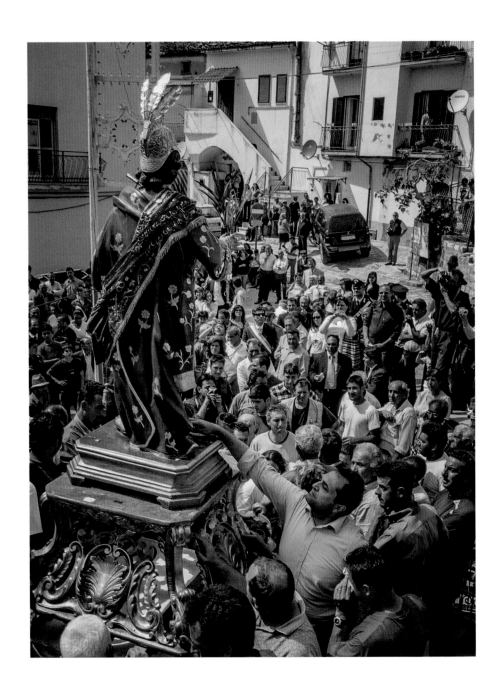

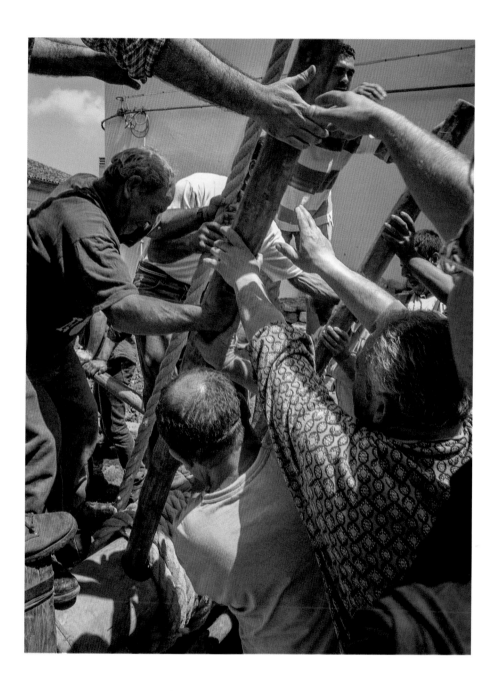

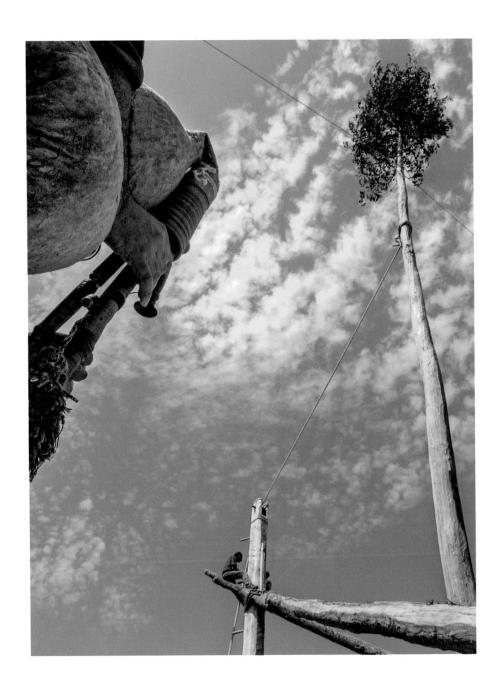

Soundscape composition – Accettura 2005 – Tuesday 17 May

This soundscape composition by Steven Feld is taken from *When the Trees Resound* (Scaldaferri and Feld 2019), where it is the sixth and final track of the first CD. Through intense editing, the composition condenses the main sonic elements of the concluding day of the *Maggio* festival.

Sound-chapter 1 – *The Saint and the tree*

This sound-chapter includes field recordings made during the *Maggio* festival in 2004–5, which focus on musical performances within the soundscape of the event, including *bassa musica*, symphonic walking bands and *a zampogna* singing. It also includes an older recording of a religious song from the archive of the parish priest of Accettura, Giuseppe Filardi, and a recent recording of the procession for St Julian's day, in January. The sound-chapter displays the variety of sound-making practices that revolve around the tree ritual of the *Maggio* and people's devotion to St Julian.

SOUNDMASKS IN RESOUNDING PLACES: LISTENING TO THE *CAMPANACCIO* OF SAN MAURO FORTE

<div align="right">

2

</div>

Nicola Scaldaferri

This chapter concerns the nocturnal parade of carriers of large cow-bells in San Mauro Forte, a village of 1400 inhabitants, at 540m above sea level, within the hilly region west of the town of Matera. This event offers the opportunity to explore some crucial issues discussed in this book, in particular the role of sound in creating a sense of community beyond its symbolic functions, the function of rhythm and bodily involvement in the creation of a group identity, the relationship between sound and the space of the village where the event takes place, and the occurrence over time of processes of heritagisation. In response to the primarily sonorous qualities of this event, listening has been a principal research method.

In contrast to what usually happens in other rituals involving bells around the period of Carnival in Europe, in San Mauro the cowbells are not used to create a clash of chaotic clangs but rather a series of regular rhythmic sequences. The participants wear a costume but do not mask their faces. In existing research on festivals involving humans and animal bells, the role of face masks and of sonic chaos has always been a central focus of discussion. The case of San Mauro, where both these elements are absent, suggests that sound might take up a masking function, both at an individual and collective level. The sound of each cowbell becomes a soundmask for its carrier, who identifies completely with the sound. At the same time, each carrier's presence in space and their relationships with others are manifested in the soundscape. *Soundmask* is understood as the temporary taking up of a sonic identity, a disguise that is perceived aurally, superseding the visual one for both the participants and the visitors. At the gathering of 'anthropological' masks in Tricarico, for example, the members of the team from San Mauro are the only ones not wearing face masks. The concept of soundmask will be our starting point for a discussion of the role of sound and rhythm in redefining people's relationship with village space and animality.

Parades of people playing animal bells in conjunction with ritual actions on important calendar days are found throughout the Mediterranean basin during the winter and spring. These parades mostly take place during Carnival, as is the case in a number of situations in Italy, Greece and Slovenia. While Carnivals have long been the subject of ethnographic inquiry with regard to their performative and symbolic aspects, only recently has the sonic dimension become the subject of scholarly attention. These studies have often revolved around the role of bells (Blau et al. 2010; Corbin 1998; Frank 2008; Harlov 2016; Panopoulos 2003; Price 1983). Particularly important was the publication of Steven Feld's multisited ethnography of bells in the form of a series of CDs (Feld 2002, 2004a, 2004b, 2005, 2006).

In Basilicata there are a number of masked parades that feature animal bells. They happen for the most part on the day dedicated to St Anthony the Abbot, on 17 January, a date that conventionally marks the beginning of Carnival. In addition to being celebrated with masks and sonic rituals, this festivity is marked by nocturnal bonfires. In the rich repertoire of symbols attached to St Anthony the Abbot in folk Christianity, he is the guardian of the fire and protector of domestic animals. He often appears in images with a small bell hanging from his staff and next to a pig, an animal that was traditionally slaughtered in winter.

In Accettura, on the night of 16 January, a massive bonfire is lit where the leftover logs from the *Maggio* festival are burned. A statue of St Anthony is carried in procession, with an escort of children who clang animal bells. In Salandra teenagers and adults, wrapped in black cloaks, flood the village streets with the sound of their animal bells. One of the most famous events happens in Tricarico: on 17 January, at dawn, dozens of people masked as *Tori* (Bulls) – covered in black and red ribbons – or *Vacche* (Cows) – in multi-coloured ribbons – enact the transhumance of a herd on the village streets at the sound of their cowbells.

The event discussed in this chapter, called *Il Campanaccio* (the cowbell), happens in San Mauro Forte the night leading to the day of St Anthony the Abbot. The event is particularly interesting for the large involvement of the local population, and for the relevance of sound in its unfolding. What follows is based on listening and participation from the early 2000s to 2019, and on conversations with some inhabitants who are actively involved in the event: first of all Rocco Giammetta, blacksmith and maker of some of the cowbells used during the event; then Francesco Diluca, for many years mayor of San Mauro; and the members of the *Pro Loco*, in particular the former president Mimì Deufemia and the young and very active president Francesco Laguardia. These protagonists of the event and of its preparation, who

belong to different generations, provided important starting points for the reflection here proposed.

Together with Tricarico, the *Campanaccio* of San Mauro was the subject of team research carried out in 2003 and 2004. In addition to my essay, Steven Feld created a soundscape composition with DSM recordings and Stefano Vaja published a photographic sequence (Scaldaferri 2005). The photographs at the end of this chapter, by Vaja, were made in the context of that research.

In San Mauro Forte, following a trend common to many villages in southern Italy, the population has decreased by half since the 1970s, on account of migratory flows that bring away young people who struggle to find employment in the local economy. The *Campanaccio* has been, starting from the 1990s, the main event of the year in San Mauro. It has a strong identity value and emigrants come back especially to take part. It also attracts scholars and visitors engaging in cultural tourism. Lately, even composers and sound artists have visited to experience the unique acoustic qualities of the festival – for example the artist Yuval Avital, whose work will be discussed in chapter 6. The *Campanaccio* welcomes visitors on the homepage of the city council website, and is in other words the public representative of the village to the wider world.

The event starts at dusk, when the teams of bell carriers, made up of men, women and even small children, start clanking around the streets. Each participant carries a large bell, which is often significantly oversized compared with what would normally hang from a cow's neck. They sling it around the neck with a strap, and hold it with both hands. The players make it clang with a sudden movement of the hands, of the chest or even of the knees – depending on the size of the bell. Each team is made up of a variable number of participants, from a few to several dozens. The event in its totality involves dozens of teams, with overall numbers in the hundreds. The traditional costumes are black cloaks and animal hides; over time, others have been added, such as tunics, military uniforms, colourful wigs, flashy hats with bright decorations, and even costumes inspired by celebrities. Some teams are made up of people of the same gender and age, some are composed of groups of friends or relatives, or just of returning emigrants. Until late at night, the teams roam the streets of the village following paths established by tradition, repeatedly. They visit the two main squares, then a small church dedicated to St Roch and circle around it three times to honour the statue of St Anthony the Abbot that is kept inside, according to a praxis common in religious pilgrimages.

During this time of year the temperatures are usually very low in this part of Basilicata, especially at night, and often snow might be on the ground. The bell carriers drink abundant wine, stopping

periodically in family-owned wine cellars. When the bell-clanking rounds are over they put down the bells and take part in a collective meal that can take them all the way to sunrise.

Humans and animals

During the *Campanaccio* the participants often carry around, as if they were trophies, richly decorated pig heads, sausages, wine demijohns, animal hides, images of St Anthony, horns, baskets, yokes and other items of pastoral and agricultural origin. Sometimes one can see live animals, such as goats or donkeys, part of a mixture of animals and humans that is not just symbolically hinted but explicitly displayed. This mixture is part of the cowbell's own nature, which around the neck of animals has as its primary use that of acoustic branding. It is a mark of the human domestication of the feral. The animal generates sound involuntarily, while walking or grazing. In so doing, it is made by its master a sounding entity. Listening to the sound of animal bells allows the herders to check on individual animals and to govern the herd, helped by specific tunings that allow them to clearly identify the position of each animal. The sonic characteristics of the bells, which vary according to their shape, allow the herders to create soundscapes in which each ringing bell interacts with the others, with the environment and with the calls of the animals. This is a conscious process that is effectively a form of sound design (Maxia 2011; Ricci 2012). At times, and especially in southern Italy, these soundscapes are joined by *zampogna* pieces traditionally played especially for the transhumance (Scaldaferri 2005).

In Italian the word *campanaccio* (cowbell or animal bell in general) is associated with a rustic and humble register, being the pejorative form of *campana* (bell). The latter is the higher register term for the bronze idiophone that is placed on top of bell or clock towers (Corbin 1998; Price 1983). *Campanaccio* and *campana*, therefore, create an oppositional couplet that draws on their materiality, their positioning and their context of use. The bronze cast bell is placed in what was one of the highest spots of a town, and is played in moments of high significance, as already remarked by Schafer, who highlights the role of church bells in defining the listeners' sense of community, as well as sound protection in frightening away evil spirits (1977: 54). The animal bell, on the other hand, is made of bent plated sheet metal and is kept close to the ground, attached to a moving animal. In the vernacular forms of Basilicata this opposition is preserved, while in other contexts there are more neutral expressions – in Sardina, for example, animal bells are called *su ferru* (the iron) (Maxia 2013). In various contexts animal bells are given gendered identities: depending on the shape – rounded

or elongated, with a large or smaller opening – they can be male or female. This distinction of gender often has a role in ritual contexts, as in the case of the masks of Bulls and Cows of Tricarico, where each mask should carry a male or female cowbell consistently with its gender (Spera 1982). In San Mauro, though, all bells can be used freely by the men and women who make up the various teams.

In classic interpretations of Carnival rituals humans who wear animal bells perform a typical inversion of roles, becoming animals in a proximity of human and non-human that is not a rigid opposition (Bakhtin 1968). The *Campanaccio* could seem, at first sight, to fall neatly into this category. However, a closer examination of the modes of performance, and the analysis of the sonic component, reveals a different situation. As we see in the following pages, sound and rhythm, in creating the identity of the group, overcome and incorporate not only the gender difference between the participants, but also that between the human and animal symbolic components.

Darkness and rhythm

The crucial peculiarity of San Mauro Forte's *Campanaccio* is that it happens after sunset. The teams of bell carriers parade in streets lit only by regular street light, and where this is lacking – as in some alleys – they perform in the dark. In this situation, vision is inevitably less pre-eminent than other sensory modalities such as hearing and touch, which come into play thanks to the vibrations of the bells and the resonance of the surrounding spaces.

Furthermore, the participants, even though they wear a variety of costumes and disguises, do not wear masks on their faces. This is a crucial difference with respect to what happens in other similar occasions, for example in Tricarico, or in the better known cases of Skyros in Greece (Blau et al. 2010; Panopoulos 2011) or in Sardinia, where the masks are often visually characterised as animals (Spanu 2014: 88–98). In San Mauro, the darkness keeps the faces of the participants in half-light, so that they are not easily recognisable. On the other hand, each participant's identification with a large bell ensures that the real cover is a sonic one. The whole person becomes a mask as a sounding entity. The participants interpret their role with concentration, walking slowly and rhythmically, their gaze ever facing in front and without display of emotion, immersed in the sounds all around with an estranged stance – the bell becomes their voice. These voices are not distinct from the point of view of gender identities: men, women and children choose their bells simply according to their weight, their decision based on whether they feel they have the endurance required to parade it for the night. Stronger participants will carry larger bells and will be able

to project stronger, deeper sounds. So the force and pitch of the sounds that resonate in the streets are a direct reflection of each participant's strength, which is perceived through listening.

Another characteristic of the *Campanaccio* is the way the components of each team clank their bells in a synchronised manner, playing on the same beat. Each team plays rhythms of 4/4, at speeds around 90–100 bpm. The sounds of the *Campanaccio* are not about producing a random and chaotic cacophony, they are disciplined according to a precise rhythmic pattern thanks to the role of a team leader who dictates the movements of their group, and who therefore has rhythmic control over their sound. The team leader can carry out this role in various ways: with a handful of small bells hanging from a staff, with which they periodically hit the ground in the double function of acoustic and visual signal, or using a whistle, a snare drum or a bass drum. Sometimes they simply place themselves at the head of the group, leading as a herd leader, dictating the pace with their bell.

A good starting point to frame the *Campanaccio* is Blacking's definition of music as 'humanly organized sound' (1973). This reference, as important as it is, is not without its limits. In recent debates within sound studies it has emerged how sometimes the principle of organisation and an explicit social purpose are not enough to consider sounds musical, especially where we face situations without a central organisation, or interactions between humans and non-humans – be they animals or machines (Sakakeeny 2015).

From this perspective, the organised patterns of clangs made by the teams of bell carriers in the streets of San Mauro, with the accompanying whistles and drums, are closer to rhythmic-musical performances than to the chaotic sound of the bells of a moving herd, which is the reference for most Carnival bell festivals. Even though it is still within the frame of a ritual event, in San Mauro the animal bell is transformed from its original role of sonic object from a pastoral context, which produces sound as a by-product of movement, into a musical instrument, thanks to a domestication of the movements in order to obtain rhythmic sequences. This specificity has fascinated musicians, producers and sound artists who have used the isochrone sequences of the *Campanaccio* as rhythm tracks in a number of music pieces. One example is Canio Loguercio's composition *Miserere*, which uses a series of beats from a recorded track as a loop that provides a percussive accompaniment for the whole song (2006: tracks 9 and 13). However, other elements differentiate the *Campanaccio* from performances with a clear musical character: among them, the absence of a defined target audience, the automatic repetition of gestures bordering reflex action and a mode of experience that involves the immersion of the whole body in the soundwaves.

Listening to what happens during the *Campanaccio*, more than observation or other forms of investigation, allows understanding of the dynamics of the ritual. Participants organise their actions and negotiate their identity mainly within the acoustic dimension. This can be grasped in particular in the function performed by the rhythm during the parade. A team's synchrony gives each group a sonic identity made of rhythmic cohesion, one that is stronger than the effect of wearing similar costumes. In part this is favoured by the scarcity of light, which brings sound in the foreground, but also because of the body's role in generating rhythmic action in a constant process of listening and feedback. The group's rhythmic sound is the outcome of a listening process that controls the unanimous movement of the team members, and its importance lies more in its role for the group's identity than in its musical significance. This is especially evident when two teams of bell carriers meet in the streets, creating a clash of rhythms. Instead of trying to synchronise the beats, each team stubbornly keeps playing its own tempo and increases the volume of its clanking. The danger is not so much one of losing a loudness duel, but of getting lost in the other team's beat, risking sonically disintegrating as a group or, even worse, of shifting the tempo to correspond with that of the opposing team – and therefore being assimilated.

However, the world turned upside-down of these humans who are sonically transformed into animals is never upside-down enough to degenerate into excess. At the *Campanaccio* one is unlikely to witness behaviour that is common in Carnival rituals, such as lascivious actions, sexual references or forms of aggressivity more or less ritually codified. The *Campanaccio*'s rhythmic discipline governs the proximity between the roles of humans and animals, limiting excesses and crossovers, and giving to the participants a ceremonial posture, hieratical and solemn. Even though its sounds are produced through actions that are mechanical in their repetition, the participants keep themselves focussed on controlling the tempo, which is sometimes no easy task because of the size of the cowbell.

Sounding masks in resounding places

As a whole, the teams of bell carriers create a densely sonorous atmosphere that takes control of the streets until late at night and can be heard across the areas surrounding the village. This sonorous atmosphere is also achieved thanks to the places, especially the streets and the buildings, which reverberate this river of sounds. Place, understood in the sense of 'presence permeated with culturally constituted institutions and practices' (Casey 1996: 46), fulfils an important role in any performance it hosts. During the *Campanaccio* streets, alleys and

buildings resonate under the powerful soundwaves of the bells and reflect the vibrations onto the participants. The teams are immersed in sound, whose materiality is perceived by the whole body as physical resonance and vibration. The soundwaves produced by the bells, as a whole, make up the flow inside which the performance takes place, as a sort of *performing in sound* inside the environment made of vibrations and reflections of the buildings, in the chilly January air. The parade can last for hours, and the effort, the repetition of the movements, the inescapable and enveloping presence of deafening sounds, combined with flowing alcohol, all contribute to the participants' experience of the *Campanaccio* as intense sensory and emotional involvement. Visitors too, who come to San Mauro every year to 'see' the *Campanaccio*, often with cameras and smartphones, are enveloped in this sonorous atmosphere. Rouget's terminology, which inside musical rituals distinguishes 'musicants' and 'musicated' ([1980] 1985: 132), can be usefully applied to the case of San Mauro. Here the visitors are musicated, being incidental elements that remain on the periphery and are hit by the sonic deluge; the soundmasks of the performers, on the other hand, are at the same time musicants and musicated.

The participants in the *Campanaccio* thus become strongly identified in their role of soundmasks, which gives them a new individual and collective identity, especially as a team thanks to the cohesion provided by the shared rhythm. They are liminal entities, projected towards other domains such as non-humanity, especially that of animals, with which the bell itself, as an object and for the sound it produces, creates a point of contact. This proximity is continuously reinforced by the presence of gestures and objects, such as ox yokes and dead animals. At the same time, the participants' immersive listening, their sensory overload and physical effort, foreshadow a state of 'trancing' (Becker 2004). The participants are aware of this, as emerges especially from conversations with the young people of the village. During the January 2020 event, a local cultural association introduced an initiative that allowed visitors to participate in the event, immersing themselves in the rhythmic and sound flow, instead of just attending from the sidelines. Significantly, the programme on the city council's Facebook page describes the initiative in these words: 'The Experiential Campanaccio: get to the heart of the event and take part first hand in the rhythm that will charm you.'

Washing through sound

The *Campanaccio* also fulfils a magic and protective function, which the participants ascribe to their performance not so much as a consequence of the symbolic qualities of sound, but of its materiality and resonance.

People from San Mauro Forte often mention the protective value they attribute to the waves of sound that the animal bells wash onto the streets. They consider them a sort of sonic membrane that spreads over the whole village. Such an idea is probably influenced by Spera's work in the 1980s, which the younger generations of San Mauro took up and integrated in the accepted wisdom of the village, similarly to what happened in Accettura with Bronzini's work, as seen in chapter 1. In an article, Spera linked the deepest meaning of the *Campanaccio* with the massive number of pigs killed at that time of winter:

> a cathartic practice (without discounting the physical sense of an actual acoustic shielding) aimed at dispersing the adverse forces that fill the air … Only those who witnessed the excruciating death of a pig by throat-cutting and exsanguination, in a house or backyard, can better grasp the sense of this proposed interpretation. (Spera 1982: 327)

Pigs, in a rural context, were the mainstay of home food and were traditionally kept at home, often in close cohabitation in the spaces of humans. They were then killed in the coldest months of winter to create a reserve of cured meat for the rest of the year. It was very common, in the past, to witness the open-air slaughtering of pigs during winter. The 'ritual' of the slaughter and the ensuing celebration were inserted in practices of exchange that had great impact on the structuring of family relationships (Marano 1999). The killing procedure was quite gory, especially because the blood had to be gathered in order to make the main ingredient for *sanguinaccio* (a pudding also including chocolate, nuts and raisins). It was an intense emotional experience for those who were present, a sensory overload made of agonising screams, rivulets of blood and water, and the pungent smell of entrails that lingered over the village for days.

The *Campanaccio* as a ritual could then be understood as a collective and purifying washing: the push from the deafening sounds of the bells, endowed with an almost abrasive power, would be meant to wash away the cries of the slaughtered animals that had bounced off those same streets and walls. But the sounds would also take away from the participants, through immersion in a thunderous wave of sounds, the sensations associated with the experience of butchering, whose memory is particularly vivid among the older generations.

Pigs have all but disappeared from the streets of San Mauro and other Lucanian villages. They have been moved to breeding farms and the screams of their killing are relegated to slaughterhouses, which use perhaps less grisly methods. In local narrative, though, the protective and cathartic function of the sound of the animal bells has not disappeared. On the contrary, once separated from its direct origin it has

assumed an even broader shielding function: the bells, projecting a steady rhythmic cadence down towards the ground, almost seem to be affecting the whole village, protecting it from any harmful influx. The teams of bell carriers become then a sort of disinfestation units, in their almost military uniforms and measured steps.

As much as it is meant to be connected to old rural ways of life, the core of this interpretation has reached the digital domain, and is repeated on the city council's own website next to a photograph of some cowbells and a pig head. In this version, pigs are given evil connotations, so that their slaughter is under the auspices of two saints. In particular, the protective function of sound is extended to any possible form of calamity:

> Animal bells have an apotropaic and propitiatory function: they are given the decisive task of averting any sort of mishap, such as hailstorms, and favour the fertility and yield of the fields ... Another fundamental component of the festival is the pig, and it is not by chance if the 15th of January, the festival of the patron St Maurus the Abbot, marks the beginning of the traditional rite of slaughtering pigs, which ends exactly on the evening of the 17th. In folk religion the pig is a symbol for evil and in St Anthony's iconography it embodies the devil's many temptations.[1]

Making sound into heritage

According to Spera, the *Campanaccio* was also closely related to the festival of the patron saint St Maurus, which used to be celebrated on 15 January but has now been abandoned. For local historians, a procession of oxen for St Maurus with the function of 'marking' the village would be the foundation of today's *Campanaccio* festival (Mirizzi 2005; Spera 1982). However, despite its continued apotropaic symbolism and its clear origins in the pastoral lifeworld, today the *Campanaccio* reveals clear traces of processes of invention of tradition. Practices that some local narratives describe as ancestral often reveal themselves to be the result of recent decisions, made for practical reasons. The *Campanaccio* in its current format derives from a campaign of heritagisation started in the 1980s by the council administration, which turned it into the village's public face and inserted it in the regional administration's programmes in support of Basilicata's intangible heritage.

The council's intervention came during a period of decline of the festival. The participation of the local population had been dwindling during the 1970s and 1980s, when only a few inhabitants would parade with their bells, becoming sometimes the target of mockery

and being associated with a backward and superstitious past. Starting in 1987 there was a change of direction, when the council started to sponsor the festival, giving it a visual identity through designing posters and other publicity, or offering refreshments to the bell carriers and to visitors. As a way to encourage participation, the council started sponsoring an award ceremony that hands each team a certificate and a trophy. In the days surrounding the 'parade of free bell ringers' – as the event is described in the official posters – there are conferences about the role of bells in folklore, in addition to concerts and theatre plays, and even a food festival, based around wine and sausages, which attracts numerous tourists. Over the years, San Mauro has created a network of twinned towns that share traditions revolving around bells, for example in Sardinia and Sicily, but has also invited visiting teams of flag throwers of medieval inspiration, as long as they are accompanied by drums that relate well to the rhythmic component of the *Campanaccio* (Scaldaferri 2009).

The *Campanaccio* is also part of a 'network of Lucanian Carnivals' started in 2014 with the aim of gathering 'Carnivals with a recognised anthropological and cultural value'.[2] The term 'anthropological' in this use evokes an ancestral aura, capable of attracting the interest of cultural tourists. These processes, in addition to attracting more tourists, have had the effect of bringing the inhabitants of San Mauro face to face with the specificity of their festival, mainly thanks to the comparison with other events and to the contribution of experts and scholars, which all resulted in an increasingly active contribution of the local residents. During the 2000s the council also tried to move the *Campanaccio* to the Saturday closest to the eve of St Anthony's day, though still providing the possibility of having a parade on the 16th, as happens traditionally. The move was initially received with hostility by the most conservative inhabitants, to the point that in 2004 there were two parades – called 'St Anthony's' and 'the mayor's', which took place on the following Saturday. As the years have passed, though, thanks to the convenience of having the festival on the night before a Sunday, many have settled on the new date. In 2019, the *Campanaccio* was even moved to the 12th, to avoid coinciding with events connected to the opening of Matera European Capital of Culture.

Frictions and models of heritagisation

Between this apparatus of collateral events set up by the council administration and the parade of bell carriers there are inevitable conflicts. The offering of free food and drinks along the path of the parade has reduced the role of stops in the participants' wine cellars. These occasions were opportunities to offer hospitality to friends and visitors,

who would be invited to the meals taking place after the parade. But the number of tourists has made these forms of spontaneous hospitality impossible. While at the beginning of the 2000s the visitors reaching San Mauro for the *Campanaccio* were limited and were regularly invited to the wine cellars, fifteen years later these invitations are a rarity, or are limited to close friends.

Listening to what happens during the ritual allows the changes introduced as a consequence of processes of heritagisation to be grasped. In fact, the main point of friction between the council and the bell carriers concerns the soundscape of the festival. In later years the council has set up forms of musical entertainment, with bands playing on stage the night of the *Campanaccio*. The sound systems of the music bands come into conflict with the teams of bells, limiting their movements. This is a typical scenario in Monastero square, where the evening concerts often take place but also a traditional meeting point for the teams. While usually the bell carriers would dominate the acoustic space of the area with no competition, in 2004 the soundcheck of the band *I Tarantolati di Tricarico* interfered with the groups of bell carriers, forcing them to alternative routes, as is clear in the soundscape composition that Feld recorded that year (track 10 in Scaldaferri 2005). In fact, these folk revival music groups are in themselves excellent demonstrations of the link between commodification of traditional music and ethnographic research, since they make explicit reference to the phenomenon of Tarantism made famous by De Martino's research ([1961] 2005). The music festival *La Notte della Taranta* (The Night of the Taranta), based in Apulia, is the centre of an international circuit that makes it an important economic factor for the region (Pizza 2004). It is understandable that San Mauro might be drawing inspiration from this model, although on a smaller scale.

In San Mauro Forte the 'archaic' and 'ancestral' value attributed to the sound of the bells plays an important promotional role. Thanks to sound recording it can be integrated in World Music circuits, where it can reach new audiences and help promote the festival. During the Matera 2019 Open Sound Festival, for example, recordings of bells from San Mauro were sampled as part of a live set of electronic dance music while the promotion of the event made large use of images of St Anthony the Abbot.

Conclusion

Despite the transformations of the event across time, the frictions arising from the expansion of the festival and its presence in the digital domain thanks to the internet, the *Campanaccio* seems to have retained its deepest core meaning as a sonic self-referential ritual with a strong

identity value for the community of San Mauro Forte. People take part for themselves, for the community and for the village, and masks, groups and places end up resonating in synchrony. The animality that the sonic mask brings to the carrier of the bell is domesticated by the rhythmic discipline imposed by each team. This rhythmic element, which continuously reaffirms humans' control of the soundmask, defies simplistic interpretations centred on the ritual exchange of roles between animals and humans. It also defies any simple oppositions between music and sound since in this case the boundaries between them are blurred.

The investigation undertaken on the *Campanaccio* has revolved around careful participatory listening. It has demonstrated how a close examination of the sonic component can generate an original contribution to our understanding of the functions and the transformations of this ritual. Given how much it lends itself to symbolic interpretations, the event has been the object of scholarly attention centred on its meanings. However, its performative characteristics, particularly its immersive soundscape, require supplementing previous approaches by putting sound in the foreground through listening.

Notes

1 www.comune.sanmauroforte.mt.it/csanmaurof/detail.
 jsp?otype=100101&id=101653 (accessed 31 March 2020).
2 www.prolocotricarico.it/lemaschere/la-rete-dei-carnevali-lucani/ (accessed 31
 March 2020).

Photographs

Stefano Vaja, 2003–7

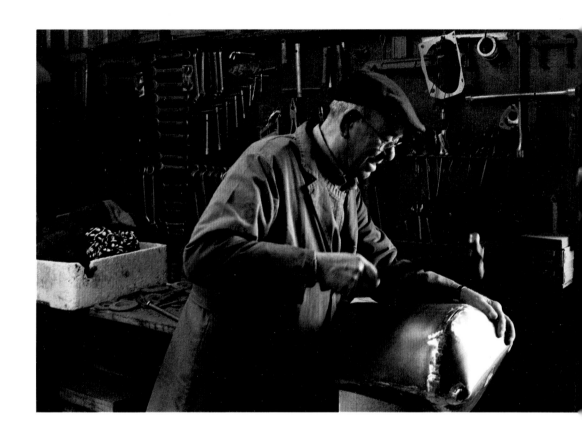

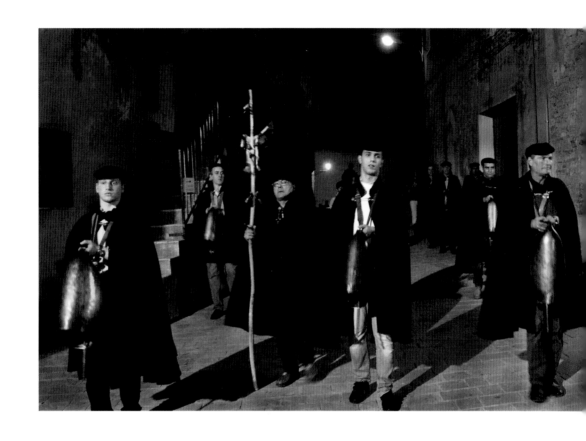

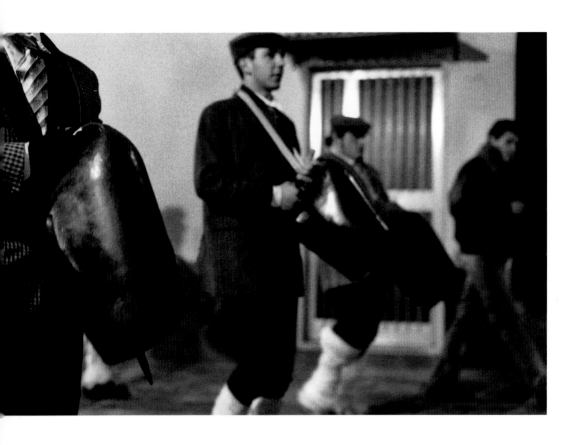

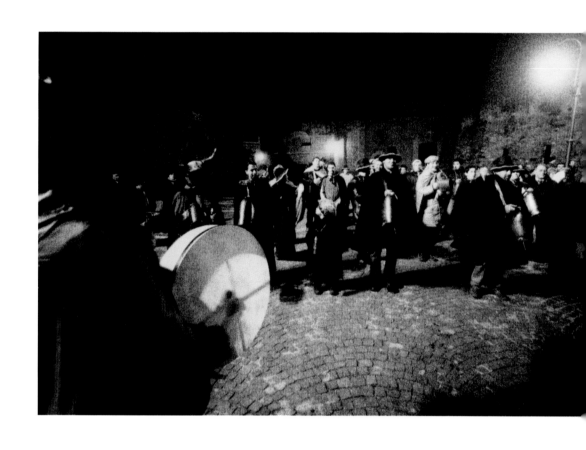

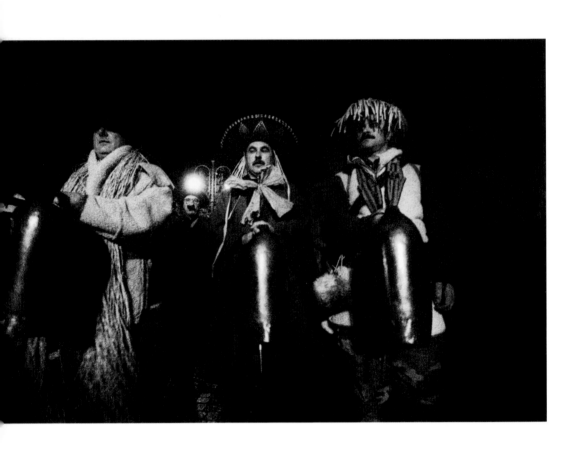

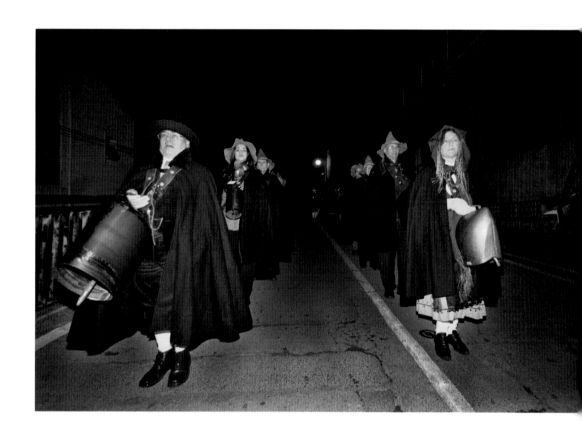

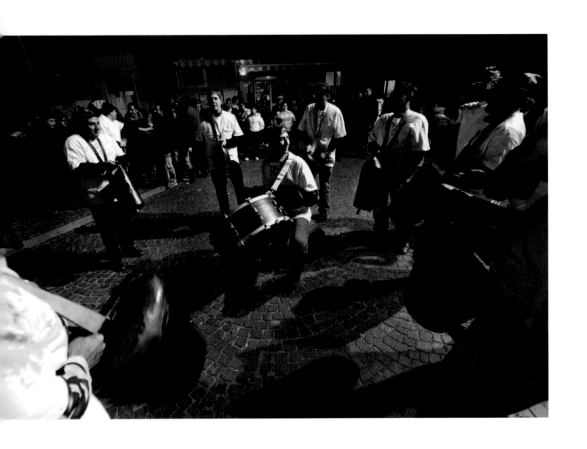

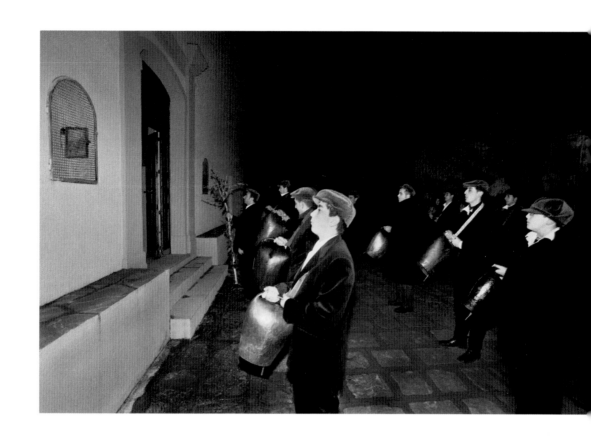

Sound-chapter 2 – *Rhythms in the dark*

This sound-chapter is a composition of field recordings made during the night of the 2002 *Campanaccio* in San Mauro. It builds a sonic narrative which highlights the obsessive rhythmic component of the *Campanaccio*, the clash between the different teams of participants and their sonic identities. This event is contrasted with the sound of cowbells in a pastoral context, recorded as they ring from around the neck of cows during transhumance.

SONIC DEVOTION AND SONIC CONTROL: STRUGGLES FOR POWER OVER A FESTIVAL SOUNDSCAPE

3

Lorenzo Ferrarini

July 2014, inside the mountain sanctuary dedicated to a statue of the Virgin Mary called Madonna del Pollino. The evening mass has just finished, as part of the annual celebrations for the Madonna, and the priest has left. A small group of musicians slowly comes in from the main door, playing and singing. There are two *zampogna* players, two play *organetto*, one *tamburello* and one alternates singing with blowing into a *ciaramella*. They sing the Song of the Madonna del Pollino, slow and solemn:

> We came a long way / to visit Mary
> and Mary we found / all beautiful and crowned …

They arrive at the statue, which is inside a glass and wood display case to the right of the altar. Around them some people take photographs and film with their phones, while some of the more elderly join in the singing. The musicians arrive directly underneath the statue, they are singing to it emphatically. Occasionally they raise their instruments against the glass, or touch the case and kiss their hands, doing the sign of the Cross. The statue holds the baby Jesus in one arm and a rose in the other hand. The song continues, repeating the same melody, verse after verse. Some more musicians join in, others drop out.

> … crowned with lilies and roses / in this chapel Mary rests
> crowned by the heart of Jesus / Madonna di Pollino help me …

One after another the musicians touch the case and, while it seems that the piece is approaching its conclusion, the *zampogna* has never stopped its droning. Suddenly the drums change pace and the music becomes a *tarantella*. Two men briefly start dancing, then one of the *organetto* players dances a few steps in front of the statue, imitated by the *zam-pogna*. Abruptly a man and a woman, volunteers with the parish of San Severino Lucano who help with the organisation of the celebrations, leave the door of the sacristy, from which they had been watching the

scene, and ask the musicians to leave. For a moment it seems as if the musicians – who never stopped playing – are heading towards the door. But then the *organetto* player, with voice loud and clear, takes the melody of the *tarantella* and starts singing a devotional song over it. The musicians turn back towards the statue; the music finds new vigour:

> Beautiful Virgin lend us your hand,
> we are strangers who come from far away.
> We came with sweet harmonies,
> Madonna del Pollino pray to God for me …

Less than three minutes later, no more music. Two *carabinieri* have intervened, and are asking the musicians to get out of the church. The moment is tense; people shout. 'This is a prayer!' shouts one of the *zampogna* players. 'There's nothing I can do about it!' retorts the *carabiniere*. His voice is drowned by shouts of '*Viva la Madonna! Viva Maria!*' and claps. The *zampogna* resumes the Song of the Madonna del Pollino. The two *carabinieri* try to discuss the matter further but without too much conviction, and slowly they leave, as if chased by the sounds. The song continues:

> … look how beautiful she is / the queen of this chapel
> she's beautiful and she's gracious / she is everyone's mother
> she's beautiful and she's divine / long live the Virgin of Pollino!

Some old ladies join in, singing with one hand open by the side of their face. The musicians finish the song on their knees, in front of the statue, eyes on her. They leave the church slowly, and re-gather on the steps in front, where the music continues with fast *tarantella* dances that involve both men and women.

This episode, as Scaldaferri and I witnessed it during the festival of the Madonna del Pollino, was a particularly conflictual expression of tensions that can be identified in a number of religious situations with a mass participation, in Basilicata and beyond. The tensions are in large part over the legitimacy of certain forms of devotion, and specifically those that are expressed as sound. These are what we call *sonic devotion*: the production and listening experience of sounds dedicated to a sacred figure, which are most of the time music – playing an instrument, singing, but also by extension dancing (Scaldaferri 2006: 16). Sonic devotion has a markedly embodied character and it is performed in ways that can sometimes be quite extreme, as was the case for the cult of the Madonna del Pollino. But it is also made up of the mundane soundscape created around pilgrimage campsites, with their cooking, singing, eating and drinking. As we will see, sonic devotion is also relational, or in other words it is part of very personal forms of establishing a direct rapport with the divinity. In some cases it becomes

a token of exchange as part of a vow, so that the faithful give their continued sounding presence at the festival in exchange for a *grazia* (divine favour) – often healing from serious illness or sometimes safe return from a migration experience.

3.1 Madonna del Pollino Sanctuary, June 2014. Devotional music in front of the statue.

Some forms of sonic devotion are controversial practices for certain representatives of the Catholic Church, who see them as backward forms of folk religiosity that need to be eradicated from rituals such as the festival of the Madonna del Pollino. The latter is a particularly relevant case not just because of the important dynamics of sonic devotion, but also because of the role that some figures of the Demartinian school of anthropology, with its Marxist approach and marked anti-clericalism, played in separating folk religiosity from official Catholicism. Since the 1990s the festival has been the centre of attempts by the clergy to 'purify' it, removing devotional practices that they consider inappropriate, and some of these attempts are directly aimed at the acoustic domain.

This chapter starts from the conflict over practices of sonic devotion to examine how the Church is able to exert control over the way people enact their devotion by restricting and disciplining the production and circulation of sounds. It asks, what is at stake in the struggle for the control of the soundscape of a festival? I start from the assumption that this

87

struggle, even though it might not always be as visible as in the episode I narrate above, has important consequences for people's experience of religiosity, identity and social hierarchy. In other words, it is not just a theological debate on the proper modalities of relating to the sacred, but touches on larger questions of the relationship between sound and social control by considering the acoustic as a primary domain in which power struggles are played out, instead of being simply echoed.

Sonic devotion at the Madonna del Pollino pilgrimage

The July festival is the middle section of a three-part pilgrimage cycle. The statue of the Madonna del Pollino remains, for most of the year, in a church in the village of San Severino Lucano (877m in elevation). On the first Sunday of June, at sunrise, it leaves the village and is brought, on shoulders, in a procession up the mountain, to the sanctuary at 1537m above sea level. Along the way the procession stops in various hamlets and farmhouses, where the residents offer food and drink. A confraternity, called Fraternita Madonna di Pollino and based in San Severino, is charged with the organisational aspects of the transport of the statue, including its safety in case of extreme weather. Its membership is only open to men. In association with the

3.2 In front of the Madonna del Pollino sanctuary, June 2014. Procession with votive offerings.

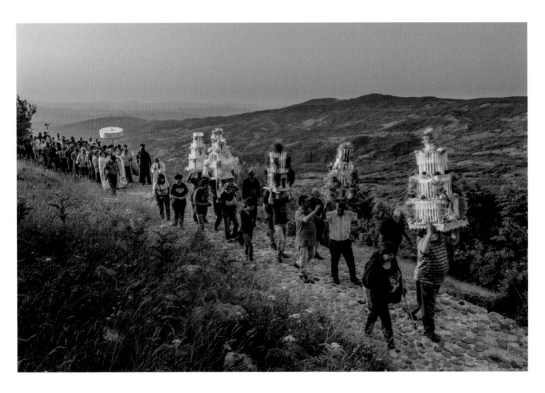

parish priest, they make sure that there are no deviations from the plans and that everyone has a chance of joining in. The procession lasts for the whole day, and is constantly accompanied by songs, the music of *zampogna* and *organetto*, and dancing. The statue arrives at the sanctuary in the evening. The second phase of the pilgrimage sees devotees camp around the sanctuary for days leading to the Friday and Saturday before the first Sunday in July. Friday night, especially, is spent in a wake during which people play and dance, and until the early 2000s they would even play music, dance and sleep inside the church, in front of the statue. During the festival days there is a lot of eating and drinking, and the music practically never stops. There are market stalls near the sanctuary, selling images and souvenirs with the statue of the Madonna del Pollino or with the lyrics of the song dedicated to her. The official religious ceremonial includes several masses and processions around the mountain, plus recitations of the rosary, in church. The statue remains in the mountain sanctuary until the second weekend of September, when on Saturday evening there is mass and again music in church. At sunrise on Sunday a procession starts the descent towards San Severino with the statue, following the same modalities of the ascent, including the musical component.

The three phases of the pilgrimage cycle assume different significance in relationship to the surrounding territory. During its ascent and descent the statue visits the dispersed rural communities on the territory of San Severino, contributing to the creation of a sense of unity and common identity. The procession, which does not simply carry around the statue but also the sounds of the faithful, creates a connection with the area, which echoes the sonic devotion of its participants. The passage of the statue is an important ritual in itself, and brings blessings and protection wherever it passes. It is the role of the faithful also to visit the Madonna during the July festival. Hundreds of pilgrims come from the southern part of Basilicata and from the northern portion of the neighbouring region of Calabria to camp at the sanctuary. The role of San Severino and of the confraternity is much reduced in this phase. In July everything revolves around the sanctuary and a nearby cave. In this area, according to oral tradition, between 1725 and 1730 the Virgin appeared to a shepherd. Shortly following this apparition two women from San Severino, who had come to ask for recovery for a seriously ill relative, found an old and seemingly abandoned wooden statue inside the cave. The chapel that became the sanctuary was built by the relative, who was miraculously cured. During the July festival the sanctuary and the cave become the centre of ritual activity, often in the form of repeated circular processions. But for many pilgrims it is their simple presence that becomes a form of ritual participation, especially if we consider that many devotees

promise to keep coming to the pilgrimage year after year for as long as they live in exchange for divine favour. During the times when the sanctuary could only be reached on foot or muleback, before the road and other infrastructure were built, climbing and camping on the mountain was no easy stroll. For some elders it was a real physical test and at the same time a proof that they were still in good health, thanks to the Virgin's intercession. Before the year 2000 it was still possible to see spectacular forms of penitence, such as ascending up the mountain barefoot or crawling to the sanctuary on hands and knees. Pilgrims would offer a variety of ex voto objects when asking for divine favour, including live animals, bridal gowns and long offcuts of women's hair. These practices would take place especially at night, after the official phases of the ceremonial were finished and the clergy had retired.

Some of the main forms of pilgrim participation are sonorous – especially dancing or at least singing in front of the statue. During the July festival there is a large presence of musicians, who create informal, temporary aggregations of people coming from distant communities. These episodes are distinct from the official, prescribed sounds of the festival, which include the liturgy and the music of a walking wind band. Though some know each other from frequenting a circuit of festivals, some of which are religious and others connected to the folk music scene, most musicians come together in a temporary community centred around musical practice, which also contributes to the circulation of skills, repertoires and styles (Scaldaferri 2006: 21–24). These are jam sessions where people join in with the instrument they can play or by singing and improvising sonic objects out of bottles, keys or cowbells. Already in 1915 Norman Douglas, a British writer who travelled through southern Italy between 1907 and 1911, noticed the rich soundscape of the festival: 'Two thousand persons are encamped about the chapel, amid a formidable army of donkeys and mules whose braying mingles with the pastoral music of reeds and bagpipes' ([1915] 1993: 149). Music in fact goes on day and night under the tents where people set up camp, right behind the sanctuary. The sense of community is enhanced by the sharing of food and wine with strangers.

Despite the formation of these temporary communities there is also a strong sense of individual relationship with the object of devotion. Most of the time this is evident in the lyrics of the songs addressed to the Virgin, which insistently request divine favour, or in people's moments of quiet conversation with the statue. But it also leads to cases of individual exposure that border on showing off, and can sometimes even result in rivalries between devotees. Though they are officially acts of devotion to the Madonna, carrying the statue for long stretches, singing, playing and dancing for hours, or eating and drinking in large quantities are also opportunities to become the centre of attention.

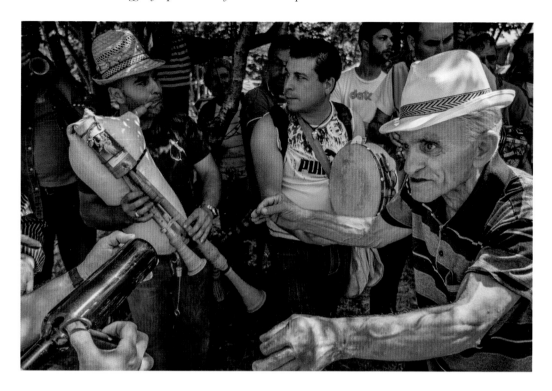

Scaldaferri observed a variety of modes of devotion during several years of attendance, starting in 1989. One in particular played out as a particularly telling form of rivalry between two *zampogna* players. Emilio, from Rotondella, is playing his *zampogna* – measuring 4.5 palms, large and loud – on the doorstep of the sanctuary. It is a strategic position, because he can be heard by the many pilgrims who pass in and out of the church. Carmine, another *zampogna* player from San Severino, stands nearby listening and waiting for a moment that allows him to play, since his smaller 3.5 palm instrument is tuned differently from Emilio's. As soon as Emilio takes a break, Carmine addresses him: 'I wish you a thousand years, mate. Stop for a little while, please!' He then starts playing his own slow piece. After a few moments Emilio gets back to his louder *zampogna*, creating a jarring dissonance effect that forces Carmine further away, looking to create his own sonic space. Not satisfied with the temporary departure of his rival, Emilio goes after him and chases him further with the sound of his instrument. But this offers Carmine the chance to outflank Emilio and go through the church door. He stops near the statue of the Virgin, another strategic point where he can be heard by all the pilgrims who go to touch and kiss the Madonna. Emilio stands at the opposite side of the sanctuary, near the door and, thanks to the acoustics of the

3.3 At the campsite behind the Madonna del Pollino sanctuary, June 2014. Extemporaneous jam session with bottle, *ciaramella, zampogna, tamburello* and *organetto*.

building and to his louder instrument, almost entirely drowns Carmine's playing. In desperation, Carmine climbs on the altar steps and plays in a visually central spot, trying to compensate for Emilio's sonic advantage. It is only when the latter musician finally gives up and leaves, after about two hours, that Carmine can dominate his favourite spot in front of the church. The entire duel took the form of a test of endurance over slow *zampogna* pieces, with no words exchanged except for Carmine's initial address.

Situations such as this are very representative of the way personal rivalries can use the channels of devotional practice and speak strongly of the role that sound plays in them. More commonly, one can observe displays of stamina in dancing, playing or carrying the statue, which in addition to being acts of personal devotion have consequences for one's social prestige within the confraternity, or within the temporary community of the pilgrimage. Some people's campsite can become a point of reference for its uninterrupted musical performances that attract the best players of the region. Others simply create a name for themselves by dancing for hours, as if in a trance, on the steep ascent to the sanctuary. While these public displays of individual devotion are almost exclusively performed by men, in the past women would use the protected space of the church to enact dramatic forms of devotion,

3.4 Festival of the Madonna di Conserva, San Costantino Albanese, August 2016. Serving the *pastorale*, a meat and vegetable stew cooked at the camp.

92

such as crawling, beating their chest and even licking the floor from the door to the statue.

These practices are visible in Luigi Di Gianni's documentary *La Madonna del Pollino* (1971), which had a role in their restriction in subsequent years. The short film, shot early in 1971 and with a voice-over by anthropologist Annabella Rossi, generated a polemic with the local clergy for its reading of the pilgrimage. Talking over the images and the post-synced music, Rossi's text describes the practices of the pilgrims as an effect of the misery of their living conditions. They are described as marginals cut off from modernity, with its circulation of knowledge, goods and services, excluded by logics of class exploitation. The voiceover builds up a sense of distance, explicitly opposing 'us', bourgeoise representatives of a hegemonic culture, and 'them', members of a subaltern class we cannot comprehend. By the same token, 'they' ask the Virgin for miracles because they don't know the real – social, economic – causes of their misery. The expository commentary prevents any alternative reading of the images and concludes by stating the necessity of denouncing the conditions of peasants who live 'as if 100–200 years ago'. The feeling of estrangement and exoticism is enhanced by the electronic soundtrack by Egisto Macchi. The film is the last Di Gianni made in collaboration with anthropologists influenced by Ernesto De Martino, which brought him to be classified as the main exponent of the Demartinian current of Italian documentary (Gallini 1981; Schäuble 2018: 8–10).

In her text, Rossi sacrificed accuracy in describing the conditions of the people of the Pollino communities in order to make what she considered a militant account of the condition of the subaltern southern peasantry. In so doing, though, she not only misrepresented and caricatured people who were, though historically marginalised, already to a point integrated in the still booming Italian economy, but also created a sense of distance and made much harder any sense of identification and shared humanity in the audience. She also underrepresented, or nearly ignored, the component of institutional Catholicism of the festival (see also Rossi 1969: 19–23). This is even more extreme a position than what De Martino wrote, for example, of Lucanian magic and Catholicism, which he considered in syncretic relationship ([1959] 2015: chapter 12). Often, though, this tradition of studies on the Italian South considered the Church a hegemonic system of oppression which laid its structures over a layer of peasant civilisation, whose rich heritage had to be unearthed in the spirit of a Gramscian history of the subaltern classes (Berrocal 2009). Similar readings were made of the Apulian Tarantism, of the *Maggio* festival in Accettura as we have seen in chapter 1 and, as we will see in the next chapter, of wheat festivals. Judging the Christian element as a later addition – often with

historical accuracy – De Martino and his associates would nonetheless downplay the role of devotion to the saints and the Virgin Mary in people's experience of these phenomena, preferring instead connections with pre-Christian practices.

Surprisingly though, the polemic that followed the release of Di Gianni's film created a convergence between these readings inspired by Gramsci and the policies with which the Catholic Church imposed a stricter control over the Madonna del Pollino festival. The film was shown at a conference of sanctuary rectors in Rome in 1976, and aired on national television the following year. Reactions of the local communities were mostly rejections of their portrayal as backward, while the Church pointed out the misrepresentation of the religious aspects of the festival. While criticising Rossi's ability as an atheist, Marxist scholar to understand folk religiosity, members of the clergy involved in the Pollino pilgrimage acknowledged the need to 'purify' and 'evangelise' the practices of the pilgrims (examples in Perrone 1983). In other words, though from an opposite perspective, the Church maintained a similar division between folk religiosity and official Catholicism as the most radical version of Demartinian ethnology. Instead of peeling away the layers of hegemonic religiosity, as the scholars did, it worked in the opposite direction at channelling 'popular piety' in forms approved by the Vatican. Yet, in so doing, it upheld a fundamental contrast between two original forms of religiosity, one oriented towards exteriority and practical returns, lived in an embodied way, and the other spiritual, focussed on the afterlife. Thus, in unpredicted ways, the circulation of Di Gianni's documentary likely played a role in the gradual enforcement of restrictions over the forms of devotion at the Pollino festival.

Some of these restrictions took the form of limiting night-time access to the sanctuary, the privileged time when the most unorthodox practices took place. But, as I started to realise during the episode that I narrate at the start of this chapter, a number of interventions were made on the acoustic space of the sanctuary. An important point of rupture was the fencing of the area facing the church, which confined the encampment of the pilgrims to the area behind the church and down the side of the mountain. In front of the sanctuary is a strip of upland that ends in a majestic view of the mountains all around and of the valley hamlet of Mezzana below. This fencing removed the clamour of the campsites, with their mundane activities of cooking, drinking, eating and especially music and dancing, from the spiritual space of the sanctuary, with its visual scenery. A further way of appropriating the sonic space of the sanctuary was to put up a fixed PA system, which from the walls of the church and adjacent buildings spreads the audio of the mass, sermon and liturgic songs. We witnessed the musicians

outside be silenced by the PA, at the same time as the priest addressed directly the 'proper' forms of devotion in his homily. What's more, all around the grounds of the sanctuary are signs that intimate 'This is a sacred place. Observe silence.' Right next to them, CCTV cameras point at various areas of the sanctuary. They remind us that changing people's behaviour is not as simple as prohibiting, but requires more subtle interventions that bring them to discipline themselves.

3.5 Festival of the Madonna di Conserva, San Costantino Albanese, August 2016. Playing *morra* at the campsite.

Control of sound and strategies of power

The Church's attempts to control the soundscape of European festivals date back to at least medieval times. Attali mentions a series of decrees from thirteenth- and fourteenth-century ecumenical councils forbidding musical processions from circling churches, and anyone from singing and dancing in them (1977: 22). The mid-sixteenth-century Council of Trent rigorously defined the characteristics of sacred music in the context of counter-reformation, prohibiting profane music in church and drastically reducing the use of liturgical music (Fellerer and Hadas 1953). Another key moment was the Second Vatican Council, which abolished the use of Latin for the celebration of mass, in the interest of making the liturgy more accessible to the people, but in so

95

doing weakened a tradition of liturgic singing in Latin and paraliturgical repertoires often managed by confraternities.

I believe that it would be incorrect to approach the situation of the Pollino festival from an opposition between sacred and profane ways of participation. The opposition, already criticised in studies of religion (Arnal and McCutcheon 2012), is not suited to giving justice to the pilgrims' sense of devotion. It is not so much my interest to get into a theological discussion of the role of sound in Catholic liturgy, especially since the parish priests managing these types of festivals do not receive explicit directions from their bishops on how to deal with local forms of devotional music and are left to develop their own interpretations. I am more interested here in interpreting the struggles over the soundscape of the Pollino festival through the insights of recent perspectives from sound studies. I also believe that the thought of Michel Foucault is pertinent to issues of discipline and governmentality of and through sound, despite his association with vision and technologies of making visible. Specifically, I highlight three strategies or micropractices of power that the clergy are using to take control of the soundscape of the Pollino sanctuary: first, they are using demarcations of space to identify certain sounds as noise; secondly, they are encouraging a passive experience of sound to create ethical

3.6 At the campsite behind the Madonna del Pollino sanctuary, June 2014. Night-time jam session with accordion and *tamburello*.

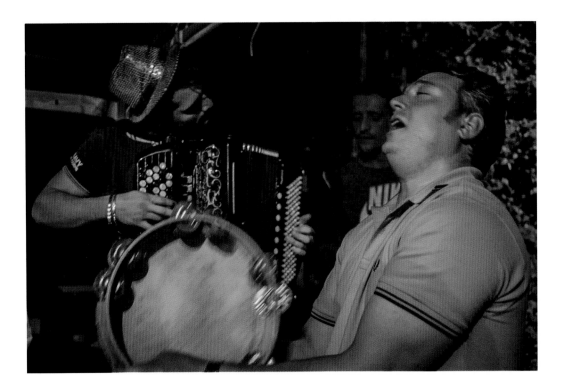

listeners; and finally, they are using technologies of amplification to establish an asymmetry in the production of sounds.

It is important to be aware that, despite the signs on the walls of the sanctuary, the clergy are not trying to make silence. In a sense, they are doing the opposite; they are trying to 'make noise', though in the sense of creating spaces to define what is noisy sound production and what is appropriate (compare Rowlands 2007). Specifically, they are trying to make noise of the music of the pilgrims and of the rest of their sonic devotion, and replace it with the sounds of praying voices and, in designated moments, the 'official' music of symphonic wind bands. This approach takes us into the realm of noise, a fascinating and multifaceted concept that has been defined in multiple ways. For our purposes I find useful an understanding of noise as 'sound out of place' (Bailey 1996; Pickering and Rice 2017), because it highlights its relative nature, its relationship with spatiality and its capacity to enact power. For Attali, because 'any organisation of sounds is … a tool for the creation or consolidation of a community' (1977: 6), noise becomes an essential tool of power for its ability to divide and demarcate space.

In fact, the definition of what is noise and who produces it has also been used to demarcate boundaries of social class and race (Cruz 1999: chapter 2; Picker 2003: chapter 2; Sakakeeny 2010). Noise has a long-time association with insubordination and revolt (Attali 1977: 122; Foucault 2009: 267), whose repression can be seen to continue in the policies of noise abatement in urban spaces. However, it is important to remark how noise also has a history of being used to repress deviance, for example in rituals of charivari, when noise or rough music is used to target 'wrong marriages'. A striking example is described by Pitt-Rivers in his ethnography of a Spanish Sierra village, where a man who had left his wife and children for a woman much younger than him was tormented every night by two hundred people armed with bells and horns, until after three months he died (Pitt-Rivers 1954: 171–72). It is interesting to note that the couple had moved outside of the village and in response to the racket they had tried to move further away – without success. Noise or music 'out of place' has been used in military operations to end siege situations, as in the case of the capture of president Noriega during the US invasion of Panama (Stocker 2013: 59). The power over acoustic space is the power to demarcate space by 'making noise' – which can mean both categorising the sounds of the other as noise and actually producing noise. This is particularly evident in the case of military aircraft noise in Okinawa studied by Cox (2013), where the noise of fighter jets is both the 'sound of freedom' for the Americans and a painful reminder of the war and consequent occupation for the Japanese (see also Goodman 2010).

3.7 Sanctuary of the Madonna del Pollino, June 2014. Loudspeakers, security cameras and signs demanding silence.

The second strategy of the clergy consists of replacing the sounds inside the sanctuary and of providing a frame for their perception within that space. The relationship between sound and the control of space has also been highlighted by studies of functional music or muzak, which serves both as a form of sonic branding of space, and as an attempt to influence the behaviour of those within it. According to Jones and Schumacher, functional music can be seen as a disciplining technology in a Foucaultian sense, which was first used to enhance worker production, and then to encourage customer consumption (1992). More recently, functional music has been connected to the repurposing of public places into private spaces oriented to consumption, where certain behaviours and social identities are more welcome than others (Atkinson 2007). The idea of using sound to influence

the dispositions of a community of listeners can already be found in Plato's thinking, where music, working affectively on body and soul through resonance, is a tool in the education of the ideal citizens of the polis (Siisiänen 2010: 159). Ethical listening is a common practice in the contemporary Muslim world, where recordings of sermons are played on a variety of media for personal use. Hirschkind has described such practices in Egypt as disciplinary practices through which Muslims 'hone an ethically responsive sensorium: the requisite sensibilities that they see as enabling them to live as devout Muslims in a world increasingly ordered by secular rationalities' (2001: 624). However, the moulding power of sound, deriving for Plato from its pre-reflective nature, was also what made it dangerous, so that it had to be under strict control to prevent deviations from the ideal Athenian virtues (Hirschkind 2006: 102–3).

This double aspect of sound's impact on listeners recalls the myth of the musical duel between the god Apollo and the satyr Marsyas. The latter challenged the god and his lyre with his aulos, a double-reed wind instrument whose tone was probably not so different from the *ciaramella* of the pilgrims. While Apollo was able to make the judges cry with his melodies, the wild sounds of the satyr's oboe moved them to dance. It was only through adding his voice to his music that Apollo was able to overcome Marsyas, who on the other hand could not do the same as he was blowing in his instrument. I find it fascinating that in the myth the oboe-playing satyr is able to move the audience to dance, thus creating bodily involvement, while the god wins thanks to voice, which is logos and by extension rationality (see Siisiänen 2010: 6.3). I understand the strategies of sound management in the sanctuary to be oriented towards creating devout listeners, whose experiences of sound are disconnected from the materiality of the body. The prohibition of dancing goes in this direction, as do the more extreme forms of involvement, but it is especially the repression of forms of music-making that creates passive subjects whose experience of devotion is markedly less embodied.

In the setting of a Scottish hospital, Rice observes similar processes of disciplining through acoustic means. These in many ways revolve around creating 'passive soundselves' whose experience of sound reinforces the partition between mind and body that underpins the condition of the patient in biomedicine (Rice 2003: 7). In mentioning Foucault's paradigm of disciplining surveillance, the panopticon, Rice remarks that the disciplining power of sound does not so much operate as forms of acoustic surveillance as through the subtle, omnipresent perception of sonic manifestations of power – a principle he terms 'panaudicism' (2013: 33). It is interesting to note that Bentham, the creator of the panopticon principle, had also devised a system of tubes

to allow acoustic surveillance of the inmates and at the same time delivery of orders by their guardians. However, Foucault writes, he abandoned the project later on because he perhaps realised that 'he could not introduce into it the principle of dissymmetry and prevent the prisoners from hearing the inspector as well as the inspector hearing them' (1995: 317 note 3).

Whether or not this is an early instance of what Sterne calls the 'audiovisual litany', which is the recurrent scholarly position whereby 'sound draws us into the world while vision separates us from it' (2003: 15), Foucault's remark brings me to consider the third strategy, that is, the use of technologies of acoustic projection to restore dissymmetry. The invention of the loudspeaker allowed a use of sound in space that before had only been possible thanks to the elevation of bells on top of a tower. Corbin, writing on church bells in nineteenth-century rural France, provides another example of sound governance enforced through dissymmetrical sound production (1998). Village bells mark time and put the acoustic space they cover under the spiritual and political authority of the powers that ring them. They impose a structure on the days of the peasants, calling them to activities determined by those powers. The way bells contribute to building an acoustic community also applies to the Islamic call to prayer (Eisenberg 2013; Khan 2011), which like bells these days is most of the time amplified or pre-recorded. The call to prayer creates an Islamic space and synchronises the faithful, who are supposed to respond to the sound with prayer (Eisenlohr 2018; Lee 1999). The open-air diffusion of amplified religious sounds is a powerful means of creating communities, but it can also amplify tensions in areas where conflicts are present (Hirschkind 2015: 170–71; Moore 2003). The capacity of the loudspeaker to bring sounds to large groups of people beyond the physical location of the original source, though, in its unidirectionality also affords silencing. The person behind the microphone has the certainty to be heard, and only when they choose to (Cluett 2010).

At the Pollino festival, loudspeakers carry the voice of the priest out of the church building, into the perimeter area, and amplify it on a procession, thanks to a portable PA system and radiomicrophone. Without them, the priest would be confined to the church as the only place in which he would be able to dominate the soundscape. The loudspeakers, on the other hand, confine the musicians and in general the whole festive soundscape of the Pollino sonic devotion to the area outside the perimeter of the sanctuary. I am not suggesting here that the Church can keep its authority at the pilgrimage only thanks to these three strategies of sonic control, especially since the episode I narrate at the beginning of the chapter demonstrates that at times it needs the help of secular institutions – and even then it

might fail. However, I have realised how strategies of control of the soundscape have changed significantly the modes of sonic devotion at the Madonna del Pollino festival since the late 1990s, when Scaldaferri started his observations, in ways that are more subtle than the intervention of the police.

Conclusion

Finally, I want to present another case of use of sound for the management of a festival. This example has both continuities and marked differences with the pilgrimage of the Madonna del Pollino. Since 2013, Don Serafino La Sala has been parish priest in Episcopia, a village of about 1400 inhabitants in the Sinni river valley, 20 kilometres from San Severino Lucano. In his role, he is a central figure in the festival of the Madonna del Piano, a mid-fifteenth-century wooden statue of the Virgin that, according to oral tradition, was found inside a hollow oak tree by some peasants (see chapter 4). Don Serafino, a young priest now in his thirties, is very familiar with the Madonna del Pollino festival, having served as an altar boy there since he was a child. In 2017 we could observe the way he managed the soundscape of the procession that, every 5 August, takes the statue of the Madonna from a countryside sanctuary to Episcopia's main church.

Episcopia, like many of the similar-sized villages of the region, has seen strong and still ongoing emigratory waves during the past century and is constantly shrinking in population. During the Madonna del Piano festival, however, many of those who moved abroad or to other parts of Italy return to their village of origin to take part in the celebrations. Episcopia's population is temporarily rejuvenated, and many youths take part in the main events on 4th and 5th of August. There is a definitely lively and sometimes wild atmosphere, with lots of wine-drinking and dancing, which contrasts with the greater reserve of other patron saint festivals in nearby villages, where youth participation is markedly smaller. On the 5th there is a morning mass at the sanctuary and people have a communal lunch nearby. Music plays for most of the day, especially *tarantelle* for *organetto* and drums, plus occasionally some *zampogna*. A walking wind band is also present, marking as usual the key ceremonial moments. The festival is markedly heterogeneous, mixing liturgical moments, wild partying, religious songs and dancing music, and its attendance brings together young and elderly people, institutional figures, clergy and folk music lovers. I was struck by Don Serafino's capacity to keep all these components together in fairly harmonious coexistence. While this is certainly due to efficient organisation and dialogue with the community, the priest's management of the festive soundscape stood out and was markedly different

from what happens at the Pollino pilgrimage. Throughout the over two-hour-long procession that brought the statue of the Madonna del Piano to Episcopia's main church, he used a radiomicrophone and a portable PA system to alternately amplify different sound sources. He would start a series of prayer songs, with which a group of mainly female devotees would join in. Then he would give space to the walking band, who played symphonic marches. After a couple of pieces he would turn the microphone to the *zampogna* or *organetto* players who played devotional songs.

In an interview with Scaldaferri, he remembers his first experience as parish priest at the Episcopia festival, which he describes as 'chaos' (La Sala 2019). He spent most of the time listening carefully, and could not help drawing connections with his memories of the Pollino festival. Commenting on a photograph of himself taken by Ferrarini in 2017, he states how he sees his role as one of managing and organising. He prefers to speak of sharing and negotiating between different ways of living the celebration, rather than taking a stance of banning and prohibiting. In the absence of explicit guidelines from the upper levels of the ecclesiastical hierarchy he prefers to run the paraliturgy in an inclusive manner, instead of applying repressive authority. Significantly, the parish priest often presides over the festival committee and can

3.8 Episcopia, August 2017. Don Serafino La Sala at the Madonna del Piano procession.

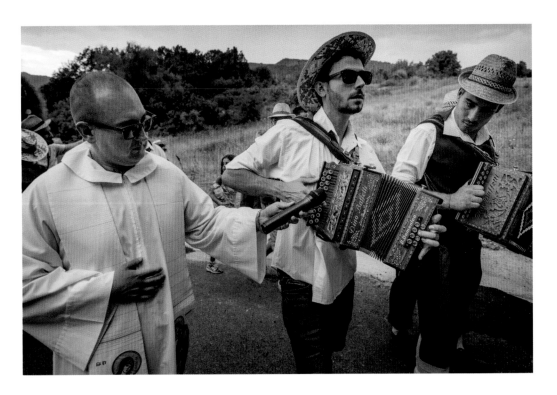

have a strong influence on the use of funds, so that his authority is not only spiritual.

The procession is a complex microcosm, made up of different participants who have very different experiences and expectations. Don Serafino is no orchestra leader and his loudspeakers cannot reach every participant. His actual control is limited, but the message he sends is powerful and goes beyond the range of the PA system. In lending the institutional amplification of his microphone he is making it clear that all those forms of sonic devotion are legitimate participants in the festival. In so doing he manages to obtain a non-conflictual sonic space around the statue of the Madonna, in which band, singers and players alternate and do not overlap. He also obtains that the drunken dancing keeps out of earshot and out of potential conflict. Despite the tolerant and inclusive approach, this use of the PA system is also a disciplining technique that allows control of the development of the festival. For example, the centrality of the priest's role as soundscape manager makes it clear that the monopoly of the festival belongs to the Church. As the performers enter a pact of mutual non-aggression that avoids duels similar to that between the *zampogna* players at the Pollino sanctuary, their sounds become institutionalised. It is not by chance that in Episcopia forms of sonic devotion are present side by side with the heritagisation of cultural performances, evident for example in the 'peasant' uniforms of folkloric dancers with wooden sickles – an aspect totally absent in the Madonna del Pollino pilgrimage.

Comparing the soundscapes of the Pollino festival and Episcopia also allows one to reflect on the future of the forms of sonic devotion that I have described in these pages, especially considering that these areas are facing depopulation and increasing demographic ageing of their permanent residents. Our ethnography has shown that the power of sound to order and structure space makes it a formidable tool to either exclude or include forms of devotion. A new generation of priests, more open and respectful of the practices that their predecessors labelled as ignorance and sought to eradicate, is perhaps showing a way in which these festivals can adapt and involve younger generations.

Sound-chapter 3 – *'We came a long way ...'*

This sound-chapter includes recordings of musical performances, religious songs and soundscapes from different moments of the festival of the Madonna del Pollino, as well as from other Marian festivals in Basilicata, made between 1989 and 2016. It provides different examples of sonic devotion and of ways in which sound can be used to mark an event and take control of space.

SOUNDS AND IMAGES OF NOSTALGIA: THE REVIVAL OF LUCANIAN WHEAT FESTIVALS

4

Lorenzo Ferrarini

During the month of August, in the southern part of Basilicata, a number of events involving wheat offerings take place during religious festivals dedicated to local patronal saints or to the Madonna. Traditionally, August was the time when most of the main agricultural work would be finished, and people had time and resources to dedicate to religious festivals. Wheat, once the main staple crop of the region, would be harvested in June–July and people would set aside bundles of ears of wheat to carry in procession on saints' days. Although many people in Basilicata are no longer involved in agriculture, wheat festivals continue to be actively practised and indeed since 2010 both the number of festivals and attendance have been on the increase.

Multilayered arrays of candles are created for the purpose of making offerings to the local saints in many parts of southern Italy. In past times, however, candles were an expensive commodity that was not within everyone's means. Peasants would instead create these arrays by tying ears of wheat together using a similar wooden frame but without the candles. Thick with ears of wheat, these offerings, often called *gregne* or *scigli*, weighed several kilos and would remain the property of the church after the festival. In some places, the name used to refer to the wheat offerings continues to be *cirii*, which in the local dialect means, literally, candles.

In addition to the act of donating a substantial quantity of wheat to the church, people's religious devotion was and continues to be expressed in the act of bearing the offering on their head. In some cases, an offering is the outcome of the collective labour of a neighbourhood or a family, while at other times it is connected with a personal vow. In the latter case, individuals ask for divine favour and in exchange undertake to carry the offerings every year, sometimes barefoot, according to the particular terms established with the saint at the time of the request. Sometimes offerings originally prepared for one particular local festival may be taken on a pilgrimage to a different

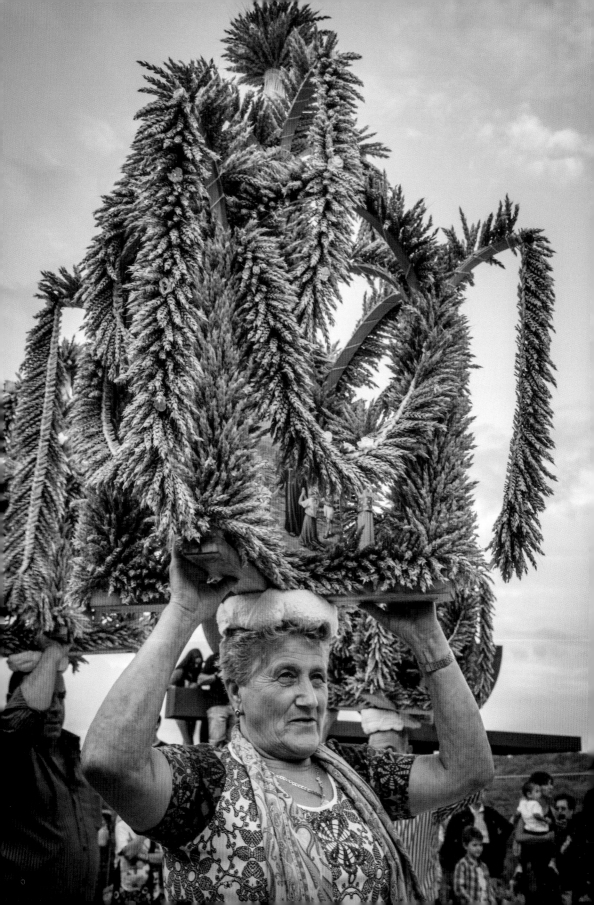

festival, as happens in the case of some of the offerings made in Teana for the Madonna delle Grazie, which are also to be seen at the mountain sanctuary of the Madonna di Viggiano.

In this photo essay I start from the evident decline of agricultural ways of life for people in this part of Basilicata. Once flourishing rural settlements are now becoming depopulated, the land dedicated to farming is significantly reduced compared with the 1960s, and rural ways of life are not as central anymore to most people. Yet, since the early 2000s, we have witnessed a revival of events involving wheat, including both religious festivals and events celebrating agricultural heritage. The politics of intangible heritage play a factor in this renewed attention dedicated to wheat festivals, but we have also noticed the strong emotional power of their association with the agricultural past. These emotional reactions are not confined to the moment of the festival itself: they are also at play in the preparatory phases of the event, which often involve activities, skills and sensations that directly evoke the agricultural past.

The photographs that make up this chapter follow a realist documentary style that is rooted in the history of anthropology in Basilicata (see chapter 7). In combination with the accompanying texts and sounds, the aim of these images is to evoke the manner in which, with varying degrees of consciousness, people in contemporary Basilicata perform cultural heritage at the same time as performing acts of religious devotion.

As is evident throughout the associated sound-chapter, music is ever present at wheat festivals, and many of the offerings dance with their carriers to the sound of *tarantelle*. Dancing with the wheat offerings is a form of sonic devotion not unlike those described in the previous chapter. In Teana, in particular, the characteristic design of the offerings includes appendages that swing and open up as the dancers rotate. Here, as in Noepoli, the opportunities for dancing are limited to designated spaces and times by those who manage the procession. It is often the priests leading the procession who determine these limited moments, on the basis of the 'profane' character of the music and of the dancing. In Noepoli the presence of ears of wheat is limited to a small bundle on top of an offering made of candles. The inhabitants point to the difficulty in obtaining manually reaped wheat as a reason for its disappearance from the offerings to the Madonna of Constantinople, a Byzantine icon that in this case takes the role elsewhere more commonly fulfilled by a statue.

A different scenario plays out in Episcopia, where the participation of villagers of all ages in the festival of the Madonna del Piano is massive. It is especially remarkable to see the numbers in attendance among the younger generations, attracted by the party atmosphere and the careful

4.1 (*Facing*)
Teana, 2016. Wheat offerings on the day of the Madonna delle Grazie.

4.2 (*Overleaf*)
Teana, 2016. Wheat offerings dance on the day of the Madonna delle Grazie.

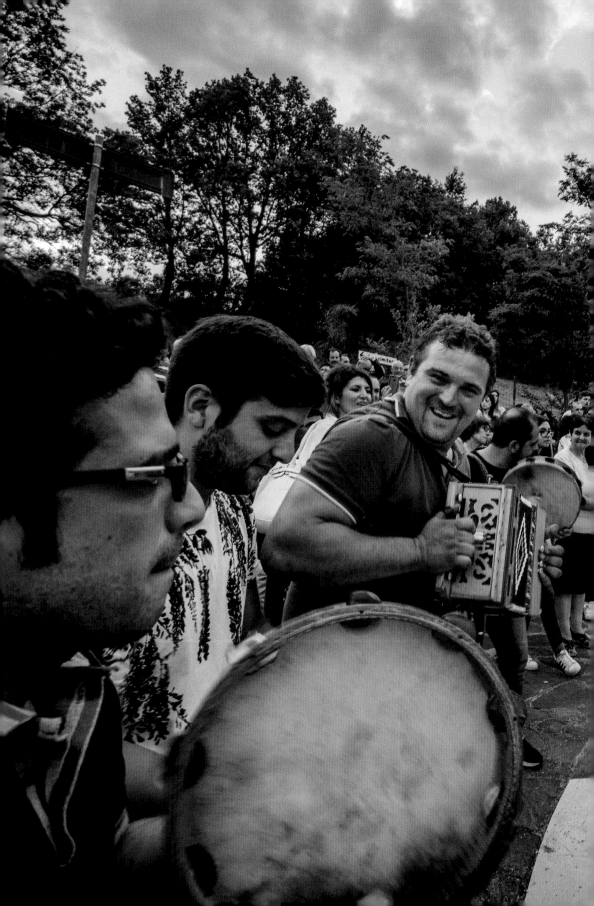

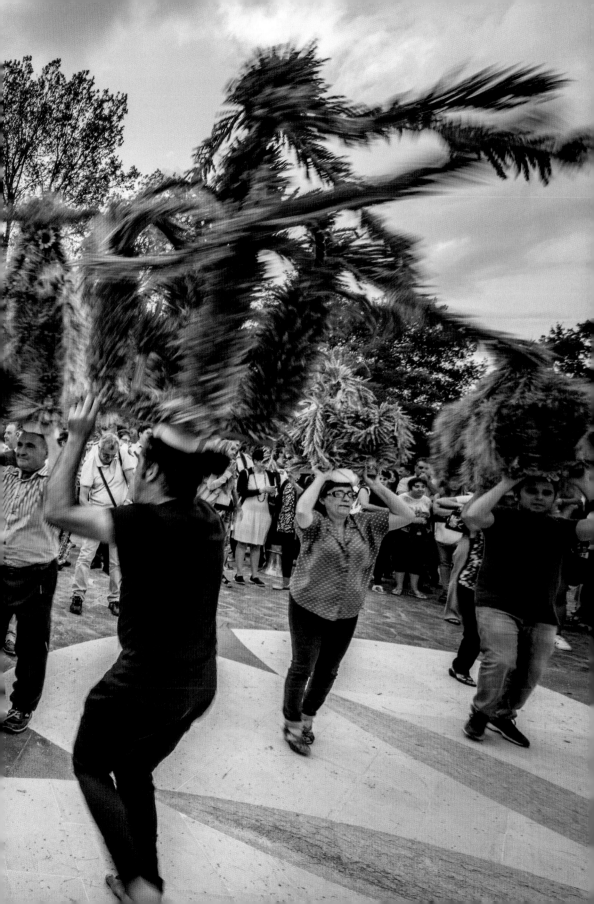

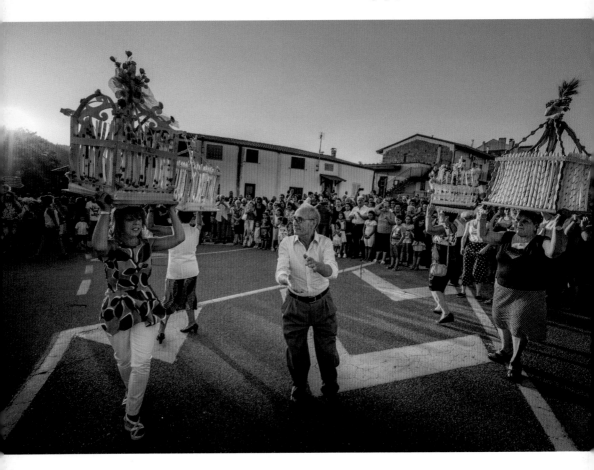

4.3 Noepoli, 2017. Candle offerings on the day of the Madonna of Constantinople.

4.4 (*Facing*) Episcopia, 2017. The wheat offering of Contrada Demanio, including a pair of caged dormice.

management of sound by the priest (see previous chapter). Here the wheat offerings, put together by village districts and hamlets, sometimes dance along the whole procession, which due to its sheer size allows the various different components – and forms of devotion – not to get in each other's way sonically. The medieval statue of the Madonna del Piano is showered with wheat as it exits the rural sanctuary that marks the beginning of the procession. She carries in one hand a bundle of ears of wheat, which demonstrates very clearly that these festivals were as much ceremonies to mark the end of the harvest and the success of people's efforts in the fields as they are Catholic festivals dedicated to the saints. Indeed, older people will often say that the saint or Madonna whom they honour with wheat will ensure a good harvest.

Yet, the analysis made by De Martino of a wheat harvest ritual in San Giorgio Lucano, called 'game of the sickle', did not relate it to the cult of St Roch of Montpellier. In this ritual, a harvester dressed up in an animal skin steals the last sheaf of wheat and is 'hunted' around

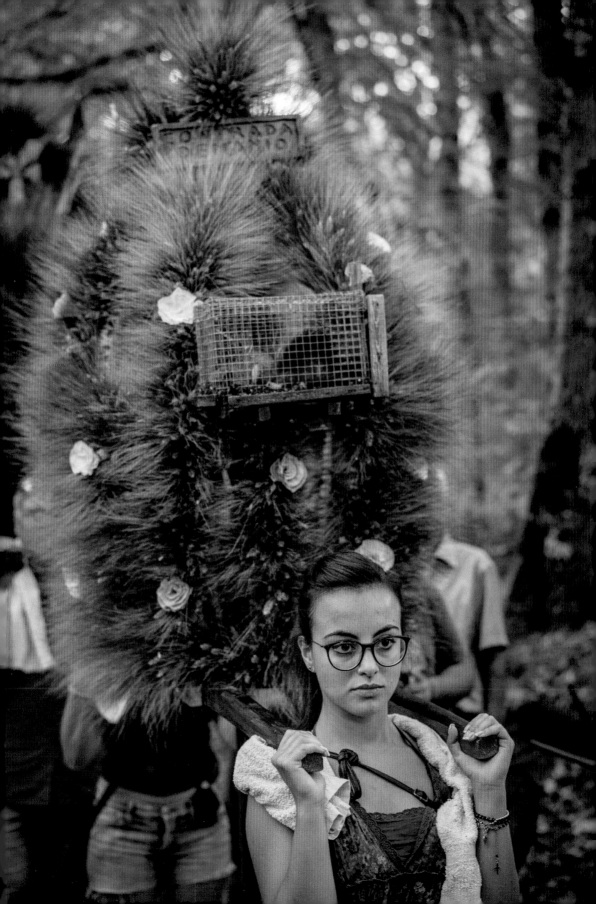

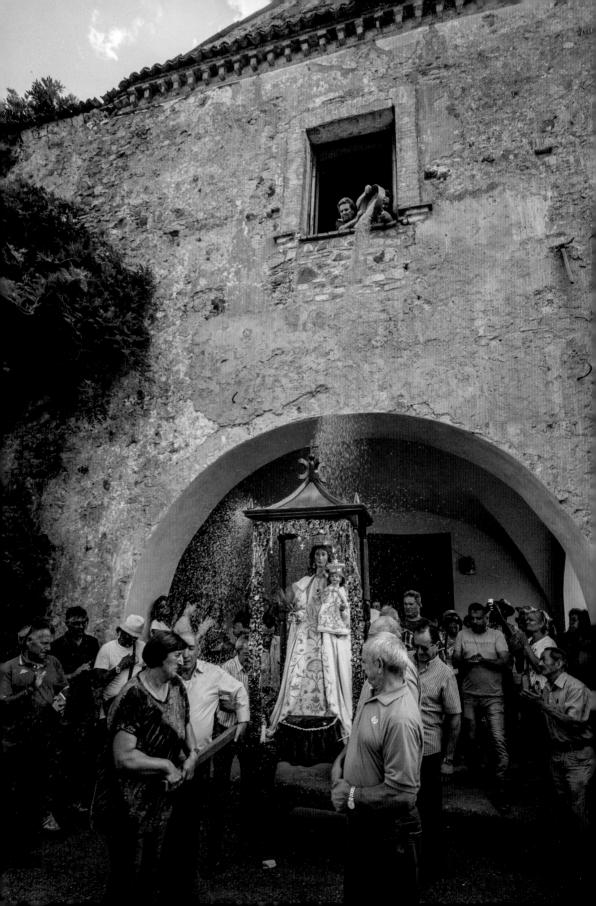

the field by the reapers. Once the harvest was complete, the workers would then ritually humiliate the landowner by undressing him using their sickles. Significantly, since in San Giorgio the property of the land was concentrated in the hands of few, most of these labourers did not own the wheat they were harvesting.

This custom had already been abandoned by 1959, when De Martino was in San Giorgio, whereas still today people carry wheat offerings in a procession with the statue on the day of St Roch. Perhaps because of the brevity of his stay and because he had been informed of this tradition by his contacts in the Workers Union, De Martino did not seem to be aware of this. Even while noting its enactment of class struggle, he called the 'game of the sickle' a survival of a pagan era, that Christianity had disconnected from the cult of the agrarian gods (De Martino 1962: 163). In the discourses surrounding wheat festivals today, it is still possible to witness the mobilisation of an imaginary 'cereal civilisation' of the Mediterranean, whose legacy should still pervade elements of folk religiosity across the Italian South.

Sixty years after De Martino, wheat festivals have assumed an important role in San Giorgio Lucano's strategy to attract regional funding in support of intangible heritage. Much of the case for support is based on De Martino's interpretation of the game of the sickle. Traces of this ritual are visible in San Giorgio in the form of posters, theatre pieces, re-enactments and other forms of public art that include mural paintings along the streets. Franco Pinna's black and white images are an important part of this process of appropriation of a practice that disappeared during the 1950s, and are seen in most of these occasions (see chapter 7). In San Giorgio the folklorisation of wheat festivals is perhaps most evident during the procession of the day of St Roch, when children are dressed up in generic 'peasant' costumes that can be seen in a variety of festivals across the region, and are made to parade with small bundles of wheat or miniature versions of the larger offerings.

The legacy of research on San Giorgio's wheat ritual has inspired a production of cultural interpretations, sometimes based on the authority of scholars appointed to validate and provide an aura of authenticity. The simultaneous presence in San Giorgio, for example, of conferences of scholars that trace the histories of the interpretations of wheat rituals from a historical and anthropological point of view, and of theatre pieces that imaginatively connect wheat rituals and pre-Christian cults, can be read in this way. Another example is the visual quotations from the film *La passione del grano* (*The Passion of the Wheat*), shot in San Giorgio by Lino Del Fra and with voiceover by De Martino (Del Fra 1960), in the music video for the song *La bestia nel grano* (*The Beast in the Wheat*) by folk-rock artist Vinicio Capossela.

4.5 (*Facing*) Episcopia, 2019. The Madonna del Piano is showered with wheat at the exit of the sanctuary.

113

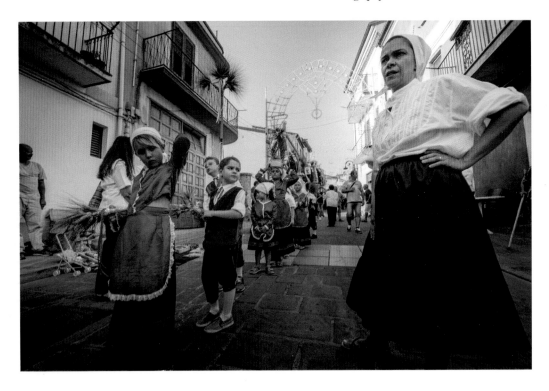

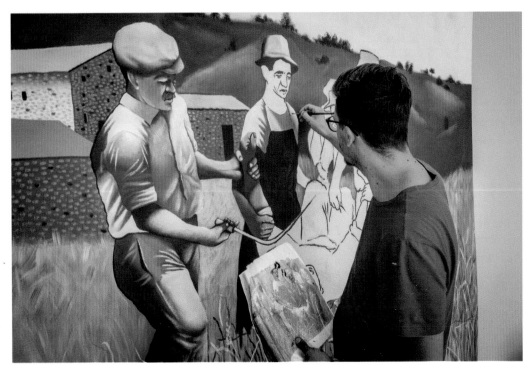

At the same time as these institutional and artistic attentions concentrate on the game of the sickle, though, the existence of wheat festivals is always in danger due to the loss of specialised knowledge connected with agricultural practices of the past. One of the paradoxes of heritagisation is that, while it generally attracts attention and resources on a cultural phenomenon, it often severs the last remaining links with its original social functions, and in doing so puts at risk the transmission of those forms of knowledge necessary to ensure its continuity: for example how to prepare the frames for the offerings, how to bend, weave and tie the wheat, which varieties to use and how to source them.

A few kilometres from San Giorgio is San Paolo Albanese, a small village heavily impacted by depopulation with about 250 permanent residents. Here, in the middle of August on the day of St Roch, a large wheat offering is carried in a procession with the statue of the saint, and two dancers with sickles face each other in a dance around a sheaf, occasionally running behind a third man who steals the wheat. This pantomime, which they call 'dancing the sickle', shares some elements with San Giorgio's game of the sickle, but would take place in a context in which most farmers were small landowners. In San Paolo the large communal offering, called *himunea* in Arbëresh, was made with wheat collected as a form of alms. As far as we know, the wheat festival of San Paolo has known no interruption comparable to that of the game of the sickle of San Giorgio. Yet, despite the proximity of the two, scholars found out about this ritual only during the 1970s and to date no comparable processes of spectacularisation have taken place.

In part, this is due to a certain resistance to change by the older generations. 'The game of the sickle is not a *tarantella*', points out Pietro Ragone, who took up the role of dancer from his father, when he settled back in San Paolo after years working in Switzerland as a cement factory worker. In remarking the distinctiveness of dancing the sickle from the generic *tarantella* dance that is heard throughout these festivals, Ragone also told us of his rejection of proposals to introduce 'folkloric' costumes and dancing women into the event. The reference here is to sounds, moves and costumes that have spread with a certain uniformity throughout southern Italy, and have contributed to turning the revival of *tarantella* from a counter-cultural phenomenon to an institutionalised and globalised trend (Inserra 2017).

During the early 2010s, however, the tradition of dancing the sickle was hanging from a thread, as the two dancers I photographed in 2005 experienced health problems. Due to the small size of the village and its demographic decline – also evident in the number of abandoned and cracked buildings – today outsiders play an important role in continuing this tradition. Returning emigrants who live in northern Italy

4.6 (*Facing*)
San Giorgio Lucano, 2017.
Children in the procession on St Roch's day.

4.7 (*Facing*)
San Giorgio Lucano, 2018.
Painter Vincenzo Blumetti at work on a mural based on one of Franco Pinna's photographs.

are taking up the dancing, learning from the older generation, while the musicians come from nearby San Costantino Albanese (see chapter 6) and some of the participants belong to families originating from nearby villages that the council has invited to resettle in San Paolo.

Procuring wheat with long stalks that can be tied to the frames that make up the offerings used in wheat festivals is a constant problem for people involved in their organisation, since the mechanisation of agriculture produces an unsuitable harvest. The wheat has to be reaped manually, and the preferred variety – called *Senatore Cappelli* – has widely been replaced by more modern hybrid seeds with a higher yield per hectare. The ears of Cappelli wheat have a different shade of gold to them, with darker streaks. Most of the makers of offerings we spoke to said that they prefer Cappelli wheat because its visual appearance is more mindful of the days of old, thus confirming that they are enacting a vision of tradition that is based on precise details from the past.

In Terranova di Pollino a holiday farm, with the support of the local tourist office, has devised a way to provide the right type of wheat and promote local produce and ways of life by setting up a manual reaping competition. The format of the event was imported from neighbouring region Campania: teams of reapers are assigned a strip of wheat field each and compete in speed, so that those who complete the harvest first receive a prize. At 1500m above sea level the wheat is ready for harvest much later than at lower altitudes, so the event can take place in early August, when the presence of tourists is at its peak.

The participants come from villages surrounding the area, and have different agendas. For the organisers, there is clear desire to spectacularise the event, turning a practice of the old rural lifeworld into a show that includes live commentary, traditional music, and branded aprons and banners, plus an audience confined to a designated area. Some of the participants have not necessarily experienced manual reaping in their lifetime, while others, visibly older, clearly take part as an opportunity to experience again the actions that they associate with their past. In 2018 it was striking to see teams made up of older men and women go about their work in a way that was not competitive at all – in fact they would not even try to catch up with the faster teams. The impression was that for them the competition was a moment to be savoured, dense in affective significance, and a way to experience actions, sounds and other perceptions that connect directly with the past. Behind one of these teams was an old lady who gleaned stray ears of wheat, saving them for an upcoming religious festival.

On the day of the competition in Terranova di Pollino we followed one of the musicians, who took a carload of the wheat from the harvest to his home in Pedali – a hamlet that is part of the municipality

4.8 (Facing)
San Paolo Albanese, 2005. Dancing the sickles at the sound of a *zampogna*.

4.9 (Facing)
San Paolo Albanese, 2005.

4.10 (Overleaf)
San Paolo Albanese, 2017. Dances in front of the church on St Roch's day.

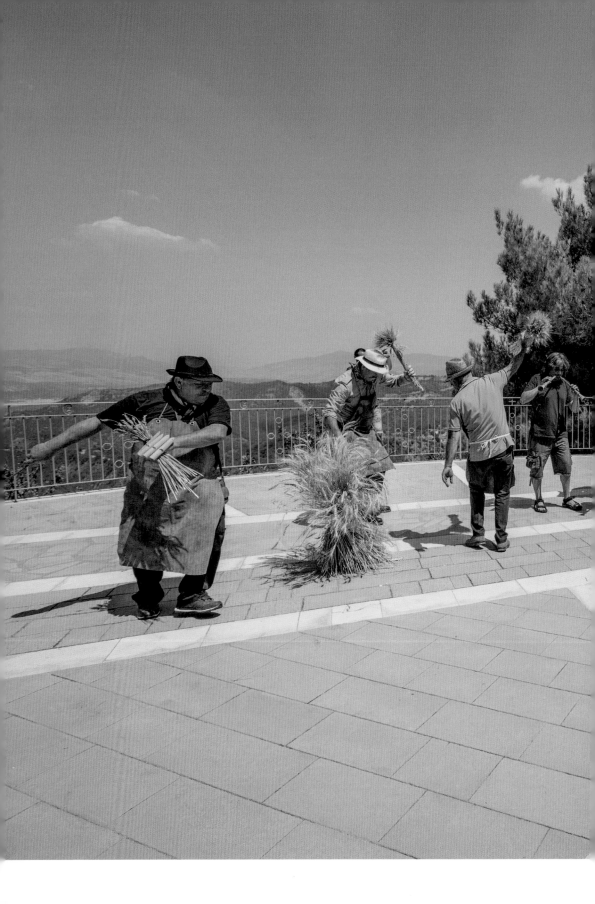

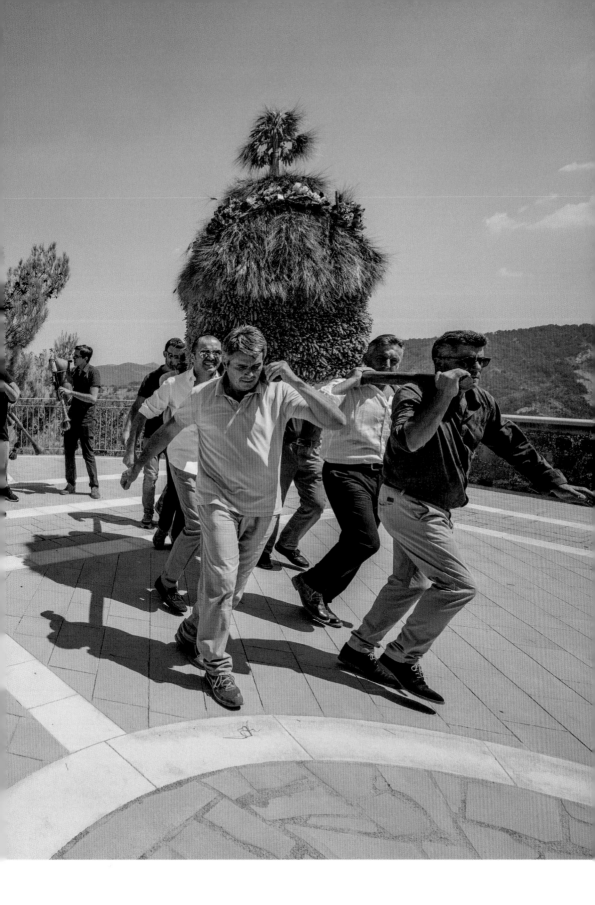

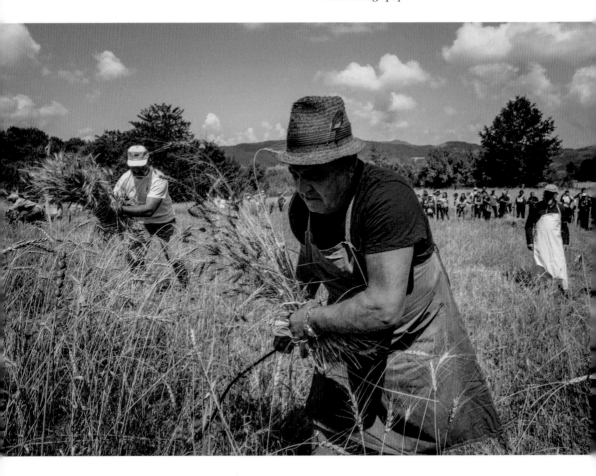

4.11 Piano delle Mandrie, near Terranova di Pollino, 2018. Reaping competition.

of Viggianello. Here a group of women were renovating the large, cone-shaped offering that was to be taken on a procession on the day of the Madonna del Carmine later that month. Viggianello is located in a fertile valley which produces large quantities of wheat, yet the opportunity to get manually reaped wheat with long stalks could not be missed, since the agriculture of the area has been mostly mechanised. This was a domestic setting, a simple courtyard in which communal work on a devotional artefact reinforced the ties within the community. The spectacularisation taking place in Terranova di Pollino seemed not to have reached the Madonna del Carmine festival in Pedali, which revolves around a small procession of wheat offerings during which live animals are donated for an auction that takes place in the square in front of the church.

The role of communal work was clear in another context in which wheat offerings are created as a common effort of a district or hamlet. In 2019 in Manca di Sopra, in the territory of Episcopia, the wheat of the

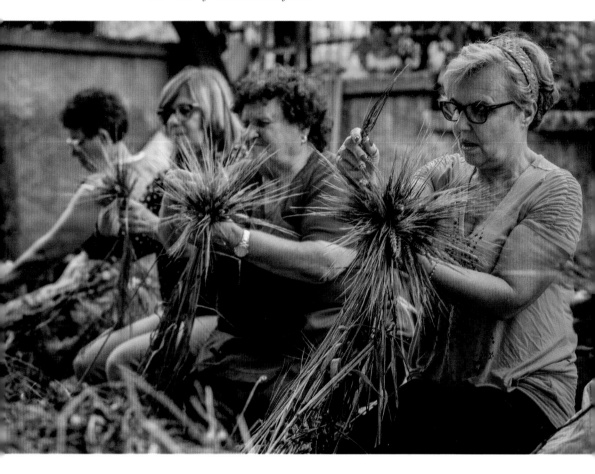

offering was renovated in a public park, which became the centre of a real feast in which each participant contributed food and drinks. Though only a minority took part in the actual process of tying the bundles of ears of wheat to the frame of the offering, many of the inhabitants of the small hamlet showed up for the occasion. The commensality added to the community-making character of the event, which also saw the presence of many returning emigrants from northern Europe or northern Italy. It is also an opportunity to transmit specialised knowledge across generations, such as that for the making of the offerings.

4.12 Pedali di Viggianello, 2018. Making bundles of ears of wheat for the communal offering to the Madonna del Carmine.

That wheat festivals are going through a process of revival is also evident in a case that shares some features with processes of invention of tradition. In Chiaromonte, formerly an important agricultural centre in the valley of river Sinni, since the first half of the 2010s the patron saint's festival of St John the Baptist has included an exhibition and procession of wheat and candle offerings coming from a number of villages in the surrounding area. Held at the end of August, the festival culminates in

a prize-giving ceremony that awards the best offering on the basis of a popular ballot. This format was introduced by local associations and the parish as a way to reinvigorate the festival. In particular, Andrea Mobilio was instrumental in the reintroduction of wheat offerings in Chiaromonte. He learned to make them from a man in San Giorgio Lucano, and since then he has been collaborating with other villages providing support and at times making new offerings for other festivals in the time left by his job as a truck driver. He has created a network of village festivals that becomes visible during the exhibition and parade in Chiaromonte, in some cases stimulating awareness of the cultural value of the offerings beyond specific acts of individual devotion.

The festival in Chiaromonte is a striking example of heritagisation. In 2018, its structure brought together offerings made for different saints or Madonnas in different villages, mixing the religious occasion of the festival of St John with a celebration of the offerings as cultural heritage. The way in Chiaromonte the two elements of devotion and cultural performance are kept together is remarkable and especially meaningful of the broader situation of the region.

The prize-giving ceremony, sponsored by groups of emigrants settled in northern Italy, makes visible the contradictions at work in the processes of resignification of wheat festivals. If they are becoming part

4.13 (*Facing, above*) San Paolo Albanese, 2017. Making bundles of ears of wheat for the communal offering to St Roch.

4.14 (*Facing, below*) Manca di Sopra, Episcopia, 2019. A feast on occasion of the renovation of the communal offering to the Madonna del Piano.

4.15 Chiaromonte, 2018. Preparing a wheat offering for the festival of St John the Baptist.

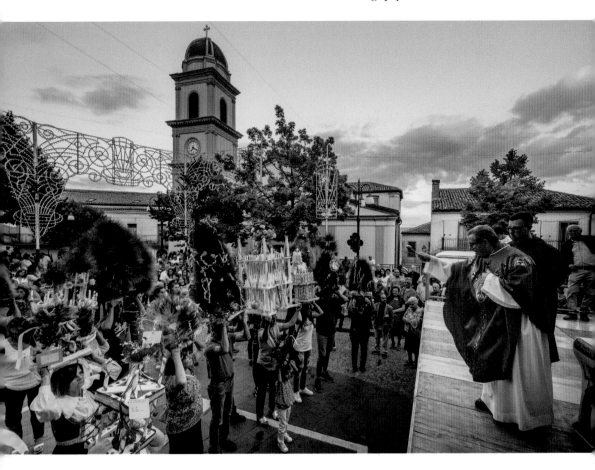

4.16 Chiaromonte, 2018. Blessing of the wheat and candle offerings at the festival of St John the Baptist.

of the image of themselves that the inhabitants display to visitors, it is also because of the opportunity that they offer to celebrate a largely imagined authentic agricultural past, which takes strongly nostalgic tints in the light of the current transformations of the area. Agriculture is less and less relevant economically and in people's daily lives, and the surface dedicated to the fields has been shrinking for the past fifty years. The same period has seen the emergence of new forms of extraction from the territory, which have reconfigured people's understandings of the land. Rich in waterways, Basilicata has become the location of several dam projects that have taken away land from some communities. It also hosts the main oil and natural gas reserves in Italy, and is a site of production of wind energy, both of which have given rise to protests revolving around the polluting impact of the former and the impact on the landscape of the latter.

If the pastoral and agricultural world where wheat festivals have their origins is all but gone, people's attachment finds in these rituals

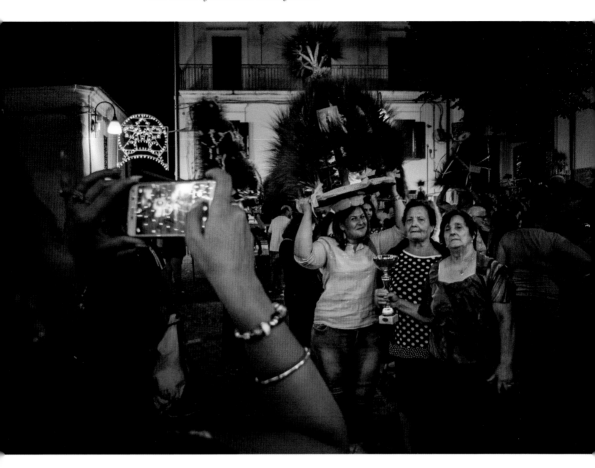

an expression that goes beyond the politics of heritage involved. This juncture of affect, devotion, reuse of anthropological knowledge and touristic promotion makes wheat festivals emblematic of the condition of much of Basilicata's cultural heritage at the time of our writing. They precariously walk a line between the celebration of rurality and becoming a defunctionalised spectacle. By engaging stereotypes and expectations of tradition through visual displays and sound-making, the protagonists of wheat festivals enact their own visions of tradition and rurality to an external audience and to themselves. This chapter, in addition to underlining the social functions of identity- and community-making that wheat festivals still perform, suggests that their protagonists have taken up a conscious and active role in representing their heritage, often appropriating stereotypes and exoticist depictions (cf. Kalantzis 2019: 3–6). It is perhaps the simultaneous presence of these diverse levels and functions in a context such as that of contemporary Basilicata that explains the present revival of wheat festivals.

4.17 Chiaromonte, 2018. After the prize-giving ceremony following the festival of St John the Baptist.

4.18 (*Overleaf*) Tempa Rossa, Corleto Perticara, 2019. A field is prepared for the next season with, in the background, an oil and gas extraction site and a wind farm.

Sound-chapter 4 – *Dancing with wheat*

This sound-chapter is entirely composed of field recordings made during wheat festivals in Basilicata between 2004 and 2018, including religious processions and secular events. The music and rhythm of the *tarantella* create a common sonic thread that connects all the festivals.

VOICES ACROSS THE OCEAN: RECORDED MEMORIES AND DIASPORIC IDENTITY IN THE ARCHIVE OF GIUSEPPE CHIAFFITELLA

<div align="right">**5**</div>

Nicola Scaldaferri

In this chapter, the topics explored in the book are approached from a new perspective, deriving from the analysis of a private archive, dating from the twentieth century, which includes written texts, photos, films and, above all, sound recordings. Thanks to these media we can retrace the story of an immigrant who, especially through his recordings of songs and voices of distant relatives, was able to reinforce the sense of community among emigrants in the USA.

In this case, the community is no longer a local one, confined to a single village or a small regional circuit, but a diasporic community whose identity must be understood on a wider transnational scale. Music and sound continue to play a crucial role in giving a meaning to its identity thanks to their strong evocative function and nostalgic component (Pistrick 2015). However, in addition to music-making practices, an even more important role is that of sound recordings. Emigrants who recorded on tape voices, musical instruments or church bells were able to offer them to their diasporic community through the magnifying glass of acousmatic listening, whereby sound is separated from its original source, to 'focus the listener on some intrinsic feature of the sound' (Kane 2014: 29). In this case, the sound itself, now separated from its source and confined to a new magnetic support, becomes more powerful and evocative, with an emotional charge which sometimes can be even stronger than its live performance.

Listening to the tapes was the first stage of this research, which became an archival sonic ethnography that revealed the role of the recordings in sustaining a network of relationships. Dealing with these recordings is also a way of listening to histories of listening; it allows exploration of the way temporary communities have been created around practices of recording and listening, with the actions of recording and listening themselves becoming meaningful practices of evocative value.

Giuseppe Chiaffitella (1900–1980) is remembered by the people of San Costantino Albanese as 'the friend of young people and sports'. He was known by his family nickname *Pepini Shirokut*, or *laj Pepini Meri-kani*, Uncle Peppino 'the American' (Scaldaferri 2014b: 9–14). Shortly before the First World War, as a teenager, he followed his father to New York, where he found a job as a tailor. He joined a large community of Italian emigrants, some from his own village, who knew him as Joe Chiaffitella. An amateur guitar player and singer, he was a member of the *Casa Italiana* choir during the 1930s (Faedda 2017). This choir, at the time directed by Sandro Benelli, was made up of various Italian amateur singers who at times performed in folkloric costumes.

Chiaffitella strived to keep alive the relationships between his birthplace and the community of migrants in the US by means of the frequent journeys that, except for the interruption of the Second World War, he made back and forth across the Atlantic. He was fond of technology, and from the 1930s he always travelled with a still camera. He would shoot a large number of snapshots, which he would send to relatives and friends with messages handwritten on the back. From 1957, he also started to travel with a Recordio tape recorder that he used to record both voices and music. A few years later he added an 8mm movie camera that he used to film public and private events. On every journey between New York and San Costantino he exchanged photographic and audio souvenirs with friends and relatives. Bearing witness to his energetic activity, there is a large collection of documents, made available to us by his heirs and recently digitised. This includes seventeen audio tapes, eight rolls of 8mm film and hundreds of photographs, in addition to letters, diaries, unpublished poetry and music scores from his days with the *Casa Italiana* choir.

Chiaffitella's generosity towards the young people of his natal village and his constant efforts to keep the memory of the village alive should probably be read in the light of the principal tragedy of his life: the death of his only son at the age of thirteen, which happened in San Costantino in 1943, while Chiaffitella was in the USA. Due to the disruptions caused by the war, he was informed of his son's death only after the end of the conflict. This threw him into a state of emotional turmoil, which he tried to address, probably only with partial success, by trying to bridge the distance that separated him from San Costantino.

Chiaffitella's is not a unique case of sound memories recorded in private and domestic contexts and used to transmit information at a distance and provoke emotions. We also know about the examples of voice mail recorded during the first half of the twentieth century (Levin 2010) and of the records sent in the 1950s by Kostantinos Chronis from the USA to his family in Greece, with recordings of vocal

letters, songs and news of the family (Panopoulos 2018). Chiaffitella's uniqueness lies in the fact that he would never mail these recordings; he would always take them with him, together with his tape recorder, to organise listening and recording sessions with his fellow villagers. Unlike Chronis, then, Chiaffitella would make the recordings travel both ways. These sessions were opportunities for celebration but also, in many aspects, ritual. At a time when transatlantic phone calls were not a realistic prospect for most people, he used sound recordings to stimulate memories and provoke emotions among his friends in the San Costantino diaspora, strengthening the sense of belonging to a community divided over two locations.

The concept of community has been under substantial discussion since the 1970s. In particular, writing about the Ethiopian diaspora in the USA, Shelemay (2011) demonstrates how, in a time of mobility and cosmopolitanism, the notion of community has broken the ties with associations to a specific geographical location, and has been revisited on levels that range from the local to the global. This debate has drawn on the works of Cohen (1985) and Anderson (1983) who, in different ways, underlined the imagined and symbolically constructed character of the processes that come to define a sense of community. If community is no longer conceived of as an entity defined in space and time, it becomes then a sort of mental construction based on the sharing of symbolic and ritual elements, and of practices that include musical ones (Shelemay 2011: 358). These are crucial in the preservation of collective identities. As underlined by Turino: 'Music, dance, festivals, and other public expressive cultural practices are a primary way that people articulate the collective identities that are fundamental to forming and sustaining social groups, which are, in turn, basic to survival' (2008: 2).

Together with direct involvement in musical activities, mediatised musical and sound events play an important role in processes of identity construction, as confirmed by scholarship that examines newer contemporary digital media in addition to older analogue practices (Connell and Gibson 2003; Panagakos 2003). The importance of musical recordings for specific communities, and especially those of migrants, has been evident since the early days of phonography, when the commercial exploitation of this market was first suggested. At the beginning of the twentieth century, the North American records market was divided into ethnic catalogues and some of these exploited the strong sentimental and nostalgic involvement connected to listening to this music by explicitly targeting migrants. Ranging from Caruso to the songs played by street musicians of the main American towns (Kelly 1988; Kenney 2003; Spottswood 1992), Italian music made up a significant portion of these catalogues. Often these records would

make themselves vehicles for the diffusion of stereotypes, contribut-
ing to the creation of preconceptions as much as they were creating
communities. Many records of southern Italian music, for example,
were full of references to the Sicilian Mafia (Fugazzotto 2010). The
importance of musical practices and sound recordings for maintain-
ing identities in diasporic communities is even more crucial wherever
the connection with the country of origin is less clearly defined and
the imaginary component is more pronounced. A good example is
provided by Shelemay in her work on Syrian Jews: it is a musical
genre, the Pizmon, that is crucial to preserving a complex and hardly
definable identity such as that of the Jews from Aleppo who moved to
the USA (Shelemay 1998).

As explored below, Chiaffitella and his New York friends come
from an Arbëresh village, founded in Italy by Albanian refugees in the
sixteenth century. Theirs is a second-stage diaspora, able to preserve in
these transitions traces of both Italian and Albanian identities. Chiaf-
fitella seems fully aware of the value of his recordings whenever he
plays back music, songs and instrumental pieces, but also soundmarks
with a strong power to evoke memories of the village, such as the
church bells on a holiday. But voices are the sounds that attract him
the most: voices of known people who send greetings from a faraway
place or send messages in Arbëresh and Italian, able to provoke loving
and engaging memories in those who listen.

Voice, thanks to its connection to language, communicative and
artistic performances, and embodiment, is a complex phenomenon
examined by philosophers, anthropologists and scholars of voice
studies including Derrida, Zumthor and Ihde. Disembodied and
(decon)textualised through recording, voice can be fixed on a new
medium. In this process not only does it not lose its emotional charge,
but it also returns it amplified during acousmatic listening; it becomes
a new object, with a variety of new symbolic and evocative functions.

Sound souvenirs

The domestic and private use of technologies of recording applied
to voices addressed to distant interlocutors is as old as the heyday of
phonography. Phonographs allowing recording and playback became
available on the market at the beginning of the twentieth century. At
the time, sound recording was seen to have a future as a communica-
tion device, as talking postcards or as a support to stenography (Attali
1977: 90–96). In early twentieth century advertisements the phono-
graph was described as a talking machine. Even its inventor, Thomas
Edison, described its future uses along similar lines (quoted in The
Talking Machine News 1905: 12). The phonographic industry would

in fact have little interest for these uses; thanks to the introduction of flat disc records and the improvement of the quality of recordings, it would soon move to marketing works of music, selling the gramophone as a listening-only home appliance for pre-recorded music.

After the Second World War, recording technologies made a leap thanks to the introduction of magnetic tape, which due to its flexibility spread to professional contexts. The tape recorder, which allows both recording and playback, changed for good the way of working of recording studios, allowing experimentation and the development of new musical genres. The diffusion of experimental music laboratories, especially in Europe, bears witness to the versatility of magnetic tape supports. The new electroacoustic music produced in these centres created new compositional and aesthetic paradigms, which often used recorded voices as their favoured material (De Benedictis and Rizzardi 2000; Manning 2013: 19–98; Scaldaferri 2014a).

At the same time, tape recorders appeared on the market that were aimed at amateurs and home environments. In their user manuals, as in the adverts of the time, they were described as tools to record family voices and create sound souvenirs, which were to be the sonic equivalent of family photographs. The underlying assumption was that sound souvenirs would take a more important role than photographs because 'sounds carried more meaning than photos' (Bijsterveld and Jacobs 2009: 29).

The expression 'sound souvenir' was first introduced by Schafer to designate 'endangered sounds, such as the sounds of pre-industrial life, that could be captured by recording technologies or stored in archives, and thus remembered after their extinction' (1977: 240). It is recovered and discussed by Bijsterveld and van Dijck (2009b), for whom it takes on a different meaning: the variety of sound artefacts, recorded on various media – reel to reel tapes, cassette tapes, long-playing albums – that acquire value because they contain traces of a family or private event that is meant to be preserved. Their playback allows the listener to re-live through memory an event at which they were present, but can also acquire meaning for listeners who were absent. Once recorded, sound acquires a power of its own, able to evoke the feelings of a past event:

> It is not merely through words that people either consciously or involuntarily recall past events and emotions, but also through sound and music. These memories of past events include the sensory experiences of having listened to particular recordings and interacted and tinkered materially with the devices that play them. Audio technologies allow people to reopen such experiences … cultural practices in which people make use of audio technologies

to elicit, reconstruct, celebrate, and manage their memories, or even a past in which they did not participate. (Bijsterveld and van Dijck 2009a: 11)

During the 1950s, the tape recorder was presented as a way to stockpile family memories to be preserved in time: voices of children or elders, or bringing into the home sounds recorded outside. While gramophones and radios only allowed a passive experience of content created by others, the tape recorder allowed an active role. It could be used to record conferences or radio programmes, or one's favourite songs in a playlist always available – thus anticipating the introduction of the more convenient cassette tapes in the mid-1960s. The interaction between tape recorder and the radio left an impression on Chiaffitella, who often recorded radio songs and programmes on his tapes. In particular, in July 1969 he recorded the moon landing during a listening session with his fellow villagers, who had to keep a strict silence.

5.1 San Costantino Albanese, August 2016. Chiaffitella's recording tools: 8mm projector and camera, medium-format folding photocamera and Recordio tape recorder.

The tape recorder, though, was not able to attain success in the home-use market. It did not replicate the success of the radio, which became a feature of most home furnishings, or of the television, which in some ways replaced the fireplace. In their analysis, Bijsterveld and

Jacobs (2009) show how one of the reasons the tape recorder never became a mass commodity was its inability to find a specific location in the home, having to shift from one place to the next and ending up set aside. At the same time, they show how the analogy with the family photo album had been overstated, mainly because of the different modes of fruition: playing back tape requires competence and time, unlike browsing photos.

These supposed weaknesses of the tape recorder are what made it fit for the use that Chiaffitella had in mind. A lover of technology, he had no problems handling the fragile magnetic tapes or storing them in an appropriate manner. Perhaps precisely because the tape recorder had no designated place in the home, Chiaffitella felt encouraged to take it on his transoceanic journeys, together with the voltage adapters he needed in the two continents. His Recordio machine, bought in the USA in the mid-1950s, travelled multiple times on the New York–Naples ship route, before ending up, after his death, in an attic in San Costantino, with other unwanted objects.

Setting up the tape reels for the recording, and especially in order to listen back to them in group sessions, were for Chiaffitella ceremonial moments, with their own gestures and timings. These were ritual moments, requiring silence and concentration, with a solemnity that was alien to a photographic album. The voices and the sounds that entered and left the machine acquired an interpersonal and collective value. Chiaffitella's sound souvenirs supported the preservation of a collective memory, which was always rich in linguistic, historic and imaginative implications (Halbwachs 1992).

Identity on the move

Chiaffitella's biography is part of the massive flux of Italian migration towards New York and the American continent. He came from an Arbëresh village, though, and maintained traces of its complex history in the USA. There, the Arbëresh call themselves *Albanesi*, using the Italian term for Albanians (Renoff et al. 1989), which is distinct from *Shqiptar*, used in Albanian to refer to people coming from the Albanian nation, as if to retain a trace of both identities that make up their heritage and at the same time to state their distinctiveness. In Italy, the Arbëresh villages have preserved for five centuries an identity in which language plays a crucial role, along with specific oral traditions, Catholic faith of Byzantine Rite, costumes and music (Ahmedaja 2001). Even though the official language studied in school is Italian, the Arbëresh language has been preserved in everyday practice but with frequent linguistic loans. Only in 1999, in Italy, did a law on the safeguarding of linguistic minorities put in place measures aimed at its

protection. The Arbëresh villages of the mountains of southern Italy have shared the same poverty and marginality of their neighbours, including the mass migration towards America. During the 1920s, the time when Chiaffitella was settling in the USA, San Costantino Albanese had about 1500 residents, who today are less than half this number due to outgoing migration.

New Jersey and in particular the New York area were one of the main targets of Arbëresh migration. Some blocks in Jersey City or Brooklyn at the beginning of the twentieth century were entirely populated by Arbëresh, who intermarried and referred to their community with the term *katund* (village). Still today, as became evident during research visits made during the 2010s to the American descendants and friends of Chiaffitella, they hold gatherings, dance to traditional musical instruments and prepare characteristic food, such as the *kulaçi* or Easter bread – now more commonly baked for Thanksgiving. In Chiaffitella's American photographs there are often celebrations and traditional costumes. He often appears as a member of the *Coro d'Italia* with an Arbëresh outfit. The recordings echo a trace of the two diasporas in the constant use of three languages, depending on the familiarity of the speakers or intended audience: English, Italian or Arbëresh. Chiaffitella translates as much as he can, constantly trying to make everything understandable for everyone.

The Arbëresh language is handed down mainly through oral tradition, and its literature, though important, was the domain of a small class of intellectuals. Furthermore, its oral tradition is steeped in a system of versification connected to rhythmic formulas, that relies on forms of embodiment (Scaldaferri 2014b). These characteristics, as will become apparent, also echo in some of Chiaffitella's recordings.

Nouns and verbs referring to technology, absent in Arbëresh, are often Italian loans or neologisms whose semantic nuances can reveal cognitive mechanisms and contain specific cultural references. For the action of sound recording, especially of voices and songs, the verb used is *marr*, which means to take, grab, but also to learn. *Marr* is also used to explicitly refer to learning by heart a song on the basis of listening, with a process of mouth-to-ear transmission typical of oral tradition. The expression *marr vesh*, literally 'taking by ear', is also common, with the meaning of listening with extreme attention and obeying, memorising a command from which one cannot be exempted.

In the lexicon and imaginary of the people who first know the 'marvel' of the tape recorder, gestures not yet consolidated in use are given meaning by first connecting them to more familiar actions that are considered to be related. The innermost meaning of the action of recording voice is assimilated to learning, implying a humanisation of the machine. The recorder is an ear that learns something to then

repeat it, as a person would after having listened closely to a song to make it available in another place and time. In this sense, Chiaffitella's tape recorder became for his fellow villagers a sort of friendly interlocutor to whom one could teach things. For those who were older and less familiar with technology recording was more than a mechanical process, to the point that they would address the machine using the parameters of teaching within oral tradition. The disembodied voice was entrusted to a new body, with almost human characteristics, which 'took' the voice and preserved it on the journey to make it resound again in front of the addressee.

Such instances of proximity between humanity and machine emerge from Chiaffitella's tapes, together with the awareness, shared by the people he recorded, of the uniqueness of the recording experience. As we will see in the next paragraph, Chiaffitella's trust in the contribution of technology to the preservation of the memories and identity of a community also emerges, especially thanks to the use of recorded voice and the emotions it can provoke.

'As my voice will come to America, I wish I could come there too'

Group recording and listening sessions are moments with an intense ritual value. They create a sense of community around the tape recorder, perceived as an object capable of creating connections that go beyond spatial and temporal barriers. An emblematic example is a tape from a recording session carrying the handwritten label 'The voice of the relatives and friends of San Costantino Albanese – to their loved ones in America, year 1958'. Chiaffitella had invited into his home and gathered around the tape recorder some of those who had relatives in America. Using different languages – Arbëresh, English or Italian – depending on the interlocutors, Chiaffitella played an authoritative role of master of ceremonies. He provided an introduction to the message of each guest, and his words betrayed a sense of wonder about the possibility of owning a machine able to record the voice and allow it to travel across the ocean.

> With this tape recording machine, we are sure living in a marvellous age, when even if we are separated from our friends and relatives by a great distance … you will have the great pleasure of hearing the voice of your relatives. And now I will talk in Albanian: I wish I could know what your heart is going to feel when you hear the voices of these relatives you left behind among the mountains of S. Costantino many years ago. Heaven knows how much they'd like to tell you, and how much they'd like to thank you for all that you've done for them.

The tone of the messages recorded on this occasion varies depending on the age and experience of those present; these variations reveal different levels of awareness of the function of the medium. Among the recordings is a message by the brothers Andrea and Franco Schillizzi, then just over twenty years old. They greet their far-away relatives with enthusiasm, expressing – as Chiaffitella had done – their amazement at the device that allows the voice and its emotional charge to travel, and gives listeners the sensation of having their relatives right beside them when they hear their voices. Note how the brothers switch to the Italian language (italicised in the translation) to emphasise their enthusiasm for the new technology:

> I am your nephew Franco, and just as my voice will come to America, I wish I could come there too; *we thank* uncle Peppino for bringing *our beautiful voices* to you in America, where you can hear it *in all comfort*, as if we were next to you.

> I am your nephew Andrea, and I thank uncle Peppino who has been so clever and has brought from America *this marvellous thing* that lets you listen to our voices.

The recording session opens, however, with a heart-rending message: the greeting of the old miller, *ce Dhurana* – Dorina Abitante – to her daughter Maria, who departed to America thirty years before with part of the family. Because the old woman is addressing a daughter she has neither seen nor heard since the day of her departure, she performs a ritual lament that closely follows the melodic modes and formulations of a funeral lament (*vajtim*). *Ce Dhurana* lists the names of their relatives, uses interjections and ritual expressions: all markers of the structure of the funeral lament carefully identified around the same time by De Martino (1958):

> O my Maria / what are you doing now / how I wish I could see you, my daughter / how is Giuseppe, my daughter / and Antonio, how is Antonio / and how is his wife / and how is Celestina / and how is little Giuseppe / Pietro, how is he my daughter / how I wish I could see you, my daughter / my daughter, how is Stella / my sister / how are all our relatives, oh my daughter / and we here are all well o my daughter / because they all love me, and I keep going / my daughter, the many things you sent me / you supported me with sweets, my daughter / o my heart, o my daughter / Maria I thank you for all the grace Christ gives me / so many years you've been away / and I wish much peace to you and your sons.

The funereal atmosphere of this song is perhaps especially apparent to a contemporary listener who, with hindsight, is able to grasp the tragic

138

proportions taken by mass emigration to North and South America in the first decades of the twentieth century (Baily 2004; Gabaccia 2003).

In the imagination and spoken practice of the inhabitants of San Costantino, as is the case with many towns and villages that have experienced transatlantic emigration to the US, 'America' (*Merka*) was the land of well-being by definition, a place where one went to make one's fortune. From there, one could gain an income that would support the family, all the while keeping up hope of going back home one day. It is worth noting that the help was often in the form of small symbolic tokens, like the sweets that *ce Dhurana* occasionally received from her daughter via Chiaffitella. There existed, however, also a complementary and opposite vision of America: the *America sperduta* (America of the lost), or *America disgraziata* (unfortunate America), where emigrants who gave no further news of themselves were said to have disappeared, whether because they had died, or because, having failed to make a fortune, they were too ashamed to keep in touch.

In rural society the metrical structuring of vocal expression could accompany not only the event of a funeral, but also traumatic moments of separation like a bride's goodbye to her parents, or a mother's goodbye to a conscripted son. The discipline of rhythm and melody was to serve as a means of controlling emotion and keeping composure while publicly expressing one's feelings, a means of banishing the risks of the phenomenon that De Martino termed 'crisis of presence' (1958: 126, 2012). For *ce Dhurana* the message to her daughter is not a personal emotional outburst but a greeting to be performed in public, in front of Chiaffitella and her other relatives. Therefore, she could only express herself by adopting a ritual form, recalling stereotypical formulas well worn by tradition.

Besides, this greeting was also to be entrusted to someone who would then pass it on to her daughter. Her greeting was to be 'taken', in the sense we explored earlier, so as to be reproduced later. For the illiterate generation, a text could be better memorised by an external subject if it was metrically formalised. As highlighted by early research on orality and literacy, the better a text is organised in verses, the more easily it will be memorised and reproduced (Ong 1982: 33–6). For the old miller, it is the metrical structure of the song that will allow it to extend itself beyond the individual performance. Verses and song-form allow the message to be easily learned by either a human ear or a machine that is listening and memorising; the content of the performance may then be reproduced later in front of the intended final recipient.

After *ce Dhurana*'s lament, Chiaffitella likely sensed that the remaining messages, especially those from female guests, were running the risk of turning into a series of formal lamentations; in passing the microphone to the next guest, he asks her pre-emptively not to sing any laments (*mos bëni bir birò!*) and to limit herself to a few words of

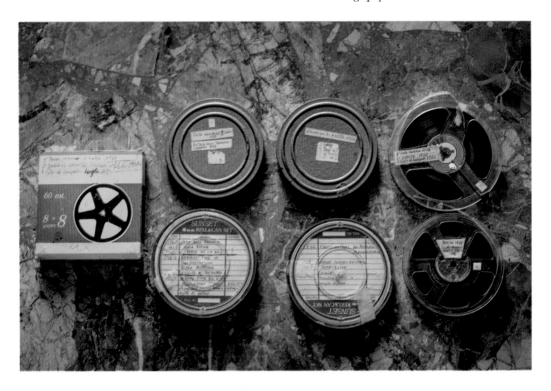

5.2 San Costantino Albanese, August 2016. Some of Chiaffitella's tapes and 8mm reels with labels in his own handwriting.

greeting. His sister-in-law obeys and does not intone a lament, but she does address the tape recorder as if she were communicating with 'something' that joined the recording apparatus to the distant figure of Maria. She thus begins by saying '*Nimirenj me Marien dopo trent'anni*' (I speak again with Maria *after thirty years*). Like the Schillizzi brothers, Chiaffitella's sister-in-law also uses a few Italian words in her message. She seems to do so in order to emphasise the special occasion that is the recording session, but also to hint at the foreignness of this machine that 'takes' her culture and language.

The laughter of Fiorina

The tape recorded in San Costantino in 1958 – which begins with the lament of the old miller – can be put side by side with one labelled 'The famous laughter of Fiorina Calimano, Brooklyn US 1960'. It was recorded while Chiaffitella was in Brooklyn, having dinner at the house of the emigrant couple Fiorina and Nicodemo, so as to listen with them to the tapes recorded in the village, and then record new greetings to take back there on his next trip. Faced with the tape recorder, Fiorina could only burst into uncontrollable laughter – which then gave the title to the tape – as if, in the absence of a guiding social

140

context, she were unable to keep her emotions in check. Nicodemo used instead a more traditional and rigorous mode of address in order to speak to the distant fellow villagers: a metrically formalised text. This was not, however, a lament – which is a predominantly female form – but a poem (*një këngë*) in which he expressed his gratitude towards Chiaffitella for this wonderful experience. Here we are probably dealing with a nostalgic reprise of a social practice common in Nicodemo's youth: that of formulaic verse greetings shared among villagers. As is clear from Nicodemo's recorded command to the recorder – '*thuaj*' (you must tell) – he humanises the artificial ear that is to 'take' his verses and later sound forth his greeting.

> You must tell them: this is the song that Nicodemo told / because I like that village so much / but I am too far away and cannot go / but tonight I have dear Peppino as my guest / and he's making merry with us / may the Lord grant him every wish / now and for a thousand years / you must be merry when he comes to the village / because he spends his whole life in merriment / be careful / and don't bother him / hearten him and have fun / because he will get you to know the world.

'The song that will forever remain in the history of our village'

Tapes and recorders are media whose use can serve different purposes. The years in which Chiaffitella makes use of his tape recorder are the same that mark the scholarly 'discovery' of Italian traditional music through field research, thanks to the CNSMP and the *Accademia di Santa Cecilia*. Researchers from these institutions, with the use of tape recorders, captured the musical practices of rural Italy. A decisive moment is represented by De Martino and Carpitella's trips (Giuriati 1995; Magrini 1994), as well as Alan Lomax's Italian journey between 1954 and 1955 (Lomax 2008), partly accompanied by Carpitella, and the resulting publication of two LPs on Italian music in the Columbia World Library of Folk and Primitive Music series. The records include a selection of songs of the Arbëresh, called *Albanians* and recorded by Carpitella and De Martino in 1954 (Lomax 1956). On that occasion the two scholars recorded twelve songs, capturing on tape for the first time the musical traditions of San Costantino Albanese (Scaldaferri 1994).

Chiaffitella often recorded music and traditional Arbëresh or Italian songs; sometimes he would even sing in them. In his recordings, he shows a clear intent to give a sense of the event where the song is being performed and the meanings it assumes from that context. He

would also decide to point his microphone on sound events from the local soundscape, if they had a specific evocative value. This was the case with the festive church bells, a soundmark whose importance had already been acknowledged by Schafer:

> The most salient sound signal in the Christian community is the church bell. In a very real sense it defines the community, for the parish is an acoustic space, circumscribed by the range of the church bell. The church bell is a centripetal sound; it attracts and unifies the community in a social sense, just as it draws man and God together. (1977: 54)

On the other hand, the ethnomusicologists who worked in Basilicata at the time would instead focus on the capture of a 'musical document', almost removed from its context, in order to analyse its stylistic and structural characteristics. This process of removal is evident in the comparison between the records published alongside their research, and their unedited tapes, which often preserve traces of the context and of the interaction between musicians and researchers (Agamennone 2015).

Chiaffitella is motivated by different aims, and he conceives of the recording technology as a means to evoke feelings. His interest is never for the specific musical piece on its own, but in the event as a whole and in the network of relationships and affects that make it meaningful. So he never records songs isolated from their context – they are inserted in a continuous stream of conversations; they are introduced and commented on, in a sort of dialogue, with singers and musicians. Such an approach, though springing from motivations that are far from scholarly, makes his recordings essential to understanding the extent of social relationships on which musical practices always rest (Small 1998; Turino 2008).

In addition to recording private events with the purpose of creating sound souvenirs for distant friends, Chiaffitella also recorded important collective events in San Costantino. In these moments he had an awareness of creating a 'monument' of the event through sound, making it part of cultural heritage as a memory that would make the past audible for the next generations. This awareness emerges in a tape labelled 'The traditional song of the *valle* of the Albanians, sung by the women in their dazzling costumes. Recorded on Easter Monday 1957'. The *valle* or *vallja* is an important ritual that used to take place every year and involved dancing and singing. A group of women, dressed in festive costumes and led by some men, would walk the streets of the village for hours, singing with a timing synced to their dance steps.

The lyrics sung on that occasion are one of the mainstays of Arbëresh poetic tradition: the story of *Kostandin* and *Jurendina* tells of the dead

man who rises from his grave to keep a promise. It's the myth of the *besa*, the promise to keep at any cost, which has its roots in Balkan epics and is present in all Arbëresh villages. Chiaffitella's recording, at about eighteen minutes in duration, represents the first complete version of this song, which includes antiphonal singing with two alternating groups of women. Recordings of similar performances of the *vallja* by researchers – including De Martino and Carpitella – are limited to fragments of the duration of a few minutes, perhaps due to a lack of awareness of the value of this song, or due to the cost of the tape.

The importance for Chiaffitella of the ritual of the *vallja* of Easter 1957 is clear from the fact that he dedicates a whole tape to it, without worrying about durations. During the dancing phases of the *vallja*, out in the streets, Chiaffitella followed the group and took pictures. Once the dance was over, he invited the women to his house and put them in front of the tape recorder, asking them to perform the song, which was recorded in its entirety, or more precisely for the whole duration of the tape.

The recording session is opened by an emotional and solemn introduction in which Chiaffitella voices the importance of the moment. The recording this time is not just something addressed to friends and relatives in the US, but to all those who in the future will be able to

5.3 San Costantino Albanese, January 2020. The door of the dressing rooms of the football pitch sponsored by Chiaffitella, reading 'Zio (Uncle) Peppe 1947'

143

listen to the tape and imagine the intensity of that moment. He even asks each singer to tell their name – which they do with some embarrassment – as if to give each component of the group an individual identity.

> Today is Easter Monday, year 1957. It is a day we will all remember because today, my heart tells me, this is perhaps the last *vallja*. *Valljas* that for years have cheered up this beautiful village, and when one day we'll listen to these voices and these songs, our heart will sigh for the songs of today. So I'd like you to sing the song you did *Ka Konget* [village location], the song that will forever remain in the history of our village [clapping]. These women who take part in the *vallja*, you who listen, I wish you could see what a beautiful *vallja*, these women with *keza* and *çofa* [parts of the headdress of a married woman], their shirts all ironed and embroidered. Now you'll hear the names of these women here present. Let's start from my wife. What is your name? [each woman tells her name] Now sing the most beautiful song you ever performed in my house, the song of the *vallja* of Kostandin.

Rural southern Italy during the 1950s was a context in motion. The years of post-war and the economic boom brought much change in small villages, including the Arbëresh ones. Chiaffitella probably had a sense of the incoming change, being an attentive traveller who had had a chance to visit the village periodically and see the broader Italian context from the vantage point of his experience of a migrant worker. Some of these same feelings pushed some researchers to practice urgent ethnography, gathering and documenting traces of Italy's rural ways of life that were thought to be about to be lost for good.

From the testimonies of the elders of San Costantino emerges how the ritual of the *vallja* of 1957, today audible in Chiaffitella's recordings and visible in his photographs, was in fact the last performance in its itinerant format, as a ritual in which the inhabitants took to the streets to reinforce their ties with the place, in the name of *besa*. The village, struck by poverty, was in the midst of different forms of emigration, this time towards Europe and northern Italy, and was abandoning many of its cultural practices. These would be recovered decades later, in decontextualised and spectacularised forms, in the frame of folkloric festivals with a nostalgic angle, as part of processes of heritagisation.

A loyal companion

In 2015 Stella Scutari, the relative who took care of Chiaffitella during the final years of his life, found a box in her attic with about two hundred film negatives made by Chiaffitella, which enlarged the

existing archive of dozens of photographic prints. In this archive there are images that echo the situations portrayed by De Martino's photographers, together with photos of friends and social occasions in the USA. Often Chiaffitella himself appears in the photographs, asking his friends and relatives to take the shot. These photos highlight his active role in the events he recorded, where he is sometimes among the singers. The discovery of these negatives confirms the long span of his activity as a photographer – all his adult years, including the time he spent in the US – compared with his relatively brief use of the tape recorder – between the end of the 1950s and the 1960s.

In the box were a group of colour negatives shot in June 1957 in San Costantino, on the day of Stella's wedding, of whose existence she was unaware. In what are likely to be the first colour photographs ever shot in the village, Chiaffitella portrays the bride and groom, relatives and friends, plus the women in their festive 'dazzling' costumes – finally rendered in colour. The choice of colour marked a special occasion in honour of Stella, who would take care of him at the end of his life and would become his heir.

The biggest surprise, though, came the following year, when in one of the tapes, unlabelled and wound backwards as if to keep its

5.4 San Costantino Albanese, August 2019. Stella Scutari holds a photograph of herself on the day of her wedding, shot in 1957 by Giuseppe Chiaffitella.

content hidden, was found a recording from the wedding. The day after the wedding the newlyweds held a more intimate reception for close friends and relatives in their home. Chiaffitella brought his recorder, to capture the voices of those in attendance. The content of this tape remained unknown to everyone until 2016, when it was digitised and Stella could listen to the voices of people who had passed away decades before. The tape acquired the value of a resonant tomb (Sterne 2003: chapter 6), able to provoke strong emotions. Chiaffitella had recorded the voices of the people he had portrayed in colour the day before, perhaps aware that sound could transmit more meaning than a photograph.

It is telling to remark how this is the only case in which Chiaffitella, even though he shot colour images and recorded voices, did not share any photographic prints with the subjects, as if the images had been for private use only. Before playing a role in the building of a sense of community among his fellow villagers, sound souvenirs and photographs probably answered a personal need to build and maintain in his memory a network of loved ones. After the death of their son, Chiaffitella's wife continued to live in Italy. The couple were reunited for only a few years when Chiaffitella settled back in the village and dedicated his old age to supporting young people, for whom he sponsored the building of a football pitch. In many ways Chiaffitella did not have a family of his own. His affects were split between a wife who lived in Italy and a circle of friends living in places a two-week ship journey away. Evocative voices and images were for him, then, primarily useful to rekindle a sense of identity, before they performed the same function for friends and fellow villagers. He was always the first listener, since the moment he used the tape recorder. His need to feel part of a community was played out through mediatised memories, that were able to evoke meaningful emotions. He would listen to his recordings in private, especially those that did not need a label because they were not made to be shared with others.

If his friends were already anthropomorphising the tape recorder, teaching it to repeat correctly their greetings, Chiaffitella saw in the machine something more, a loyal companion, carried along from one end of the world to the other, across land and sea, always ready to incite a chain reaction of emotions and give a sense to his individual identity.

Conclusion

Dealing with archival sound recordings, as I did in this chapter, offers an opportunity to explore in other ways the function of listening as a research method. During ethnographic fieldwork, listening to the field is the initial source of knowledge; the sounds we record, and

later listen to, constitute a memory of our experience in the field. In the case of sound archives, listening to them is not connected with a personal experience in the field; we know sounds recorded in the past only in their mediatised form. Listening to these recordings requires a comparison and completion with other materials and documents to reconstruct and imagine their context of origin. Listening is the starting point of a research which requires complementary information and documents.

The journey through Chiaffitella's materials represents an archival sonic ethnography; listening to the sounds fixed on tape, combined with his photos, historical documents and other information, provides a valuable perspective on the role of sound recordings and listening in building and sustaining a sense of identity (Panopoulos 2015). Moreover, as archival material, tapes and other objects involved in these processes constitute boundary objects (McMurray 2015: 265) whose importance and functions exceed their primary intended purposes as a medium, making of them objects of affection but also cultural objects at large.

Chiaffitella's recordings help us understand how recorded voices can be attributed social value, how they derive from negotiations between recordist and recorded person, and what functions and meanings they acquire once in their mediatised form. Group identity in a diasporic context is maintained also thanks to the existence of listening communities, whose connections are not only imagined and symbolically constructed, but also built over time thanks to recording and listening practices.

Following three pages: a selection of prints, negatives and writings from the archives of Giuseppe Chiaffitella

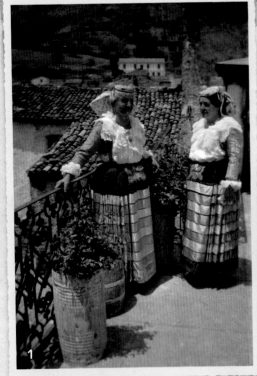

Gt. Barrington - 30.7.48

Scritto esclusivamente
 per la gioventù sportiva del
 nostro paese.
 Un cordialissimo saluto da chi vi ricorda
spesso di voi, e di quelli che nel 47 dettero
opera, e denaro, nella speranza di poter
dare finalmente al nostro paese un
"Campo Sportivo" - che a secondo le ambizio-
ne di allora doveva essere il più
bello in quella Il 47, e l'ora memorabile
Ebbene → per tanto della nascita del "Campo S."
sogno non si pote
secondo me
Uno dei ostacoli

malgrado quel che mi
raccontano sul tuo
riguardo - Lo scrivente
non potrà mai dimenticare
il tuo spirito d'incoraggia-
mente offertomi per questa
sportiva impresa
Fatemi sperare - che il figgir

tempesta
natura - piano

1961

Dal amico
Peppino

esclusivamente alla vostra
tiva - dove la politica, è e

CORO D'ITALIA

SANDRO BENELLI, *Director*

Casa Italiana Columbia University

117th Street and Amsterdam Ave., New York

Group _____ Name _____

...ments to the president of the group...
...dollar ($1.00) for which the member receives a
...opy of the by-laws, music and instruction in choral
...ng.

...OF CORO D'ITALIA IS TO ACQUAINT THE AMERICAN
PUBLIC WITH THE COLORFUL FOLK COSTUMES AND DANCES OF ITALY AS WELL
AS ITS SONGS. MEMBERS ARE REQUESTED TO PROVIDE THEMSELVES WITH AUTHEN-
TIC COSTUMES AND TO LEARN THE DANCES.

5.5 (*Previous spread, left*)
1. Chiaffitella's wife Maria (right) and her friend Domenica Cortese dressed in the traditional Arbëresh festive costume.

2. Boys at the football pitch.

3. The slaughter of a pig in the winter.

4. Easter Monday, 22 April 1957. Women in festive costume perform the *vallja* in the streets of the village. Shortly thereafter they will move to the house of Chiaffitella to record the song on tape.

Background: Letter with thoughts on the blues.

5.6 (*Previous spread, right*)
1. View of San Costantino Albanese.

2. "The memorable time of the birth of the football pitch", sent to his friend Salvatore D'Amato, 1947.

3. Photo souvenir sent to his neighbours Lorenzo and Rosa Scaldaferri, 1961. Handwritten: 'From your friend Peppino'.

4. Chiaffitella's wife Maria (right), in Arbëresh daily clothes, with workers in a field during harvest.

Background: Letter to the young sportsmen of San Costantino, 1948.

5.7 (*Facing*)
1. Chiaffitella singing in the USA for his distant friends in Italy. Handwriting: 'How unhappy I am, away from you my friends. But if one day I'll see you again, I will sing for joy'.

2. Studio portrait autographed 'My best souvenir': Chiaffitella, his wife Maria and their infant son Salvatore, born in the USA. 5 September 1930, shortly before mother and son moved back to San Costantino.

3. Chiaffitella travelling.

Background: Inside cover of his personal songbook as a member of *Coro d'Italia* choir.

Sound-chapter 5 – *Memories from a loyal companion*

This sound-chapter uses Chiaffitella's recordings from 1957–62 to create a narrative inspired by the pioneering compositional experiences of radio documentaries and electroacoustic music, which often revolved around recorded voices. Chiaffitella's own voice, which speaks in three different languages – English, Italian and Arbëresh – acts as a leitmotif. This main thread is woven with other voices in a plurality of moods and expressive registers, as well as with instrumental music.

DOING RESEARCH IN SOUND: MUSIC-MAKING AS CREATIVE INTERVENTION

Nicola Scaldaferri

This chapter is centred on my research into sound identities and musical practices in Basilicata, which started at the end of the 1980s. Ever since, I have used performing music as a form of research by way of active participation as a musician in the local scene. Performance-based research has a long history within ethnomusicology (Cottrell 2007). One of its most famous formulations is found in the concept of bimusicality proposed by Mantle Hood, who considered musical practice a privileged way to approach a foreign musical culture (1960). As a native researcher, my case has been characterised by a shifting positionality, constantly moving between musical activity as an insider musician and academic reflection addressed to an audience of outsiders. Doing research in sound has meant that listening, playing and researching have been interconnected actions taking place within a sonic environment that I helped to create as a performer.

During my fieldwork in Basilicata, my activity as a musician, and specifically as a *zampogna* player, represented a constant opportunity to interact and have a dialogue with local musicians and through them with the local communities. Research then became synonymous with constant participation – musically active and intellectually alert – in religious festivals, pilgrimages and collective rituals. As analysed in a variety of contexts in this volume, these forms of sociality often represent the main opportunities to observe musical practices and intense sonic involvement beyond the specificities of their religious implications.

Such a methodology requires first of all a performative conception of research, especially in its fieldwork phase, as underlined by Turner (1986). At the same time, it fits within recent debates on the inter-penetration between artistic and ethnographic practices. The reasons for this convergence arose as anthropologists redefined their research methods, experimenting with forms of ethnographic representation and abandoning the myth of the ethnographic encounter as the

foundational moment of the discipline; at the same time, on the other front, many artists expressed a need for detailed studies, field research and interdisciplinary dialogue on methods and content (Foster 1995; Marcus 2010; Rutten et al. 2013).

Similarly, my research involved interdisciplinary collaborations with anthropologists, artists, filmmakers and photographers, generating multiple outcomes, including books, concerts and performances, as well as mixed-media installations. From 2005, these activities took place under the wing of LEAV – the Ethnomusicology and Visual Anthropology Lab at the University of Milan.[1] The laboratory was set up in collaboration with a number of colleagues (Elisa Piria, Lorenzo Ferrarini and Tommaso Vitali) and was inspired by conversations with Steven Feld over a long period. From its foundation, LEAV was intended to be a place for experimenting with different media and for developing dissemination strategies that would be refined through teaching. Most of the materials produced by LEAV have taken the form of short books incorporating a high-quality sound component – often a CD – and a photographic section (see for example Scaldaferri 2005; Scaldaferri and Feld 2019; Scaldaferri and Vaja 2006). This format has involved balancing the textual, photographic and sonic components, with due attention given not just to technical quality but also to aesthetic considerations, all with a view to developing polyphonic narratives in which diverse forms of representation can find a synergy. A key precondition was the decentralisation of writing and the increasing diffusion of theories and practices testing the role of sensoriality (Cox et al. 2016; Schneider and Wright 2010).

Researchers focussing on musical practices and cultures, though, developed much earlier collaborative practices and digressions towards art. Moreover, since the beginnings of ethnomusicology, the study of non-Western and folk music has required the adoption of systems of sound recording in order to delimit an object of study in its materiality. This created a proximity with recording technologies that remains central and opened the door for further developments in the field of multimedia.

The foundational experience of Béla Bartók at the beginning of the twentieth century shows a synergy between his studies of Hungarian folk music and his activity as composer; more specifically, the latter stimulated his research and became a way to make a creative use of its results. Cases such as Bartók's were frequent, though not very often analysed in scholarly discourse, and suggest how in its heyday ethnomusicology was quite 'fluid' in methods and practices. Later on, the discipline became more consolidated, thanks to the influence of historic musicology and anthropology, which had more academic seniority and prestige.

Simha Arom's (1991) study of African polyphonies at the beginning of the 1970s is a good example of research employing active intervention during fieldwork, re-drawing the relationships between researcher and 'informant' through a dialogue revolving around the production of musical sounds. Arom, who had a background as a high-level classical musician before becoming a researcher, aimed at understanding and translating according to European musical categories the rhythmic models that musicians have in mind when they execute complex polyrhythmic music. In order to achieve this result and 'separate' the complex rhythmic parts played by a percussion ensemble in the Central African rainforest, he used techniques normally used in recording studios, such as overdubbing and playback, training musicians to perform for re-recording. Thanks to the centrality of sound, this method altered significantly the relationship between scholar and musicians involved in the research, who thus become 'true scientific collaborators' (Arom 1976: 495) with an active and conscious role.

Arom's ultimate aim was the creation of a musical transcription or score, similar to that which a hypothetical composer would have written in a Western music context. Composers such as György Ligeti and Luciano Berio were fascinated by his ideas well before Africanists, and adapted some elements of his work to their compositions. A strategy such as Arom's is far removed from the idea of fieldwork as gathering of 'documents', which could be defined as a real 'documentary prejudice' (Scaldaferri 2014b: 2). Rather, recording introduces factors of subjectivity and choice that end up giving an authorial role to the person who records the performance, sometimes creating a relationship that resembles that between a composer and their favourite interpreters (Scaldaferri 2018).

Recently, Steven Feld underlined Arom's pioneering role in creating collaborations in sound and in introducing 'new knowledge about African music, and new possibilities for listening to it' (Feld 2015b: 91). Feld, who made dialogue and collaboration central features of his own work, is also an active musician and has been experimenting with recording technology throughout his career. Recording and playback technologies informed his landmark research on Kaluli – including compositional techniques and re-recording, especially in the making of the filmic version of *Voices of the Rainforest* (Feld et al. 2019). His research in Ghana (2012), on the other hand, received important input from his musical activity with Accra musicians, which resulted in performances and record productions (Accra Trane Station 2007a, 2007b; Annan 2008).

The examples mentioned above represent some pathbreaking experiences in the introduction of new research and fieldwork methods of sonic intervention as well as new ways of listening to musical practices.

It is perhaps not by chance that they come from researchers whose experience of music-making intersected with technological experimentation. As proved true in my own experience, joining intellectual interests with first-hand practice created fertile ground for creative experimentalism.

Provoking in sound

Ever since I was a teenager, in parallel with classical musical studies I have played *zampogna*, a musical instrument that has appeared in a number of the previous chapters thanks to its widespread diffusion in rural Basilicata. A *zampogna* can be manufactured in different sizes, from small instruments around 50cm in length to those beyond 160cm. They are made of four pipes – two chanters and two drones – with double reeds, inserted in a single wooden block and oriented towards the ground. The bag is made out of a whole goatskin, which is so recognisable that in some areas the instrument is called 'the sounding goat', an expression that some scholars have picked up in the title of their works (Lortat-Jacob 1984; Ricci and Tucci 2004). In some areas the *zampogna* is called '*i suoni*' (the sounds), which exemplifies its status as musical instrument *par excellence* but also suggests the substantial aural impact that it has in local perceptions. A *zampogna* is capable of dominating the soundscape, and its frequent use in festivals, pilgrimages and other moments of socialisation make it particularly suited to creating a sense of sonic community, understood in a sense similar to that suggested by Schafer (1977: 214). It can bring people together and control the movements of dancers but also of other musicians, who have to adapt to its key and to its volume (see chapter 3). Some *zampogna* players love playing while walking, in open spaces or through the streets of a village, interacting with the place, testing the resonance of the walls. Some love playing in narrow alleys, getting close to the walls, or aim the pipes into cavities to maximise resonances. Antonio Forastiero, among the best players and builders in Basilicata, was fond of playing in the woods, especially inside a hollow tree, as seen in Rossella Schillaci's documentary (2005). Pasquale Ciancia, my *zampogna* teacher, during his final years had become very introverted and played in his house only, making it resonate as a huge sounding box and projecting his sound to the whole neighbourhood.

Listening and the materiality of sound are crucial elements of the way music for *zampogna* is transmitted from master to disciple. Music is learned through imitation, without forms of explicit teaching, and pupils learn through being exposed to the performances of their teachers. They have to 'absorb' from the observation of gestures, listening carefully and committing to memory rhythms and melodies,

which are not visualised or transcribed. This transmission process is found in many musical cultures, and is defined by Timothy Rice in his study on Bulgarian *gaidar* Kostadin Varimezov as a 'learned but not taught' tradition (1994: 65). In their jargon, Lucanian *zampogna* players often say '*facenno e mbaranno*' (learning by doing) to refer to this type of education.

The way the sound of a *zampogna* tends to fill the surrounding space has played a role since my first involvement in field research, in 1990, when I was a student at the conservatory. I was part of a team of scholars from the University of Basilicata led by Francesco Giannattasio research-ing the musical traditions of the Arbëresh villages of the Sarmento valley (San Paolo Albanese and my home village of San Costantino Albanese). My role was supposed to be of native research assistant, but soon trans-formed into that of musician, since at that time I was the only active player in the area. Some important singers had stopped performing due to the lack of players, and my role became fundamental to creating a situation in which they could perform. In *a zampogna* singing the instrument is not just an accompaniment but acts as a provocation for

6.1 Accettura, May 2005. Scaldaferri playing for a singer during the *Maggio* festival.

the singer. Its volume and piercing timbre create a dense soundwall that demands of the singer their best effort, sparking an almost aggressive reaction. In order to break through the soundwall created by the four double reeds, a singer's voice has to be powerful and sharp, engaging in a very physical duel that is not within everyone's reach. It is an almost shouted singing style, somewhat liberating. In many Arbëresh villages it is called '*shtie një voxh*' (to throw a voice). It is characterised by 'tumbling strains', which in Sachs's classic definition (1961: chapter 5) are descendent melodic movements starting from high-pitched loud sounds, following the dynamics of a shout. The sound of a *zampogna* can provoke shouted interjections that are present already in Carpitella's recordings from the 1950s (Adamo 2013: CD 3).

The deep connection between performers during *a zampogna* singing can be perceived in their posture: the singer, positioning a hand by the side of the mouth as if to direct the voice, 'throws' the song towards the player, almost as a 'sound challenge'. Alternatively, singer and player can perform side by side directing their sounds to a third element. Melodies and songs are mostly improvised, so singer and player have to listen carefully to each other to be able to interact, and when this is successful a sort of timbrical fusion takes place at the end of a song. The relationship between singer and player has a character of totalising challenge, which creates an intimate proximity that is nonetheless externalised in public for its volume and extension in space. The relationship happening in that moment becomes a priority, and everything else becomes secondary – including the notion that the player is also a researcher.

It was thanks to my experiences as a musician during that research in the 1990s that I learned a different way to listen to the musical performance. I acquired an awareness of establishing a deep connection in sound with other performers, creating an event that implicitly becomes a form of control of acoustic space. In particular, observing my colleagues and trying to fit their research strategies and their expectations through my playing generated an awareness that became the basis for the research that I developed in Basilicata ten years later. Here, I had a *zampogna* constantly by my side in order to encourage singers and players, and to revitalise musical repertoires that were being neglected. In many situations I used as an instigation an old *zampogna* by famous builder Carmine Trimarco (1864–1952), considered by some the Stradivari of *zampogna* makers. The same instrument was heard on the recordings from the 1950s that I used for playback sessions. Listening to old recordings always provoked strong emotions, especially among those who would hear deceased family members.

During public events and festivals, when I needed to juggle the roles of player and filmmaker or interviewer, I needed to plan accurately

when to shift roles, especially if I was playing with other musicians. This was easily done with younger musicians but was a real problem with players from the older generations, who lived my shifting positionality with unease. Agostino Carlomagno, a senior player with whom I visited many Carnival festivals, would sometimes ask me rhetorically if we were really going to play or if I was there to do something else.

My positionality, continually shifting between that of an almost insider player and that of a researcher, played a decisive role during the team research on the *Maggio* festival in Accettura in 2005 – both in terms of favouring some logistical aspects and of orienting our attention on the sonic features described in chapter 1. I had familiarity with the village, whose festivals I had been attending as a musician. But the real promoter of the team experience of 2005 was the extreme fondness of the people of Accettura for *a zampogna* singing. In the village there is a long-standing lack of players, as if people preferred taking up the challenge of singing rather than to propose it. Players from other villages, on the other hand, visit gladly because they are treated very well. Being known locally as a player was a springboard for the development of the research, which initially was perceived as an extension of my musical activity.

The Accettura 2005 'research tribe' (Feld and Scaldaferri 2019: 86) was made up of eight researchers, with the addition of three of the best *zampogna* players of the region, Alberico Larato, Quirino Valvano and Leonardo Riccardi. I invited them with an awareness that their presence, in addition to mine, would have a crucial importance in directing moments of the festival and in provoking other musicians. The *Maggio* is a very inclusive festival, attended by hundreds of participants and dozens of musicians from the whole region – some of whom are occasional performers. The musicians are spread over the full extent of the festival and the sounds they make fit into the soundscape of the festival. But the quality of a musician, especially a *zampogna* player, does not go unnoticed for long and can influence significantly the sonic unfolding of the festival. Feld's soundscape composition and the other recordings from those days allow an immersive journey in the rich festival soundscape, including extraordinary voices provoked by top-level players.

In Accettura, *a zampogna* songs are based on shorter melodies compared with those spread around the rest of the region, which are much more elaborate. This allows the singers to interact with the player and especially to alternate with each other in 'song duels'. A player who understands their style can find himself surrounded by a group of singers who, in crowded situations such as the cutting and transport of the trees, challenge each other in competitions of endurance that can get priority over everything else. The players' 'sound challenges' act as forms of control over space through acoustic aesthetic criteria,

attracting the best singers and other musicians, inviting them to inter-
act. In situations in which performers who often don't know each
other create temporary communities, the best musicians find each
other through playing and singing.

The impact that four esteemed *zampogna* players could make on
the soundscape of the ritual, and consequently for the development
of the research, emerged clearly during the procession of the small
statue of St Julian, on Monday evening. This is a much more private
phase of the festival, mostly attended by the people of Accettura
during breaks in the operations to prepare the raising of the trees
in the square. This procession, in its sonic richness, attracted Feld's
attention to the point that he dedicated to it a third of the whole
soundscape composition (Scaldaferri and Feld 2019: track 5 of CD
1). An important feature of that year's procession was the presence of
an ensemble formed by myself and the other three players I invited.
The formation, which played a small and a large *zampogna* tuned an
octave apart, a soloist *ciaramella* and a double *ciaramella*, is commonly
seen during important regional pilgrimages such as that to the Marian
sanctuary of Viggiano. The parish priest Don Giuseppe and the festival
committee were enthusiastic about the proposal to accompany the
procession with this ensemble, seeing it as a celebration of the role of
double-reed instruments in an official situation. From that year on, on
Monday evening during the festival a team of players has accompanied
the procession of the small statue of St Julian. Still today this involves
an invitation (and an implicit obligation) for me to perform on that
occasion. A section of Feld's soundscape composition is about the team
of double-reed instruments (track 5 from 14'40'). The ensemble forms
a single, compact sound source that traverses the narrow streets and
makes them resonate. In the recording it is possible to perceive the
changes in reverberation from the different surfaces of the walls and
the stone pavements – the provocation of the reeds this time is thrown
to the village of Accettura, rendering to the listener a perception of its
urban spaces.

Insider repatriation

Shelemay underlined how the presence of a field researcher always
represents an element of interference, and sometimes even becomes a
major player in the transmission of the knowledge and practices they
intend to study (1996: 35–51). All the more so in the case of insider
researchers, whose activity is not limited to the circumscribed time-
spans of research and fieldwork but is a constant presence or a sharing
of everyday life. For this reason Narayan, writing on the figure of the
native researcher, suggested how a rigidly dualistic paradigm should be

replaced by a rethinking of a researcher's role, which is characterised by 'shifting identifications' (1993: 671) and the quality of the relationship thus created.

In my community of origin, my presence was never perceived as neutral and detached. I was often explicitly required to provide a concrete contribution, thanks to my competence as a musician or as a researcher, such as intervening to support practices that were going through hard times. In San Paolo Albanese, a village that is undergoing such depopulation that in addition to its cultural practices it endangers the community's own survival, a heartfelt tradition is the 'dance of the sickle' during the festival of St Roch (see chapter 4). In the past, the village was well known for its *zampogna* players, who had been studied by researchers as early as the 1970s. However, because of depopulation, already during the 1990s there were no remaining players. In the absence of musical accompaniment, the dance had become a sort of silent pantomime that the performers were almost too embarrassed to stage. At the beginning of the 2000s I agreed with the main dancers at the time, Pietro Ragone and Costantino Osnato, that some young players from San Costantino and I would play each year if they guaranteed that they would perform the dances. This allowed the revitalisation of a tradition which, thanks to returning emigrants, is still ongoing despite the decrease in population.

Other times, the request to collaborate came from institutions such as museums, schools, local administrations or associations. I perceived these requests as a duty of returning the results of my research in tangible terms, often in the form of archival material that a community could use to preserve collective memories and to build a collective heritage. Similar themes emerged in various activities of repatriation of sound archives, in the use of sound recordings beyond research activities or more in general for the activities discussed by proponents of an applied ethnomusicology (Nannyonga-Tamusuza and Weintraub 2012; Pettan and Titon 2015).

In my hometown of San Costantino Albanese, one such project involving the local primary school became a sort of self-repatriation – a term I use to underline how the returning of the community's heritage was performed by an insider. In San Costantino my research has become, with time, part of the local heritage, and often my collaboration is required as a sort of civic duty. The project was called *Lule sheshi* (wildflowers) and was centred on the work of the Arbëresh poet Enza Scutari, who taught in the local primary school for more than forty years. The main aim was to revitalise the use of the Arbëresh language, which has been undergoing decline for the last few generations, through songs to be performed by schoolchildren. Local and outsider musicians were involved, as well as schoolchildren with

whom we went through the village sound archives, thus bringing back old repertoires into circulation. The project resulted in the publication of a book on the work of Scutari, with attached CD, and later of a second CD in which the children performed songs and selected archival recordings by three generations of singers (*Lule sheshi* 2016; Nikolskaya and Scaldaferri 2010). The result follows Narayan's sugges- tion of an 'enactment of hybridity' in the textual production of authors who show their belonging 'simultaneously to the world of engaged scholarship and the world of everyday life' (1993: 672). The unfolding of this project followed a creative approach, aimed at generating aes- thetic relationships between historical recordings and new songs, texts, poems and images. The project had an impact on the transmission of local song repertoires: the young singers, enthusiastic about the CD, continued to perform the songs outside the school space. Some of them created a female vocal ensemble, which in the years following has continued to perform and participate in other musical projects, such as URLA by artist Yuval Avital, which I will discuss below.

Again, my activity as a musician and in particular as a *zampogna* player had a relevant role, helping me to manage my shifting posi- tionality and interacting with the other performers. An example is the song *Trëndafile baxhanare* (Nikolskaya and Scaldaferri 2010: track 12, included in sound-chapter 6), which I composed on lyrics by Scutari, and whose basic track is a *tarantella* that I played on two overdubbed *zampogna* tracks, with the addition of instruments from both local and classical traditions. The song represents a crossing between my role of musician, ethnomusicological researcher and a technical role of mixer and editor, which all came together in the recording studio.

Composing tradition

In 2019, the designation of the city of Matera as European Capital of Culture was the opportunity for a number of initiatives in dialogue between art and ethnography. The Sassi area became a set for artistic experimentations. One of the main projects was I-DEA,[2] which took inspiration from John Cage's *Rolywholyover: A Circus*. In this 'composi- tion for museum', Cage transformed the Philadelphia Museum of Art in a 'circus for artworks' that each day switched works from forty-five museums and special collections of the area (Bianchi 2016; Murphy 1996: 458–63). In Matera, artists were invited to create exhibitions and installations based on their creative interpretation of archival collec- tions. In this context, where I was an adviser, some exhibitions were based on my research in Basilicata and its recordings. One of these was the installation *When the Trees Resound*, which used recordings and photographs from research on the 2005 *Maggio* festival in Accettura.

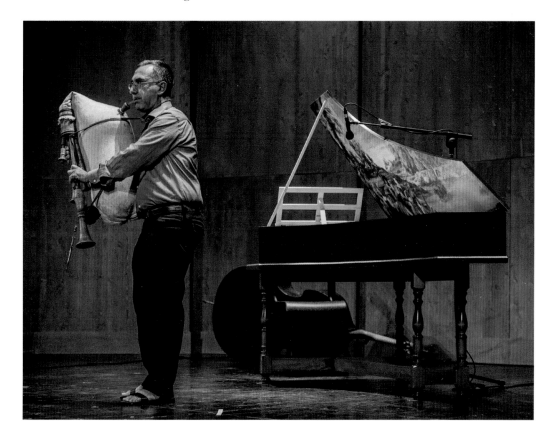

Feld's soundscape composition was played in an ad hoc, theatre-shaped space, where people could lie on mats and listen. At the same time, in the entrance two screens played slideshows of Vaja and Ferrarini's photographs, which were meant as a preliminary phase to the listening. Another exhibition, *The Land of Cockaigne* by Navine G. Khan-Dossos and James Bridle, displayed a large wheat offering from Pedali di Viggianello, inside which a loudspeaker played a harvest song recorded by De Martino and Carpitella. Four large *zampogne* from my collection were placed horizontally on low pedestals, suggesting the idea of dead animals, as loudspeakers played back the sounds of each instrument. The same exhibition featured an installation based on Rossella Schillaci's documentary *Pratica e maestria* (2005), a film in which the filmmaker's observational approach built upon my close knowledge of some of the best *zampogna* players in Basilicata.

In these cases, the outcomes of previous research (as recordings, objects or audiovisual productions) became the substance that the artists used to create their own interpretations. Elsewhere, I have collaborated with composer and multimedia artist Yuval Avital, who opens

6.2 August 2010. Scaldaferri on stage at the Portogruaro International Music Festival.

163

his work to ethnographic research, based on field encounters and in dialogue with a researcher. His creative career is full of references to contexts dense with cultural meanings and significance, at times connected with biblical and Israelite heritage, combined with the exploration of multiple artistic languages and technologies. His works are often based on field research and involve dialogue and collaboration in ways that are mindful of ethnographic research. The relationship between researcher and artist is here closer, but also presents new potential problems insofar as the methods are aimed at different goals.

My first collaboration with Avital resulted in the opera *Samaritans* (performed at Festival MiTo, Milan, 2010). Defined by the artist as 'icon/sonic opera' (see Scaldaferri 2015: 380–85), *Samaritans* mixes multimedia playback with live music performances, which include some singers from the Samaritan community of the area of mount Gerizim. I was involved as an expert of fieldwork methods by recording and filming rituals in the West Bank, which would then find a place in the multimedia component of the opera. *Samaritans* is a work with strong identity and religious connotations, which raises ethical issues similar to those that ethnographers encounter whenever local practices are put into relationship with a global scenario (Shelemay 2013). A crucial aspect, for example, was the inclusion of Samaritan religious rituals within the opera. These had been negotiated with the religious leaders of the community and had been authorised by the high priest of the Samaritans, who had approved the presence of a priest on stage saying that a prayer is a prayer regardless of the context in which it is uttered.

Avital planned my presence on stage as a multi-instrumentalist, playing parts for violin, accordion, *torupill* (Estonian bagpipe) and for a large 6 palm *zampogna*. A *zampogna* is a very limiting instrument to fit in a concert performance, because of its difficult tuning and fixed dynamic. In *Samaritans* it was inserted within a rigorously annotated score, and put side by side with instruments of the Western classical tradition – a string quintet, wind instruments, grand piano, classical guitar. Aware of the *zampogna*'s morphology and musical limitations, Avital used it to evoke ancestral sounds, as a support of the Samaritan vocal ensemble with low-pitched sounds, creating an evocative sound with hieratical and ceremonial features.[3]

Within the initiatives for Matera European Capital of Culture 2019 I collaborated with Avital in the creation of URLA, a work of crowd music that involved more than three hundred performers from different parts of Basilicata. Most performers and most sounds had been selected through my history of research in the region, in part discussed in this book: the teams of bell carriers from San Mauro and Tricarico, the sound of the *zampogna*, the walking wind bands, the *cupa-cupa*

(friction drums), the 'shouted' songs, the Arbëresh polyphonic songs of the young female choir from San Costantino.

In planning this project, I defined these phenomena 'sound monuments' because of their collective identity, acknowledged as part of their heritage by the whole region, beyond the communities in which they originated. In URLA, the performers were divided into four groups, who toured the Sassi district according to a geographic score. Along the path they would come across 'sound terminals' made of amplified instruments, kickstarting sonic or ritual acts. I managed the network of contacts required and the rehearsals. The main challenge was to get the performers to understand the requests made by Avital through his score, which were very different from their usual musical practices. One of the groups was made up of fifteen *zampogna* players, among the best known in the region, with instruments of different sizes, directed by me at the head of the group while recording with a microphone on my back. These sixty double reeds, playing mostly long notes with effects of tonal dissonance, were aimed at obtaining microtonal clusters similar to those which can be heard in some of Ligeti's compositions. Avital's idea was that of a huge-sounding lung, breathing and moving through the picturesque streets of the Sassi district and making them resonate. The cluster effect, which cancelled the perception of melodies or harmonic intervals, represented a real challenge for the players, who are used to playing on their own and to paying close attention to their tuning. It required specific training and a collaborative stance on their part. Avital is not new to similar collaborations between performers with diverse backgrounds, who are at times placed side by side in compositions in which each has to perform according to their own traditional canons. These formats raise questions on the creative role of the composer when dealing with musicians who perform within specific traditional guidelines, instead of instrumentalists who follow his instructions. In a conversation in which we discussed URLA, Avital explains his position on this subject:

NS: The involvement of whole communities has created a close relationship with the territory, its rituals and traditions. It was necessary to set up a collaborative approach that took a long time and could not be taken for granted.

YA: In Basilicata I encountered communities with a strong sense of identity, carriers of important traditions and capable of original creations. I can define them as real communities of artists, in which every traditional action constitutes an authentic artistic ritual. This is something that struck me and I had to consider.

NS: Working with a large number of real artists, each with specific cultural and identity traits, did not just entail collaboration but

also negotiations and sacrifices. Did you feel limited in your
role of composer? Do you think that this can cause a crisis of
authorship?

YA: I never perceived it as a limitation or a way to undermine
my role. We should consider the primary meaning of the term
composer: putting together, side by side, situations, objects, and
with them creating a new order. What emerges is something
new. (Scaldaferri 2020: 77)

Avital's explanation of the etymological role of the composer
almost echoes the classical definitions of music as organised sound.
More precisely, the artist can be seen as someone who, rather than
placing together musical and sound phenomena, removes them from
their context to blur their limits, thus trying to suggest new possible
relationships and ways to listen.

Conclusion

My work in Basilicata unfolded in the spirit of overcoming the sepa-
ration between researcher and research subject. This process has been
based on continuous intersections of playing music as an insider musi-
cian, learning, as well as recording and establishing dialogues. These
activities required shifting positionalities and adaptive strategies, in
which the practical and technical knowledge of a musical instrument
and its sound represented an anchor point. Listening has always been a
crucial stage of knowing musical repertoires, but also a research method
that creates forms of interaction by relying on the circularity between
performance, cognition and produced sound, as illustrated by Merriam
(1964: chapter 1). Performed sound was not just the medium in which
the research was carried out but became a form of representation that
went beyond traditional textual forms. The multiplicity of roles and
relationships that I built through music-making became the inspira-
tion for layered and multi-authored research outputs, which spanned
across multiple media and forms of dissemination – including forays
into the arts scene. Importantly, my collaborations with local insti-
tutions – sometimes requested as a sort of civic duty – resulted in
forms of repatriation of the outcomes of the research, which often
were integrated into the local politics of heritage.

Thanks to provoking and interacting through creative interventions,
the examples described in this chapter allow exploration of the variety
of relationships that can develop between a sonic context and some
musical practices. They provide a more nuanced perception of cultural
dynamics in which, as shown by Yung (2019), creativity and tradition-
ally established practices are in a relationship of complementarity.

Notes

1 www.leav.unimi.it (accessed 31 March 2020).
2 www.matera-basilicata2019.it/en/programme/pillar-projects/i-dea.html (accessed
 31 March 2020).
3 www.yuvalavital.com/press/item/68-samaritans-icon-sonic-opera-new-video-
 clip (accessed 31 March 2020).

Sound-chapter 6 – *A musical journey with my* zampogna

This sound-chapter includes recordings from 1990 to 2019. In these diverse situations Scaldaferri used playing *zampogna* as a way to do research in sound. Through forms of interaction that range from provoking singers to collaborations with contemporary artists, he used creative practice as a research approach.

PHOTOGRAPHING AS AN ANTHROPOLOGIST: NOTES ON DEVELOPING A PHOTO-ETHNOGRAPHIC PRACTICE IN BASILICATA

7

Lorenzo Ferrarini

There are a number of reasons why photo-ethnography, understood as 'the use of still photography as a means of … presenting ethnographic information and insight' (Wright 2018: 1), is not nearly as developed in both practice and theoretical reflection as ethnographic documentary (Edwards 1997: 53). As remarked by Wright, while most ethnographers carry and use a camera during fieldwork, the production of photo-ethnographies is very limited. A few ethnographers have, in the past, tried to develop arguments visually by making extensive use of photographs in their monographs – a pioneering but isolated example is *Balinese Character* (Bateson and Mead 1942), followed years later by *Gardens of War* (Gardner and Heider 1968). In recent times, it is still uncommon to find authors of ethnographic monographs who include in their books images that go beyond a merely illustrative role, offering instead an account that is parallel to the text. Examples include *A Space on the Side of the Road* (Stewart 1996) and more recently *Monrovia Modern* (Hoffman 2017). However, in 2016 the journal *Visual Anthropology Review* and the Society for Cultural Anthropology launched a platform for photo essays which has already created a significant corpus of work.[1] A somewhat more established practice has involved collaborations in which an anthropologist writes a text that is accompanied by images taken by a photographer – often on the basis of the anthropologist's research and personal contacts (e.g. Blau et al. 2010; Bourgois and Schonberg 2009; Keil et al. 2002; Meintjes 2017). Indeed, this way of working has had an important role in the history of ethnographic research in Basilicata, as I will describe later.

Even though my list is far from exhaustive, it is apparent that since Collier's now-dated book ([1967] 1986), not only practical examples of photo-ethnography but also academic reflections upon it have been much more limited than those on photographic archives (Edwards 1992; Morton and Edwards 2009; Pinney 2011) or on the study of local photographic cultures (Buckley 2000; Pinney 1997; Wright

2013). Reflecting on the reasons for this trend, two main aspects stand out for me: first, the association of photography with a problematic, objectifying gaze which links it with practices of power and the early history of anthropology and colonialism (Pinney 1992). This critique originates beyond anthropology and is exemplified by such well-known works as Sontag's *On Photography*, in which she compares the photographer to a voyeur who exploits the pain of others without intervening (1977: 11–12). Meanwhile, later analyses of the representation of non-Western cultures in mainstream publications have posited an association between photography and an exoticising gaze (Lutz and Collins 1991). The noble savage and other neo-colonial narratives are alive and well in some photographic practices that may be erroneously associated with the social sciences, as for example in the project *Before They Pass Away* by Jimmy Nelson (2013), who describes himself as an ethnographic photographer. With a legacy of primitivism that runs from Edward S. Curtis's work on native Americans to Sebastião Salgado's *Genesis* (2013), passing through Leni Riefenstahl's images of the Nuba (Franklin 2016: chapter 2), photography might seem too compromised to invest in as a form of ethnographic output. On the other hand, some recent contributions to the discussion on photo-ethnography have stressed the potential of photographic collaborations to break these associations (Graham 2016; Mjaaland 2017).

The other major point of contention is photography's ambiguity, especially in comparison with ethnographic text. Critics of ethnographic uses of photography accuse it of being too open to interpretation and 'an impoverished substitute for text, incapable of rendering the complex contexts, information, and arguments necessary for ethnographic understanding' (Wright 2018: 1). A well-known example of this line of thinking is Hastrup's characterisation of photographs as 'thin description', limited to appearances that text, on the other hand, can overcome thanks to its capacity for analysis (1992).

In this chapter I propose to add to these general challenges to the very idea of photo-ethnography by considering the particular history of documentary photography associated with ethnographic fieldwork in Basilicata. In this region, this history has resulted in very loose and problematic uses of the words 'ethnographic' and especially 'anthropological' as qualifiers of images that often follow a tradition that started with the photographers who accompanied Ernesto De Martino in his 1950s field trips to the region. I start by considering both the continuities and the discontinuities between these historical examples and my own photographic work, in order to outline how I developed a photo-ethnographic practice that is specific to my role as a visual anthropologist. This has revolved around three main principles: an awareness of ecosystems of circulation of images, the development of

dialogic photographic practices, and the exploration of relationships between images, text and other media – which is also an opportunity to provide a rationale for the design of this book in which a main focus on sound is paired with still images. In other words, the principles behind my practice have less to do with formal qualities to be retraced in the photographs than with relationships surrounding them – with other images, with people in the field, with texts and with sounds. The intention is to make a twofold contribution to the debate: on the one hand, to contextualise the production and circulation of images associated with ethnography in Basilicata in order to position my own practice, and on the other to help address the current need for methodological reflections on photo-ethnography.

Photography and anthropology in Basilicata

Even though the legacies of the work of De Martino and his associates come back time and again throughout this book and are very important also in the field of photography, it is important to remember that a large portion of the representation of Basilicata in the media of post-war Italy happened through the lens of foreign photographers. David Seymour, for example, visited southern Italy in 1948 during his trip documenting the post-war condition of children across Europe (Seymour 1949), and in Basilicata had Carlo Levi as a guide. Henri Cartier-Bresson initially visited Basilicata in 1951 and 1952, and was hosted in Tricarico by the poet and socialist mayor Rocco Scotellaro, much like De Martino in the same period (see Cartier-Bresson 1974). There are also local photographic practices that pre-date these experiences, including family and studio photography (Mirizzi 2010).

It was, however, with the work of Italian photographers such as Fosco Maraini, Federico Patellani and Mario Carbone that the photographic representation of Basilicata, and more broadly of the Italian South, became strongly characterised by a neorealist aesthetic, a movement that during the 1950s also spanned cinema, painting and literature (Haaland 2012; Konewko 2016; Shiel 2006). The photographers who worked with De Martino – sometimes with him during his research trips, sometimes on their own but developing themes of his work – were in different ways influenced by neorealism and their work had wide circulation in Italian printed media – especially newspapers and magazines. These outlets are in fact more substantial than the actual use of images in De Martino's books, which was limited. During the time of his research trips during the 1950s, De Martino often published write-ups in popular magazines – *Espresso Mese, Radiocorriere, Il Mondo* – in which the photographic component had a similar role to the photo essays published by American periodicals such as *Life*.

This was for him a way to contribute beyond academia to a public debate on the condition of the peasant classes of the Italian South, but also a clever way to give public resonance to his research and attract funding for further trips.

De Martino practised ethnographic research in a different way from the Anglo-American tradition of long-term, solitary participant observation. The way he planned and carried out his short – usually around a month – research trips is more reminiscent of the French tradition of Griaule and of his collaborators, in at least two ways. First, he concentrated a great deal of work into the limited time he stayed in a given community, often summoning informants and requesting performances of the phenomenon he wanted to study, if it did not happen spontaneously (cf. Clifford 1988). Secondly, he assembled interdisciplinary teams at times composed of a medical doctor, a psychiatrist, an ethnomusicologist, an anthropologist and a filmmaker in addition to a photographer. Whenever he had the resources, and often with the technical support of the national radio-television or the first Italian ethnomusicological archive, he employed the three media of film, sound recording and photography to support and document his research, an approach that was pioneering for the context of the Italian social sciences of the time. However, it is important to remember that De Martino saw writing as the only way to properly convey his findings, and mostly used photographs in an illustrative manner in some of his books. As much as he valued photographs in the research phase, he undervalued them as ways to present ethnographic knowledge in an academic context (Faeta 1999: 85–6). Still, thanks to the processes of institutionalisation of anthropological knowledge that we have seen at work in some of the previous chapters, the work of the photographers he took with him to Basilicata has acquired special significance for some of the communities where it was made. Additionally, the style of these photographers remains an important model for all sorts of image makers working in that part of Italy who want to claim to produce anthropological work.

The first photographer De Martino took with him to Basilicata was Arturo Zavattini, who accompanied the research team to Tricarico in June 1952. The stay was centred on investigating and documenting the peasants' general living conditions. Zavattini's photographs portray house interiors, the proximity of humans and animals, the wait of day labourers in the main square and a number of musical moments too, a feature that will recur in almost all subsequent trips. Zavattini's images are in 6×6 format, often formally very elegant and mindful of American social realist photography, which perhaps reached him through his father Cesare's collaboration with Paul Strand. In his photographs the peasants are poor but dignified, and often look straight into the lens.

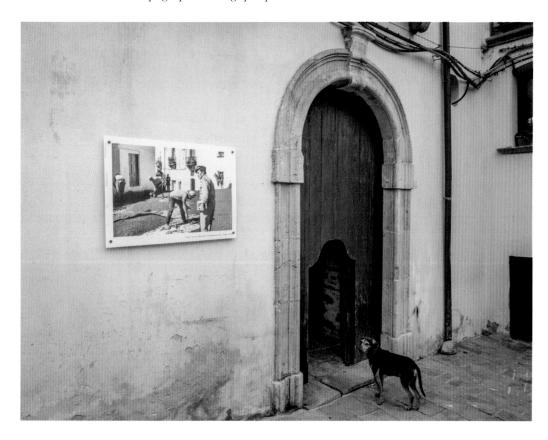

This collaboration did not last, though, and later in 1952 De Martino travelled back to Basilicata with Franco Pinna, then a young, politically engaged photojournalist who would also collaborate with him in Apulia and Sardinia over a period of seven years – until they broke up over issues related to the use of Pinna's images in De Martino's books and the lack of image credits in *La terra del rimorso* (see Caruso 2016: 104–7; De Martino [1961] 2005). From this time on, the research focus and methods became more established: the researchers would move from village to village, record songs and interviews thanks to ethnomusicologist Diego Carpitella, concentrate their research on magic and develop what later would become a specific focus on moments of crisis and transformation: ritual, illness, healing, death. Pinna received some general instructions from De Martino at the beginning of the trip, then was left to develop his own visual language. His work presents similarities with Zavattini's, especially in the realist style of his pictures of daily life, but also developed an independent approach with a marked focus on dramatic moments, often within ritual. We know that Pinna was juggling the needs of the research for which he was

7.1 Pietrapertosa, January 2020. A photograph by Henri Cartier-Bresson is on permanent exhibition next to the place where it was shot in 1973.

173

hired and a desire to use his images in the left-wing periodicals that at the time represented his main income. He certainly adapted his praxis to the demands of the research, for example systematically adopting the tactic of portraying events in sequences of photographs rather than looking for single images that could tell the whole story – as would have been more common in a publishing context. This is a way of working that was shared by Zavattini, who probably derived it from his training as a cinematographer, by Pinna and by Gilardi – the third photographer to follow De Martino as a temporary replacement for Pinna on a research trip on Lucanian magic in 1957.

The body of work produced by these three photographers during their work with De Martino (see Gallini and Faeta 1999), despite individual differences, developed in a realist tradition that is markedly different from the later work of other photographers of the Italian South who worked in teams with ethnographers. Despite the common use of black and white film, Scianna (1965) and Jodice (in De Simone 1974), for example, perhaps freer to think of their images as independent artistic outputs and less framed in a role of supporting research, made use of motion blur and close-up perspectives to suggest emotion (Vaja 2006: 45). The realist photographic work developed with De Martino has been interpreted critically as a well-intentioned form of orientalism, inspired by a desire to improve the condition of the peasant classes of the Italian South but at the same time portraying them as an example of radical and exotic alterity, cut off from the rest of the nation (Faeta 2003). The agrarian ways of life, the harshness of the landscape that echoes the marks of a hard life on elderly people's faces, the omnipresence of death and its manifestations, the mystical take on Christianity, are all visual themes that underline the South's marginality and exoticism, and in many ways the incapacity of left-wing intellectuals to adequately represent it (also compare the case of the documentary *La Madonna del Pollino* examined in chapter 3).

Many of these themes are developed through images of women. Represented as mourners, hard-working peasants, custodians of occult knowledge and sometimes enchantresses, these female figures were approached by the male photographers through the mediation of Vittoria De Palma, De Martino's partner in life and research assistant (Gallini 1999). In few images is the constructed nature of these depictions more evident than in the photograph of the 'enchantress of Colobraro' shot by Pinna in 1952 and published in *Magic: A Theory from the South* (De Martino [1959] 2015). The bearded, skinny and wrinkled old lady, all dressed in black, stands with her hands joined and a severe expression. The caption of enchantress and the name of Maddalena La Rocca, as with various biographical details given by Pinna in later publications of the image, have been revealed to have been made up

(Imbriani 2016). The combination of the captioning and the removal of surrounding details such as some children and an overhead power line, through cropping and darkroom techniques, made this woman the icon of the ominous fame of the village of Colobraro that De Martino had contributed to amplifying on a national scale through his writing.

This photograph can be encountered time and again across a variety of cultural initiatives throughout Basilicata, from institutional posters to theatre pieces (image 7.2) to works of artists, where it seems to represent an ancestral identity to promote proudly. In the current processes of heritagisation that occur in many parts of the region, if the written work of anthropologists plays a crucial role for the validation of cultural heritage, the historical images of those practices represent an even more valuable asset. They allow the provision of a visible component to the aura of authenticity of these cultural practices, validated by their realist style and use of a technology – analogue photography, in black and white – that is associated with the past. It is not a surprise, then, to see local administrations make liberal use – more or less

7.2 Colobraro, August 2018. Part of the set design for the street theatre piece '*Notte a quel paese*' juxtaposing images from Italy's unification/annexation of the South with Franco Pinna's 1952 photograph of the 'enchantress' of Colobraro.

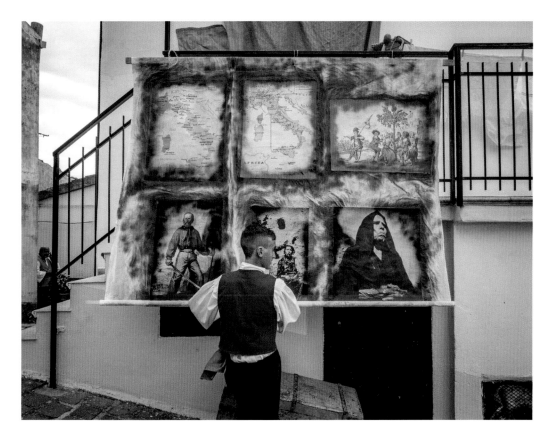

175

7.3 A design based on one of Franco Pinna's photographs from San Giorgio Lucano, titled *Radici* (roots), by Kalura Meridionalismo.

authorised – of images made in their territories for the promotion of their cultural events or to attract tourists. This has happened with Cartier-Bresson's images in Tricarico (published in Cartier-Bresson 1990) or in Pietrapertosa, where they have been enlarged and hung in the locations where they were made (image 7.1).

Part of the regional funds in support of the intangible heritage of these localities is used to create billboards and booklets on the traditional culture of a particular place, for the most part richly illustrated by archival and contemporary documentary photography. An example

is San Giorgio Lucano, where Pinna photographed a re-enactment of the 'game of the sickle' in 1959 (published in De Martino 1960). The images, this time mostly shot in 35mm format – Pinna shot some colour medium format but these are rarely seen – are present in cultural initiatives, conferences and publications that took place during the 2010s in the village. Here, the ritual that marked the end of the reaping of wheat was abandoned in the early 1950s, only recently to become the centre of the local administration's efforts to promote local cultural heritage. They also appear in commissioned mural paintings in San Giorgio (some of which, remarkably, were painted monochrome) and even on the t-shirt designs of activist collective Kalura, for which they become symbols of counterhegemonic resistance (image 7.3). If the images were originally produced as part of an orientalist discourse, then today they have been re-appropriated – often reproducing essentialist depictions – and sometimes turned on their head by exploiting the positive components often present in discourses of exoticism (Kalantzis 2019).

Developing a relational photographic practice

Thanks to the histories outlined above, many amateur and professional photographers working in Basilicata claim an ethnographic, and sometimes even anthropological, status for their images. In a sense, we face the opposite problem to the one I described at the beginning of this chapter: instead of having too many anthropologists who have withdrawn from photography, we have too many photographers who have appropriated anthropology. Sometimes these claims are based on continuities of style with the classic examples of the 1950s, but more often it is a matter of subject: religious festivals, portraits of elderly men and especially women, musicians playing traditional music, elements of the agricultural world. As a visual anthropologist, I find very problematic that the choice of subject might determine the anthropological value of a representation, first of all because it is a way to perpetuate the worst associations between anthropology and colonialism. Furthermore, it downplays the role of the approach that constitutes the expertise of the anthropologist and allows layers of complexity to be added to the images. These principles are by now well established within ethnographic documentary, which struggled to get rid of an association with exotic cultures and black and brown peoples as subject (Ruby 1996).

It makes more sense, then, to consider what constitutes photographing as an anthropologist rather than an anthropological photograph. A focus on the approach also has the benefit of avoiding scholasticism and keeping open a multitude of genres and styles that each situation

and research question might call for, including those outside of realism and even outside documentary photography. Patrick Sutherland expresses himself along similar lines when considering the key aspect of photo-ethnography to be

> the conceptual framework within which the practice is situated rather than what the specific individual images taken by a visual anthropologist actually look like. I suspect that the anthropological nature of still photographic practice is to be found less within the individual imagery and more within the interrelationships between groups of images and with their relationship to accompanying text. (Sutherland 2016c)

I would extend the awareness of the relationships between images to the histories and economies of circulation of images (Poole 1997), which constitute an ecosystem that influences the perception of new photographs. This is less the visual culture competence that a photographer develops by getting acquainted with other colleagues' work and creating a personal style, than it is an anthropological attention to the social uses of photography, be it for personal use or published in professional contexts. Histories of image-making such as those of the earlier paragraph, together with the episodes of re-appropriation of more recent years, can constitute a powerful orientation for an anthropologist photographer. They can be developed visually through framing, by which I mean the creation of images that show relationships with other images, either as references to styles and works of the past, or more broadly as looking for ways in which people try to re-enact images of the past.

Throughout this book there are images inside images, and sometimes images of people making images, as a product of this attention. My choice of working entirely in colour, since the very beginning, was initially a partly unconscious desire to mark a distinction from the classic work of the 1950s and 1960s, and later a more conscious desire to avoid the associations of authenticity that such work brings with it. As simple as it might sound, colour – especially in the context of Basilicata, with its photographic histories – can mean a statement on the contemporary nature of the subjects, to discourage any association with timelessness that some subjects might suggest. Similarly, I made a point of showing the active involvement of younger generations in the phenomena we examine in the book, because even though the region – and to a lesser degree Italy as a whole – is going through progressive demographic ageing and emigration of its youth, the role in the revival of many of these practices of those who remain – or return – is key.

A researcher's photographs too can become part of local ecosystems of images and in so doing create new opportunities for research.

Photographic prints make for excellent gifts – especially for the older generations – and allow the creation or consolidation of relationships that start with the making of an image at a public event (image 7.4). More recently I have sent digital versions of my photographs that people will later use on social media – sometimes on the spot where the shot was taken, thanks to wireless connection between the camera and a smartphone. Over the years I have given photographs to local museums, where they appear next to archival images, and to institutional publications. This is not just a way of cultivating existing relationships in the field but also a means of expanding the scope of our research by creating new opportunities.

There is a danger, though, of interpreting these relationships as a facilitator for an 'extractive' practice, thereby reproducing the associations between photography and objectification with which I opened this chapter. This danger is all the more present in the case of event photography, where it is easy to limit all relationships to the duration of the festival or ritual. I prefer to steer the cultivation of relationships towards dialogic practices. The term 'dialogic' has its origins in

7.4 San Paolo Albanese, January 2020. Pietro Ragone looks at prints of photographs of himself dancing the sickle for the festival of St Roch, which I shot between 2005 and 2017.

Bakhtin's writings (1981), where it refers to the reciprocal interdependence between representations, and was an important keyword in the literature of the reflexive turn in anthropology (especially Tedlock 1979), where it designates practices of representation that preserve the polyphonic and intersubjective origins of ethnographic knowledge (see also Feld 1987).

Ever since I started reflecting on my photographic practice and how to develop it in a dialogic direction, I have found inspiration in the work of Magnum photographer Susan Meiselas. In her first book *Carnival Strippers* (1976) she extensively used collaborative portraiture and collaborative photo-editing, avoiding reproducing photographically the visual consumption that her subjects underwent in their occupation. She followed up her reporting on the 1979 Sandinista insurrection in Nicaragua with a film, *Pictures from a Revolution* (Meiselas et al. 1991), in which she visited the protagonists of the revolution, retracing the afterlife of her pictures and the biographies of the people who appeared in them. In 2004, twenty-five years after the overthrow of Somoza, she installed poster-sized versions of her images in the places where they were shot, a form of repatriation and a way to promote a public debate on the legacy of the revolution. Other works, that juxtapose the curation of archival bodies of work with original reporting, deal in different ways with the creation of representations of the other and the parallel process of their political subjugation in Kurdistan (Meiselas 1997) and Irian Jaya (2003). In short, Meiselas's practice 'hinges on a transformation of the charged relationship between the person photographing and the person photographed from one of power to one of exchange' (Keller 2018: 139). I take from her work an inspiration to develop photography through long-term engagement, in which images travel in both senses – they are 'taken' and 'given back', to then generate new perspectives and new images.

The potential of photographs to propel conversations and help people reveal information had already been noticed by Collier (1957). Even though I do not share the positivistic interrogation framework through which Collier approaches photo elicitation, for the research behind this book we made use of conversations propelled by photographs I had taken. The aim in gifting prints and starting conversations on them was not so much one of extracting 'data' from our 'informants', but in general to give reciprocity to the act of photography as research. Thus, photo elicitation has the potential to become a 'postmodern dialogue based on the authority of the subject rather than the researched' (Harper 2002: 15), which for a researcher can sometimes mean radically changing their interpretations. It can also be the starting point for processes of collaboration in which photographic subjects, made more aware of their appearance, try to gain more control on their

representation, potentially opening up the possibility of working with enactments and collaborative portraits. Encouraging dialogic practices around the production of photo-ethnographic work is a good starting point in response to the criticism of the objectifying, distanced and unidirectional photographic gaze. It can restore the centrality of collaboration between photographer and subject (Gallop 2003) that is the foundation of ethical practices of image-making.

Text and photographs

Besides relationships between images and between images and people, photo-ethnographies can find a specificity in relationships between images and other media. Of these, text deserves special attention because of an established tendency in anthropology to use photographs in a subordinated, in most cases illustrative, role to text. However, this is not the only reason and is just a starting point. In fact, there are a number of ways of putting into relationship text and photographic images that have been developed in illustrated magazines, newspapers and photobooks. Strategies such as proposing parallel visual and written essays, captioning, using quotes from the subjects or doing away entirely with textual information have all been tested in the varieties of formats a photo essay can adopt (Sutherland 2016b). In the conception of this book we maintain the parallel and complementary roles of text, images and sounds as a central tenet of our project. We cannot call this a photobook in Parr and Badger's definition as a book 'where the work's primary message is carried by the photographs' (2004: 6), but we do see images and text working 'within a dialectical relationship' in which 'the photograph is integral and essential, and not merely supplemental, to the work's meanings' (Di Bello and Zamir 2012: 4).

I develop the relationship of the photographs with text in three different ways, the first of which is a photographic sequence that follows the written essay. As in the case of chapters 1 and 2, this is separate from the text and does not use captions or other forms of verbal description of the content of the images. The aim is to allow the photographer to develop an independent narrative made of images that can be experienced in parallel to the orientation provided by the text. In selecting the sequence on the *Maggio* festival in Accettura, for example, I did not look for correspondences with the text that precedes it. Instead, I aimed first of all at rendering a general sense of the development of the central days of the festival. Then I chose visual themes that created a unique angle: the rendition of movement, for example, or masculinity and collective labour, combined with stark vertical lines and horizontal motion blur. The sequence also has an internal structure that makes photographs work with each other across a page spread, so that they

are paired in contrasting movement and stasis, or comparing similar actions in different contexts. On the other hand, the text that precedes the sequence has the advantage of clarifying in a general way what is happening in the images, so that it is possible to do without the captions. The strategy of the independent sequence allows the photographer to develop a visual narrative that is not reliant on words; its pairing with an essay allows the reader of the book to be aware of the contexts and specificities of the situation with a depth that the photographs alone would never allow. Separating words from images on the page is always a partial strategy, because I am aware that text in other parts of the book still interacts with a photographic sequence in some measure. A common strategy in photobooks, then, is to put the captions of a photographic sequence at the end, in a separate section. The key point here is separation, which makes it clear that the images should be experienced on their own – even if this can sometimes be disorienting.

At the opposite end of the spectrum is the use this book makes of photographs as directly integrated in the text. In chapters 3 and 5, for example, I have placed the images roughly in the area of the text they relate to, but not so closely that they have to be looked at directly after a paragraph about them. This would make them hopelessly illustrative, whereas in the format I adopt the captions allow readers to view them when they find it most appropriate. In fact, these images could be ignored during reading and then looked at as a separate narrative, similarly to the previous example. However, my advice and intended mode of fruition for these chapters is that readers alternate between the text and the photographs, letting the two media build up their understanding of the piece as a whole through reciprocal influences.

The mainly sound-centred descriptive portions of the text on the festival of the Madonna del Pollino, for example, can usefully be given a visual complement by my photographs of that event in which sonic devotion is relevant. The images in chapter 5 build a more complex and suggestive relationship with the text, showing a series of objects that represent the legacy of Giuseppe Chiaffitella's work, and a sample of his archival production. The relationship to the text here is less immediate and lends itself more to being experienced as a separate essay. Elsewhere, as in the introduction or in the two methodological chapters – this and number 6 – the photographs are simply meant to illustrate those texts that, not by chance, are not ethnographic in nature.

A third format does not conform to either the first or the second relationship between images and text. In the photo essay that constitutes chapter 4, the narrative is led by the photographs, each accompanied by a basic caption and periodically interspersed by text. The latter is used to give context, to develop a theme or expand on the

backstory of an image – yet it is not a type of text that is meant to be experienced without the photographs. There is no preferred way of reading this chapter; one can alternate the images with the text or experience them separately. But in terms of their conception, this strategy is unique among the three I adopted to present images and text, because of the way the selection of images and the writing of the text was done at the same time and in close relationship. For example, out of the vast corpus I shot on wheat festivals, some images were selected also because they could bring up a theme in writing, and the text had to conform to the pace of the images within the essay. In the case of the separate sequence following the text, on the other hand, the selection of images was independent of the text, while in the case of photographs interspersed inside a textual chapter the images were chosen after the text had been completed and on the basis of it. These temporal shifts in the making of each chapter are revelatory of the different rapports of power between the verbal and the iconic in each format. The mode adopted in chapter 4 seems to me to represent a particularly fertile and stimulating opportunity for photo-ethnography, for the way it puts text and images on a level of parity and allows a reciprocal contamination of the two narratives, typical of the photographic essay (Mitchell 1994: chapter 9), in which the photographs are not subservient to the verbal content.

Listening to images

The final type of relationship that I will examine is that between photographs and sounds. This is worthy of special attention in the first place because the core characteristic of this book is to propose ethnographies developed through text, still images and sounds, explicitly meant to be working together as different layers of knowledge. It also offers an opportunity to discuss how the evocative potential of photography – with or without a pairing with sounds – can be used as a form of sensory ethnography (Cox et al. 2016).

It is interesting to note that during their research trips, De Martino's team were striving as much as possible to create a correspondence of time and place between photographic documentation and sound recordings, to the point that it is possible, by going through the archives, to create pairings between Pinna's images and Carpitella's recordings (Ricci 2007: 21–9). While their pioneering multimedia approach is still an inspiration for ethnographers in southern Italy, our approach is substantially different. While in general, correspondences between the audio and the photographs that make up this book could be traced, we are more interested in what the gaps between the two can evoke in reader-listeners. We are interested in the connections that

they will make between text, photographs and the sound recordings as a space for synaesthetic montage that can go beyond the sum of what the three media provide. In comparison with documentary film – the other more established form of pairing of images and sounds in ethnographic practices – our presentation of still images and sound recordings is more open and fragmentary. Open, because it does not provide synchronicity in the way a film – in which images and soundtrack are in a fixed relationship – would do. Fragmentary, because the time dimension of the photographs – a few slices in time – is markedly different from that of the sound recordings, which extend themselves over longer durations – at times they are also composed out of sounds coming from distant decades. In fact, we are aware that some people might decide not to experience the photographs and the recordings at the same time, something that is fine precisely because they were conceived as related but independent narratives. However, if after listening to the sounds one can look at the photographs with different eyes, or vice versa the photographs can create a different experience of the audio tracks, then the gaps between the two forms of recording

7.5 Accettura, May 2005. Transport of the *cima* during the *Maggio* festival.

created by openness and fragmentarity will have made space for evoking experiences beyond the audible and visible – perhaps synaesthetic, not unlike what happens for experimental montage (Suhr and Willerslev 2012).

Image 7.5, for example, is a photograph that I had initially excluded from my selection of shots from Accettura, due to its lack of clarity and poor composition. It was shot in the rush of the transport of the tree, walking backwards and shortly before I slipped on the mud. However, after listening to Feld's soundscape composition I decided to include it among the sixteen images that were printed in *When the Trees Resound* (Scaldaferri and Feld 2019), because its blur felt like a visual analogy for the incoming rustle of the leaves of the *cima* launched at full speed, accompanied by the droning sound of the *zampogna* that can be heard on the CD. It is a photograph that works well in conjunction with the recording, and evokes the sense of rush and confusion experienced by the participants of that situation.

Photographs do not come with sounds attached, unless they are part of photofilms (Schneider 2014). Historically, this has been a component of their ambiguity – for example, people represented in them cannot speak through their own voice. However, photography's ambiguity can also be harnessed as a strength when it is embraced as a form of complexity that can open up 'alternative readings' and space for 'the audience's imagination' (Sutherland 2016a: 38). Such was the position of John Berger and Jean Mohr, who celebrated and used photography's ambiguity to particularly good effect in *Another Way of Telling* (1982). Some reflections on the potential uses of photography in anthropology refer to 'lyrical expressiveness' (Edwards 1997: 58) and 'poetic forms' (Orrantia 2012: 54) to describe how still imagery can make visible metaphors and local aesthetic conceptions or how it can evoke feeling and sensation. A classic example is Feld's discussion of two photographs he took during the research that led to the publication of *Sound and Sentiment* ([1982] 2012: 233–38; see Cox and Wright 2012: 120–22; Pinney 2011: 112–15). The first portrays a dancer in his costume according to a realist aesthetics, and is rich in visual information – clear, sharp and detailed. The second, on the other hand, is an attempt to render the trope of the dancer becoming a bird in Kaluli culture through extreme motion blur – much further from a traditional documentary aesthetics but closer to local understandings. In going beyond illustration, it makes sense for visual anthropologists to look at photography as an art practice in order to develop interpretive, expressive and evocative styles that make the most of its fundamental ambiguity.

I have come full circle. The challenges that in some views stand in the way of a photo-ethnographic practice – lack of reciprocity,

dependence from text, partiality and ambiguity – can be overcome by focussing anthropologically on the relationships that surround the images. This means engaging with ecosystems of circulation of images through awareness of histories of image-making, practising photography as dialogic relationships with those who appear in the images, and putting photographs in critical relationship with other media and ways of knowing. We see this book as an experimental ethnography whose contribution lies in the way it combines established modes of representation with each other in innovative ways, a 'single ethnography' (Werbner 2011: 209) for the way text, sounds and images interact organically.

Note

1 http://societyforvisualanthropology.org/writing-with-light/ (accessed 31 March 2020).

AFTERWORD

It is a pleasure to contribute a few words to close this book, and for multiple reasons.

First, the multi-mediated conversations of Lorenzo Ferrarini and Nicola Scaldaferri have long struck me as among the most interesting, progressive and experimental of border-crossing dialogues between anthropology and ethnomusicology. Specifically, they have struck me as going far beyond familiar polemics and prescriptions for 'multi-modal' research and publication, by actually putting into expansive collaboration two different kinds of scholar-artists, one a theoretically sophisticated ethnographer who is also artistically accomplished as a photographer and filmmaker; the other, a theoretically sophisticated ethnomusicologist who is also artistically accomplished as a musical performer.

A second reason is that this kind of scholar-artist collaboration doubly extends the multiple, collective and emergent forms of knowledge production of the newest trends in both sonic and visual ethnography. The first of these extensions is in the interplay of materials and media, that is, the opportunities offered to an open-minded public willing to take the time to juxtapose listening, viewing and reading experiences and grapple with both the depth and comprehensiveness afforded, as well as newly critical questions raised about ethnographic authority and representation. The second of these extensions is a further dialogue on the nature of media and mediation, particularly surrounding sound and image technologies and how they operate in histories of memory circulation. In effect, this positions the ethnography of Basilicata as the production of multilayered archives whose mediated materials must be considered relationally, from when old technologies and techniques were new, to how new technologies and techniques become their mirror.

The third reason is, bluntly, self-interest; I have been in regular contact and conversation with the authors for fifteen years, and count our

187

many conferences, dialogues and Basilicata recording collaborations among the most stimulating of my forty-five years of experimental sonic, visual and textual inter-media collaborations in Papua New Guinea, Europe, Japan and West Africa.

That leads me to say that one of the most productive dimensions of the collaborations reported here is their inter-medialities. For example, there are many scholarly examples of rich sonic ethnography, work that goes considerably deeper than musical ethnography in the classic practice of ethnomusicology. But here we experience something more than just a shift in focus from song repertoires to sonic relations, something more than an inquiry into the 'power of sound to order and structure space'. Starting anew from both the ordinary and special practices of listening, a sonic ethnography can invite a rethinking of strategies for making images both of performers/performance and multiple proximal and distal forms of participation. With listening central to the construction of aural ethnographic inquiry, images can explore the sensorium of resonances of sonic ambience, both in the experience of the photographer and the experience of the photographed. This is rather modestly presented, in the introduction, as an 'ecological' approach to sound/ing as a 'capacity to enact relationships'. But it strikes me as something considerably more radical in potential: the possibility to imagine that one can practise a listening through the image or, conversely, imagine an imaging with the sound recorder. In other words, this is not just thinking and working through the multiple media of text, sound and image, but rather working cumulatively at their conjunctions, disjunctions, overlaps and interplays. What is at stake is a larger imagination of collusions and collisions of media narrativity. This strikes me as a particularly rich intervention by the authors, especially given the depth and range of earlier representations of Basilicata in all media, following the legacy of celebrated scholars Ernesto De Martino and Diego Carpitella.

Another highly productive dimension of this collaboration is the distinctive voicings of reflexivity that it puts into juxtaposition. Chapters 6 and 7 are particularly potent in this regard, no matter where or when you read them in the larger process of engaging the sounds, images and text. Take the 'shifting positionality' in Nicola Scaldaferri's contextualisation of being both a researcher and a research subject, that is, a musical performer in the Basilicata events whose forms and processes he recounts here. This goes considerably beyond still commonplace but evermore simplistic differentiations of 'outsider' and 'insider' knowledges. In its place, it develops a nuanced sense of how knowing in sound involves a multiplicity of 'outsides' and 'insides' in shifting refraction. Likewise, take the theoretical contextualisation and practical examples of multiple strategies in Lorenzo Ferrarini's

photography. Again, we move considerably beyond still commonplace but evermore simplistic differentiations of 'research' and 'art' intentions to realise how art practice can be employed to advance theoretical agendas as much as those agendas can translate into new art practice.

Finally, a recommendation. Engaging a project like this one typically proceeds from reading to viewing, and then to listening. Do try it the other way around: listening first, and then either sequentially or simultaneously viewing, and then reading. Perhaps you'll experience a similar sensation to the one that struck me: a sense that no media controls primal authority either when it comes to memorability or to explanation. Indeed, the strength of inter-mediality is less in distinction through the blur, as hinted in Clifford Geertz's memorable quip: 'art and the equipment to grasp it are made in the same shop', something equally true about the sonic worlds of Basilicata and the rich contribution this work makes to their apprehension.

<div style="text-align: right">Steven Feld</div>

LISTENING GUIDE

The audio files can be found at
http://www.manchesteropenhive.com/sonic-ethnography/sound

<div align="center">

Accettura 2005 – Tuesday (17 May) –
by Steven Feld (6:37)
</div>

Track 6 from Steven Feld's soundscape composition, published in *When the Trees Resound* (Scaldaferri and Feld 2019, CD 1). Feld's track, in its extreme temporal compression, in a few dense minutes distils the main sonic elements of the frantic concluding day of the *Maggio* festival.

0:01. Sounds of ropes tensing during the raising of the tree.

0:50. *A zampogna* songs (3 palm *zampogna* played by Alberico Larato, voices of Giuliano Moles and Domenico Fanuele). From the lyrics: 'This *zampogna* is the colour of gold / the hands of those who play it are more beautiful'.

2:30. Music for *zampogna*, single *ciaramella* and *ciaramella* duo (played respectively by Alberico Larato, Nicola Scaldaferri and Quirino Valvano).

5:50. Voices. Local hunters shoot at the *maggio*.

Sound-chapters – by Nicola Scaldaferri

Unless otherwise stated, all recordings are by Nicola Scaldaferri; editing by Nicola Scaldaferri and Lorenzo Pisanello; mastering by Lorenzo Pisanello.

<div align="center">

1 The saint and the tree (11.58)
</div>

This sound-chapter includes field recordings made in Accettura, mainly during the *Maggio* festival but also on different occasions. Its aim is to display the variety of sound-making practices that revolve around the tree ritual of the *Maggio* and people's devotion to St Julian.

0:03. Accettura. 30 May 2004. Evening of Pentecost Sunday. The *cima* arrives in the village. Its carriers and young people sing and dance,

while the *bassa musica* guides and controls their movements through the streets. Excerpt from track 19 in Stella (2005).

1:36. (rec. Cristina Ghirardini). Accettura. 7 May 2005. Pentecost Tuesday. The symphonic march *Sivigliana*, composed by Adolfo Di Zenzo, is performed by a large symphonic band, the Orchestra di Fiati Raffaele Miglietta, from Corato. The band is accompanying in procession the statue of St Julian in the main street of Accettura. This is the core of the religious ceremonial of the festival. Excerpt from track 6 in CD 2 in Scaldaferri and Feld (2019).

3:51. Woods of Gallipoli–Cognato, near Accettura. 30 May 2004. Pentecost Sunday. *A zampogna* song performed in the woods, during the cutting of the *cima*. Alberico Larato accompanies with a small *zampogna* the singers Domenico Fanuele, Giuliano Moles and Antonio Fanuele, who challenge each other with a satirical take on some romantic lines: 'How beautiful you are, lucky you / lucky the mother who holds you / I got a beating and I will get some more / but I have to keep my pride / How beautiful is it to be close to your love / you can hear her call the chickens / You can hear her call the chickens / my beauty, come and visit me'. Excerpt from track 18 in Stella (2005).

5:42. Accettura. 1 June 2004. Night of Pentecost Tuesday, conclusion of the *Maggio* festival. The soundscape is dominated by the fireworks; however, the *bassa musica* keeps fulfilling its role by playing a waltz in the background and interacting with the bangs. Excerpt from track 5 in CD 2 in Scaldaferri and Feld (2019).

7:16. (rec. Giuseppe Filardi). Accettura. 1983. *The Lord's Prayer of St Julian*, performed by Filomena Bartiluccio, aged eighty-eight. The recording comes from the research archive of the parish priest. From the lyrics: 'The night has come and may God be praised / let us address the Lord's Prayer to St Julian / St Julian of Altomonte / walked across valleys and mountains'. Excerpt from track 1 in CD 2 in Scaldaferri and Feld (2019).

8:13. Accettura. 1 June 2004. Pentecost Tuesday, after the *maggio* has been raised. Berardino Barbarito accompanies the old singers Vito Piliero and Giuseppe Rocco with his *organetto*. They challenge each other with a satirical take on some romantic lines: 'Olive leaf fix your braids / because your father wants to give you away / Here comes the one who loves me / with one broken leg and the other in a bad way / Oh young man, break these chains / when I was your age, poor girls'. Excerpt from track 19 in Stella (2005).

10:24. Accettura. 26 January 2020. Eve of St Julian's day. The statue of St Julian is carried in a procession despite the rain, wrapped in plastic sheets. The members of Accettura's symphonic band play some pages from Verdi's *Ernani*.

2 Rhythms in the dark (9:20)

This sound-chapter is primarily a composition of recordings made on the night of the 2002 *Campanaccio* in San Mauro Forte. They were all made in the small square in front of the church of St Roch, where the largest sonic convergence happens. All teams of bell carriers must transit by this location at least once during the ritual. They pay homage to the statue of St Anthony the Abbot by circling three times around this church, where the statue is kept. Teams often confront each other in the square, creating sonic jams in which each team tries to keep their own tempo without being diverted by the others.

The teams of bell carriers, each with their own tempo, were recorded separately during their arrival at the church. The recordings are edited so as to highlight the sonic identity of each team and the duels that take place when teams meet. As a coda, almost as a reverberation, the track ends with the soundscape of a valley near the village of San Mauro: cowbells are recorded as they ring from around the neck of hundreds of animals descending from the hills.

0:03. San Mauro Forte. 16 January 2002. Composition of recordings made during the night of the *Campanaccio*.

7:05. Valley of the river Sauro. 26 January 2020. A bovine herd with cowbells descends along the road, heading from the hills towards the sea.

3 'We came a long way...' (11:40)

This sound-chapter includes sound events recorded in different moments of the festival of the Madonna del Pollino, as well as at other Marian festivals in Basilicata. Throughout, sound is used to mark an event and take control of space.

0:03. Sanctuary of the Madonna del Pollino, San Severino Lucano. Sunday 2 July 1989. A portion of the sonic duel between two *zampogna* players, Emilio and Carmine, at the entrance of the sanctuary (see chapter 3). It is the day after the main event of the festival, when the church remains open and the statue receives the homage of the pilgrims who could not join during previous days. At 1:05, when Emilio takes a break, Carmine addresses him: 'I wish you a thousand years, mate. Stop for a little while, please!' But as Carmine starts to play, Emilio again blows in his louder instrument and forces Carmine to leave the church.

2:44. (rec. Lorenzo Ferrarini). Sanctuary of the Madonna del Pollino. Evening of Friday 4 July 2014. Soundwalk around the area in front

of the church, not far from the spot where years before the duel between *zampogna* players had taken place. The quickly changing soundscape reveals the presence side by side of different groups of pilgrims, each with their musical instruments and styles, as they prepare to go inside the church.

5:20. (rec. L. Ferrarini). Sanctuary of the Madonna della Conserva, San Costantino Albanese. Saturday 20 August 2016. A game of *morra* on the evening of the festival. The players are involved in a face-to-face challenge made of sounds and gestures; they dominate the surroundings with their shouts and attract people nearby.

6:41. Sanctuary of the Madonna del Pollino. Night of Friday 4 July 2003. Soundscape inside the church, recorded with the microphone in front of the statue of the Madonna. The changes in music reveal a succession of different groups of pilgrims. We hear *zampogna* music, devotional songs, *organetto*, *tamburello* and bottle percussed with a metal key. Excerpt from track 8 in Scaldaferri and Vaja (2006).

8:46. Sanctuary of the Madonna del Pergamo, Gorgoglione. 12 June 2003. Song performed by the piercing voices of the women who carry the statue of the Madonna in the procession. The festival is in its most intense phase and approaches its conclusion. This is the last opportunity to ask the Madonna for divine favour, promising to come back next year: 'The Madonna all around / calls her devotees / Calls them all together / give me divine favour my Madonna … Now I have to go / what will I leave you with? / I leave you with the Ave Maria / take care my Madonna'. Excerpt from track 10 in Stella (2005).

4 Dancing with wheat (11:06)

This sound-chapter is entirely composed of field recordings made during wheat festivals in Basilicata. The music of the *tarantella* creates a common sonic thread that connects all the festivals and invites the participants to dance.

0:03. Piano delle Mandrie, Terranova di Pollino. 5 August 2018. Soundscape of the *Palio del Grano* reaping competition. The sound of the sickles at work is layered with the amplified voices of the organisers, who provide a live commentary of the unfolding of the competition. In the meantime, *zampogna*, *organetto* and *tamburello* play *tarantella* music.

2:15. Teana. 9 August 2011. Madonna delle Grazie festival. At the end of the procession, in front of the church and the statue of the Madonna, people dance with wheat offerings on their heads to the sound of a *tarantella* played by *zampogna*, *organetto* and *tamburello*.

3:20. Teana. 8 August 2016. Madonna delle Grazie festival. In front of the sanctuary dedicated to the Madonna, just outside the village, people dance with the wheat offerings to a medley of popular songs played by a walking band.

4:31. San Paolo Albanese. 16 August 2005. St Roch festival. Quirino Valvano plays the *zampogna* for the dance of the sickle, at the head of the procession.

5:41. (rec. Yuval Avital). San Paolo Albanese. 16 August 2010. St Roch festival. Antonio Abitante, Nicola Scaldaferri (*ciaramella*) and Piero Abitante (*zampogna*) play for the dance of the sickle performed at the head of the procession.

6:16. Senise. 16 August 2016. St Roch festival. Soundscape of the procession along the village streets: fireworks and *tarantella* with *organetto*, *zampogna* and *tamburello*, while the participants dance with wheat offerings.

6:54. Noepoli. 6 August 2004. Madonna di Costantinopoli festival. Soundscape at the entrance to the village: walking bands and *organetto* play a *tarantella*, while the participants dance with candle and wheat offerings.

7:49. Episcopia. 5 August 2015. Madonna del Piano festival. On the arrival of the procession from the sanctuary at the village square, the participants dance and sing with wheat offerings, to the sound of clapping hands, drums and of a walking band.

9:19. Pedali di Viggianello. 21 August 2004. Evening of the Madonna del Carmine festival. In the village square a folk band performs on an amplified stage, providing music for dancing with wheat offerings: 'Water is bad for you / wine makes you sing / Something in the air of Pedali / always lifts you up'. On the same day tractor engines, church bells, *tamburelli* and *organetti* can be heard at the end of the procession.

5 Memories from a loyal companion (9:55)

This chapter comprises tape recordings made by Giuseppe Chiaffitella between 1957 and 1962 in San Costantino Albanese and in Brooklyn, New York. It is structured in three sections, each making a different use of the recordings. In the first, soundbites of voices in different languages and instrumental music are edited with a fast pace, using overlaps and cross-fades, following the model of magnetic tape compositions from the 1950s. In the second section, music is a background for speech, which is maintained in the foreground in a similar way to radio programmes. In the third section songs are in the foreground and only partially overlapped with the spoken word. Chiaffitella's voice,

speaking and singing in three different languages, acts as a common thread.

I) Sound memories.

0:03. In English, Chiaffitella introduces a recording session in San Costantino, in order to bring voices to some American relatives. Holiday bells of the main church.

0:36. Voices of friends and relatives in Arbëresh, Italian and English.

1:08. *Zampogna* music performed by Pietro Laico.

2:06. Music performed by Attilio Cardone (violin), Michele Schillizzi (guitar). A nun's speech thanking the emigrants for the money received to build a kindergarten. A speech about friendship by Antonio Scutari, future mayor of the village. Dhurana's ritual lament for her distant daughter.

2:50. Music performed on accordion by Pasquale Scaldaferri.

3:13. The laughter of Fiorina and Nicodemo's poem, in Brooklyn. Friends in San Costantino record their names.

II) 'Terra straniera'

4:15. Domenico Chiaffitella, Giuseppe's cousin, performs the Italian song *Terra straniera* (foreign country), made famous in the 1950s by singers Claudio Villa and Luciano Tajoli. At the time, the song was an anthem for the emigrants. Layered with the voice of Giuseppe Chiaffitella and with that of Agostino Canosa, who introduces a recording session with voices and songs addressed to Giuseppe from his friends 'to take as souvenirs across the ocean and to listen to in moments of sadness and nostalgia'.

III) Homeland as song

6:38. The song of the *vallja* ('that will forever remain in the history of the village', see chapter 5) performed on Easter Monday by the women of the village, layered with the voice of Chiaffitella introducing it in Arbëresh.

7:20. Male voices perform a love song accompanied by Vincenzo Carbone (accordion), Nicola Trupo (percussion) and Michelino D'Amato (guitar): 'Oh dark carnation I would like to kiss your mouth / Oh scarlet carnation I would like to kiss you all night'.

8:10. Chiaffitella and other male voices perform the religious song *Christos Anesti*, in Greek, announcing Christ's resurrection in the early morning of Easter.

9:03. A song of love and nostalgia composed and sung in the USA by Chiaffitella, remembering the faraway village: 'Tonight the stars are shining / like that time when I was in love / a love that flew

away / and left me only a memory / When I pass by those places / and remember those kisses / my eyes fill with tears / and my heart sighs'.

6 A musical journey with my *zampogna* (10:14)

The chapter includes recordings from separate moments of Scaldaferri's activity with the *zampogna* in Basilicata, some in the frame of academic research and others as part of artistic practice.

0:03. (rec. Francesco Giannattasio). San Paolo Albanese. 13 May 1990. During team research led by ethnomusicologist Francesco Giannattasio, Scaldaferri plays a 3.5 palm *zampogna* to accompany the voices of Caterina Osnato, Domenica Caluori and Andreana Buccolo. The women singers 'respond' to the instrument with a piercing and almost shouted song, which includes typical lines of greeting: 'Oh what a day this is / I could sing until tomorrow / I only regret having turned old'. Excerpt from track 26 in Scaldaferri (1994).

2:07. (rec. Elisa Piria). Stigliano. 29 August 2002. Scaldaferri uses an old *zampogna* of 4.5 palms made by Carmine Trimarco and recorded during the research of De Martino in the 1950s. Fifty years later, in the same area, he 'provokes' the singer Leonardo Ripullone to remember a love song: 'I went up and I came down / I found my beauty drying clothes / Peppe plays and Caterina sings / so they say they are happy'. Excerpt from track 6 in Stella (2005).

3:37. (rec. and mastering Gerardo Greco). *Trëndafile baxhanare* (*The Vain Rose*). Lyrics by Enza Scutari and music by Nicola Scaldaferri, sung by Quirino Valvano, Pina Ciminelli, Dina Iannibelli, Pina Magno-cavallo and Alexandra Nikolskaya. Lyrics: 'A rose so vain / stood alone in a meadow / Along came some flowers and told her / 'Come with us, oh vain / if you come with us / you will become even more beautiful!' / 'I can't come with you…'. The song is based on a traditional *tarantella* rhythm, played by Scaldaferri with two overdubbed *zampogne* (3 and 6 palms), and accompanied by other instruments (*tamburello*, violin, mandolin, accordion, piano), plus male and female singers in a traditional Arbëresh style. Scutari's poem tells the story of the vain rose, who disdains the company of other flowers. The song is part of the project *Lule sheshi*, devoted to the poet Enza Scutari. Excerpt from track 12 in Nikolskaya and Scaldaferri (2010).

6:38. Matera. 1 September 2019. A portion of URLA, an itinerant crowd music composition by Yuval Avital, part of the initiatives for the European Capital of Culture. The more than three hundred

performers, from the most representative sound traditions in Basil-icata, were divided into four itinerant groups. One of them was made up of fifteen *zampogne* ranging from small 2 palm instruments to giant-sized 8 palm ones (over 2m long). Following the directions of the composer, the instruments performed sonic textures, crossing along their path the sound of other performers placed in the streets. The group of *zampogne* was led by Scaldaferri, who played a small *zampogna* and at the same time recorded with a microphone fixed on his back.

REFERENCES

Accra Trane Station. 2007a. *Another Blue Train*. CD. Santa Fe: VoxLox.
——. 2007b. *Meditations for John Coltrane*. CD. Santa Fe: VoxLox.
Adamo, Giorgio, ed. 2013. *Musiche tradizionali in Basilicata. Le registrazioni di Diego Carpitella ed Ernesto De Martino (1952).* Archivi di Etnomusicologia. Roma: Squilibri. With 3 CDs.
Adamo, Giorgio, and Francesco Giannattasio. 2013. *L'etnomusicologia italiana a sessanta anni dalla nascita del CNSMP (1948–2008).* Roma: Accademia Nazionale di Santa Cecilia.
Agamennone, Maurizio. 1989. 'Etnomusicologia italiana: radici a sud. Intervista a Diego Carpitella sulla storia dell'etnomusicologia in Italia'. *Suonosud* II/4, Ottobre: 18–41.
——. 2015. 'Recording Out-takes: What Can Be Discovered in the "Historical" Recordings of Traditional Music'. In *Musical Listening in the Age of Technological Reproduction*, edited by Gianmario Borio, 357–72. Farnham: Ashgate.
Ahmedaja, Ardian. 2001. 'Music and Identity of the Arbëreshë in Southern Italy'. In *Music and Minorities: Proceedings of the 1st International Meeting of the ICTM Study Group Music and Minorities, Ljubljana, Slovenia, June 25–30, 2000*, edited by Svanibor Pettan, Adelaida Reyes and Maša Komavec, 265–76. Ljubljana: ICTM.
Anderson, Benedict. 1983. *Imagined Communities: Reflections on the Origin and Spread of Nationalism*. London: Verso.
Annan, Nii Otoo. 2008. *Bufo Variations*. CD. Santa Fe: VoxLox.
Arnal, William, and Russell T. McCutcheon. 2012. *The Sacred Is the Profane: The Political Nature of 'Religion'.* Oxford and New York: Oxford University Press.
Arom, Simha. 1976. 'The Use of Play-back Techniques in the Study of Oral Polyphonies'. *Ethnomusicology* 20 (3): 483–519. https://doi.org/10.2307/851046.
——. 1991. *African Polyphony and Polyrhythm: Musical Structure and Methodology*. Cambridge: Cambridge University Press.
Atkinson, Rowland. 2007. 'Ecology of Sound: The Sonic Order

of Urban Space'. *Urban Studies* 44 (10): 1905–17. https://doi.org/10.1080/00420980701471901.

Attali, Jacques. 1977. *Noise: The Political Economy of Music*. Minneapolis and London: University of Minnesota Press.

Bailey, Peter. 1996. 'Breaking the Sound Barrier: A Historian Listens to Noise'. *Body & Society* 2 (2): 49–66. https://doi.org/10.1177/1357034X96002002003.

Baily, Samuel L. 2004. *Immigrants in the Lands of Promise: Italians in Buenos Aires and New York City, 1870–1914*. Ithaca and London: Cornell University Press.

Bakhtin, Mikhail M. 1968. *Rabelais and His World*. Cambridge, MA: MIT Press.

——. 1981. *The Dialogic Imagination*. Austin: University of Texas Press.

Bateson, Gregory, and Margaret Mead. 1942. *Balinese Character: A Photographic Analysis*. New York: New York Academy of Sciences.

Becker, Judith. 2004. *Deep Listeners: Music, Emotion, and Trancing*. Bloomington and Indianapolis: Indiana University Press.

Bekmambetov, Timur. 2016. *Ben-Hur*. Paramount Pictures, Metro-Goldwyn-Mayer. 125 mins.

Berger, John, and Jean Mohr. 1982. *Another Way of Telling: A Possible Theory of Photography*. New York: Pantheon Books.

Berrocal, Emilio Giacomo. 2009. 'The Post-colonialism of Ernesto De Martino: The Principle of Critical Ethnocentrism as a Failed Attempt to Reconstruct Ethnographic Authority'. *History and Anthropology* 20 (2): 123–38. https://doi.org/10.1080/02757200902875803.

Bianchi, Pamela. 2016. 'The Random Placement of Art: An Alternative Presentation of the Collection'. *Studies in Visual Arts and Communication* 3 (2): 1–9.

Bijsterveld, Karin, and José van Dijck. 2009a. 'Introduction'. In *Sound Souvenirs: Audio Technologies, Memory and Cultural Practices*, edited by Karin Bijsterveld and José van Dijck, 11–24. Amsterdam: Amsterdam University Press.

——, eds. 2009b. *Sound Souvenirs: Audio Technologies, Memory and Cultural Practices*. Amsterdam: Amsterdam University Press.

Bijsterveld, Karin, and Annelies Jacobs. 2009. 'Storing Sound Souvenirs: The Multi-sited Domestication of the Tape Recorder.' In *Sound Souvenirs: Audio Technologies, Memory and Cultural Practices*, edited by Karin Bijsterveld and José van Dijck, 25–42. Amsterdam: Amsterdam University Press.

Blacking, John. 1973. *How Musical Is Man?* Seattle and London: University of Washington Press.

Blau, Dick, Agapi Amanatidis, Panayotis Panopoulos and Steven Feld. 2010. *Skyros Carnival*. Santa Fe: VoxLox. With CD and DVD.

Boissevain, Jeremy. 2008. 'Some Notes on Tourism and the Revitalisation of Calendrical Festivals in Europe'. *Journal of Mediterranean Studies* 18 (1): 17–41.

Borbach, Christoph. 2017. 'The Sound of Science: Hearing Research in Ernst Karel's "Heard Laboratories"'. *Sound Studies* 3 (1): 85–87. https://doi.org/10.1080/20551940.2017.1300865.

Bourgois, Philippe I., and Jeffrey Schonberg. 2009. *Righteous Dopefiend*. Berkeley and Los Angeles: University of California Press.

Bronzini, Giovanni Battista. 1979. *Accettura – Il Contadino – L'Albero – Il Santo*. Galatina (Lecce): Congedo.

Brubaker, Rogers, and Frederick Cooper. 2000. 'Beyond "Identity"'. *Theory and Society* 29 (1): 1–47. https://doi.org/10.1023/A:1007068714468.

Buckley, Liam. 2000. 'Self and Accessory in Gambian Studio Photography'. *Visual Anthropology Review* 16 (2): 71–91. https://doi.org/10.1525/var.2000.16.2.71.

Carpitella, Diego. 1992. 'L'esperienza di ricerca con Ernesto De Martino'. In *Conversazioni sulla musica (1955–1990). Lezioni, conferenze, trasmissioni radiofoniche*, 26–34. Firenze: Ponte alle Grazie.

Cartier-Bresson, Henri. 1974. *La Basilicata*. DU Magazin, 401 July. Conzett & Huber.

———. 1990. *La Lucania di Henri Cartier-Bresson*. Roma: Edizioni della Cometa.

Caruso, Martina. 2016. *Italian Humanist Photography from Fascism to the Cold War*. London and New York: Bloomsbury Publishing.

Casey, Edward S. 1996. 'How to Get from Space to Place in a Fairly Short Stretch of Time: Phenomenological Prolegomena'. In *Senses of Place*, edited by Steven Feld and Keith H. Basso, 1st ed., 13–51. School of American Research Advanced Seminar Series. Santa Fe and Seattle: School of American Research Press; distributed by the University of Washington Press.

Cirese, Alberto Maria. 1973. *Cultura egemonica e culture subalterne*. Palermo: Palumbo.

Clarke, Eric F. 2005. *Ways of Listening: An Ecological Approach to the Perception of Musical Meaning*. Oxford and New York: Oxford University Press.

Clifford, James. 1988. 'Power and Dialogue in Ethnography: Marcel Griaule's Initiation'. In *The Predicament of Culture: Twentieth-Century Ethnography, Literature, and Art*, 55–91. Cambridge, MA: Harvard University Press.

Cluett, Seth. 2010. 'Acoustic Projection and the Politics of Sound'. *Working Paper #41*. Princeton: Princeton University.

Cohen, Anthony Paul. 1985. *The Symbolic Construction of Community*. London: Routledge.

Colclough, Nevill. 2001. 'Trees and Saints: Continuities and Change in Civic Ceremonial in a South Italian Mountain Village'. *Journal of Mediterranean Studies* 11 (2): 375–93.

Collier, John. 1957. 'Photography in Anthropology – a Report on Two Experiments'. *American Anthropologist* 59: 843–59.

Collier, John, and Malcolm Collier. [1967] 1986. *Visual Anthropology: Photography as a Research Method*. Rev. and expanded. Albuquerque: University of New Mexico Press.

Connell, John, and Chris Gibson. 2003. *Sound Tracks: Popular Music Identity and Place*. London and New York: Routledge.

Corbin, Alain. 1998. *Village Bells: Sound and Meaning in the Nineteenth-Century French Countryside*. New York: Columbia University Press.

Cosci, Marco. 2015. 'Listening to Another Italy: Egisto Macchi's New Music for Italian Documentaries of the 1960s'. *Journal of Film Music* 8 (1–2): 1–17.

Cottrell, Stephen. 2007. 'Local Bimusicality among London's Freelance Musicians'. *Ethnomusicology* 51 (1): 85–105.

Cox, Rupert. 2002. *The Zen Arts: An Anthropological Study of the Culture of Aesthetic Form in Japan*. London: Routledge Curzon.

——. 2013. 'The Political Affects of Military Aircraft Noise in Okinawa'. In *Sound, Space and Sociality in Modern Japan*, edited by Joseph D. Hankins and Carolyn S. Stevens, 57–70. London and New York: Routledge.

Cox, Rupert, and Angus Carlyle. 2012. *Air Pressure*. Frankfurt/M.: Gruenrekorder. With CD.

Cox, Rupert, Andrew Irving and Christopher Wright, eds. 2016. *Beyond Text?: Critical Practice and Sensory Anthropology*. Manchester: Manchester University Press.

Cox, Rupert, and Christopher Wright. 2012. 'Blurred Visions: Reflecting Visual Anthropology'. In *The SAGE Handbook of Social Anthropology*, edited by Richard Fardon, Oliva Harris, Trevor H. J. Marchand, Cris Shore, Veronica Strang, Richard Wilson and Mark Nuttall, 116–29. Los Angeles, London, New Delhi, Singapore and Washington, DC: SAGE.

Cruz, Jon. 1999. *Culture on the Margins: The Black Spiritual and the Rise of American Cultural Interpretation*. Princeton: Princeton University Press.

De Benedictis, Angela Ida, and Veniero Rizzardi, eds. 2000. *New Music on the Radio: Experiences at the Studio di Fonologia of the RAI, Milan, 1954–1959*. Roma: RAI ERI. With CD.

De Martino, Ernesto. 1949. 'Intorno a una storia del mondo popolare subalterno'. *Società* 5 (3): 411–35.

——. 1958. *Morte e pianto rituale nel mondo antico. Dal lamento pagano al pianto di Maria*. Torino: Bollati Boringhieri.

——. 1960. 'Il Gioco Della Falce'. *Espresso Mese* 1 (3): 80–87.

——. 1962. *Furore, simbolo, valore*. Milano: Il Saggiatore.

——. 2002. *Panorami e spedizioni. Le trasmissioni radiofoniche del 1953–54*. Edited by Luigi Maria Lombardi Satriani and Letizia Bindi. Torino: Bollati Boringhieri.

——. [1961] 2005. *The Land of Remorse: A Study of Southern Italian Tarantism*. London: Free Association Books.

——. 2012. 'Crisis of Presence and Religious Reintegration: Prefaced and Translated by Tobia Farnetti and Charles Stewart'. *HAU: Journal of Ethnographic Theory* 2 (2): 431–50. https://doi.org/10.14318/hau2.2.024.

——. [1959] 2015. *Magic: A Theory from the South*. Translated by Dorothy Louise Zinn. Chicago: HAU Books.

De Simone, Roberto. 1974. *Chi è devoto.: Feste religiose in Campania*. Napoli: Edizioni Scientifiche Italiane. Photographs by Mimmo Jodice.

Del Fra, Lino. 1960. *La passione del grano*. 16mm. Corona Cinematografica. 10 mins.

Di Bello, Patrizia, and Shamoon Zamir. 2012. 'Introduction'. In *The Photobook: From Talbot to Ruscha and Beyond*, edited by Patrizia Di Bello, Colette Wilson and Shamoon Zamir, 1–16. London and New York: I. B. Tauris.

Di Gianni, Luigi. 1971. *La Madonna del Pollino*. 16mm. Nexus Film. 18 mins.

Di Méo, Guy. 2005. 'Le renouvellement des fêtes et des festivals, ses implications

géographiques'. *Annales de géographie* 114 (643): 227–43. https://doi.
org/10.3406/geo.2005.21419.

DiMaria, Salvatore. 2018. *Towards a Unified Italy: Historical, Cultural,
and Literary Perspectives on the Southern Question*. Italian and Ital-
ian American Studies. London: Palgrave Macmillan. https://doi.
org/10.1007/978–3–319–90766–6_4.

Douglas, Norman. [1915] 1993. *Old Calabria*. Evanston: The Marlboro Press/
Northwestern.

Drever, John Levack. 2002. 'Soundscape Composition: The Convergence
of Ethnography and Acousmatic Music'. *Organised Sound* 7 (1): 21–27.
https://doi.org/10.1017/S1355771802001048.

Edwards, Elizabeth, ed. 1992. *Anthropology and Photography, 1860–1920*. New
Haven: Yale University Press.

——. 1997. 'Beyond the Boundary: A Consideration of the Expressive in
Photography and Anthropology'. In *Rethinking Visual Anthropology*, edited
by Marcus Banks and Howard Morphy, 53–80. London: Yale University
Press.

Eisenberg, Andrew J. 2013. 'Islam, Sound and Space: Acoustemology and
Muslim Citizenship on the Kenyan Coast'. In *Music, Sound and Space:
Transformations of Public and Private Experience*, edited by Georgina Born,
186–202. Cambridge: Cambridge University Press.

Eisenlohr, Patrick. 2018. *Sounding Islam: Voice, Media, and Sonic Atmospheres in
an Indian Ocean World*. Oakland: University of California Press.

Faedda, Barbara. 2017. *From Da Ponte to the Casa Italiana: A Brief History of Ital-
ian Studies at Columbia University*. New York: Columbia University Press.

Faeta, Francesco. 1999. 'Dal paese al labirinto. Considerazioni sull'etnografia
visiva di Ernesto De Martino'. In *I viaggi nel Sud di Ernesto DeMartino.
Fotografie di Arturo Zavattini, Franco Pinna e Ando Gilardi*, by Clara Gallini
and Francesco Faeta, 49–93. Torino: Bollati Boringhieri.

——. 2003. 'Rivolti verso il Mediterraneo. Immagini, questione meridionale
e processi di "orientalizzazione" interna'. *Lares* LXIX (2): 333–67.

Falassi, Alessandro, ed. 1987. *Time Out of Time: Essays on the Festival*. Albuquer-
que: University of New Mexico Press.

Feld, Steven. 1984. 'Sound Structure as Social Structure'. *Ethnomusicology* 28
(3): 383–409. https://doi.org/10.2307/851232.

——. 1987. 'Dialogic Editing: Interpreting How Kaluli Read Sound and
Sentiment'. *Cultural Anthropology* 2: 190–210. https://doi.org/10.1525/
can.1987.2.2.02a00020.

——. 1996. 'Waterfalls of Songs: An Acoustemology of Place Resounding in
Bosavi, Papua New Guinea'. In *Senses of Place*, edited by Steven Feld and
Keith H. Basso, 1st ed., 91–136. School of American Research Advanced
Seminar Series. Santa Fe and Seattle: School of American Research Press;
distributed by the University of Washington Press.

——. 2002. *Bells & Winter Festivals of Greek Macedonia*. CD. Smithsonian Folk-
ways Recordings. 13731047.

——. 2004a. *Soundscapes of Italy, Finland, Greece and France*. CD. Vol. 1. The
Time of Bells. Santa Fe: VoxLox.

——. 2004b. *Soundscapes of Finland, Norway, Italy and Greece*. CD. Vol. 2. The Time of Bells. Santa Fe: VoxLox.

——. 2005. *Musical Bells of Accra, Ghana*. CD. Vol. 3. The Time of Bells. Santa Fe: VoxLox.

——. 2006. *Soundscapes of Italy, Denmark, Japan, Finland and USA/Iraq*. CD. Vol. 4. The Time of Bells. Santa Fe: VoxLox.

——. 2012. *Jazz Cosmopolitanism in Accra: Five Musical Years in Ghana*. Durham and London: Duke University Press.

——. [1982] 2012. *Sound and Sentiment: Birds, Weeping, Poetics, and Song in Kaluli Expression*. 3rd ed. Durham and London: Duke University Press.

——. 2015a. 'Acoustemology'. In *Keywords in Sound*, edited by David Novak and Matt Sakakeeny, 12–21. Durham and London: Duke University Press.

——. 2015b. 'Listening to Histories of Listening: Collaborative Experiments in Acoustemology with Nii Otoo Annan'. In *Musical Listening in the Age of Technological Reproduction*, edited by Gianmario Borio, 91–103. Farnham: Ashgate.

Feld, Steven, and Keith H. Basso, eds. 1996. *Senses of Place*. 1st ed. School of American Research Advanced Seminar Series. Santa Fe and Seattle: School of American Research Press; distributed by the University of Washington Press.

Feld, Steven, and D. Brenneis. 2004. 'Doing Anthropology in Sound'. *American Ethnologist* 31 (November): 461–74.

Feld, Steven, Dennis Leonard and Jeremiah Ra Richards. 2019. *Voices of the Rainforest. A Day in the Life of Bosavi Papua New Guinea*. 2nd ed. Santa Fe: VoxLox. Photo book with CD and concert film 7.1 Bluray.

Feld, Steven, and Nicola Scaldaferri. 2019. 'Sound Documentation and Representation: A Dialogue'. In *When the Trees Resound: Collaborative Media Research on an Italian Festival*, edited by Nicola Scaldaferri and Steven Feld, 80–93. Udine: Nota.

Fellerer, K. G., and Moses Hadas. 1953. 'Church Music and the Council of Trent'. *Musical Quarterly* 39 (4): 576–94.

Ferrari, Chiara Francesca. 2016. 'Cinema and Sassi: Urban Development and Film-Induced Tourism in Matera and Basilicata'. *Journal of Italian Cinema & Media Studies* 4 (2): 267–82. https://doi.org/10.1386/jicms.4.2.267_1.

Ferrarini, Lorenzo. 2017. 'Embodied Representation: Audiovisual Media and Sensory Ethnography'. *Anthrovision: Vaneasa Online Journal*, no. 5.1 (July). https://doi.org/10.4000/anthrovision.2514.

Ferretti, Rossana. 1993. 'Indici delle raccolte degli Archivi di Etnomusicologia'. *EM* I: 157–90.

Filardi, Giuseppe. 2001. *Appunti per la storia di Accettura*. Perugia: Gramma.

Foster, Hal. 1995. 'The Artist as Ethnographer?' In *The Traffic in Culture: Refiguring Art and Anthropology*, edited by George E. Marcus and Fred R. Myers, 302–9. Berkeley: University of California Press.

Foucault, Michel. 1995. *Discipline and Punish: The Birth of the Prison*. Translated by Alan Sheridan. 2nd ed. New York: Vintage Books.

——. 2009. *Security, Territory, Population – Lectures at the College De France, 1977–78*. Basingstoke: Palgrave Macmillan UK.

Fournier, Laurent Sébastien. 2013. *La fête en héritage. Enjeux patrimoniaux de la sociabilité provençale*. Sociétés contemporaines. Aix-en-Provence: Presses universitaires de Provence.

Fox, Aaron A. 2004. *Real Country: Music and Language in Working-Class Culture*. Durham and London: Duke University Press.

Frank, Rolsyn M. 2008. 'Recovering European Ritual Bear Hunts: A Comparative Study of Basque and Sardinian Ursine Carnival Performances'. *Insula* 3 (June): 41–97.

Franklin, Stuart. 2016. *The Documentary Impulse*. London: Phaidon Press.

Fugazzotto, Giuliana. 2010. *Sta terra nun fa pi mia. I dischi a 78 giri e la vita in America degli emigranti italiani nel primo Novecento*. Udine: Nota. With CD.

Gabaccia, Donna R. 2003. *Italy's Many Diasporas*. London and New York: Routledge.

Gallini, Clara. 1981. 'Il Documentario Etnografico "Demartiniano"'. *La Ricerca Folklorica*, no. 3: 23–31. https://doi.org/10.2307/1479451.

———. 1995. 'La ricerca, la scrittura'. In *Note di campo. Spedizione in Lucania, 30 sett. – 31 ott. 1952*, by Ernesto De Martino, edited by Clara Gallini, 9–74. Lecce: Argo.

———. 1999. 'Percorsi, immagini, scritture'. In *I viaggi nel Sud di Ernesto DeMartino. Fotografie di Arturo Zavattini, Franco Pinna e Ando Gilardi*, by Clara Gallini and Francesco Faeta, 9–48. Torino: Bollati Boringhieri.

Gallini, Clara, and Francesco Faeta. 1999. *I viaggi nel Sud di Ernesto DeMartino. Fotografie di Arturo Zavattini, Franco Pinna e Ando Gilardi*. Torino: Bollati Boringhieri.

Gallop, Jane. 2003. *Living with His Camera*. Durham: Duke University Press. Photographs by Dick Blau.

Gandin, Michele. 1954. *Lamento funebre*. 16mm. 4 mins.

Gardner, Robert, and Karl G. Heider. 1968. *Gardens of War: Life and Death in the New Guinea Stone Age*. New York: Random House.

Gell, Alfred. 1995. 'The Language of the Forest: Landscape and Phonological Iconism in Umeda'. In *The Anthropology of Landscape: Perspectives on Place and Space*, edited by Eric Hirsch and Michael O'Hanlon, 232–54. Oxford: Clarendon Press.

Gershon, Walter S. 2012. 'Sonic Ethnography as Method and in Practice'. *Anthropology News* 53 (5): 5, 12.

———. 2013. 'Vibrational Affect: Sound Theory and Practice in Qualitative Research'. *Cultural Studies ↔ Critical Methodologies* 13 (4): 257–62. https://doi.org/10.1177/1532708613488067.

Gibson, Mel. 2004. *The Passion of the Christ*. Newmarket Films. 127 mins.

Giuriati, Giovanni. 1995. 'Country Report: Italian Ethnomusicology'. *Yearbook for Traditional Music* 27: 104–31. https://doi.org/10.2307/768106.

Goodman, Steve. 2010. *Sonic Warfare: Sound, Affect, and the Ecology of Fear*. Technologies of Lived Abstraction. Cambridge, MA and London: MIT Press.

Graham, Aubrey Paige. 2016. 'Pictures and Politics: Using Co-creative Portraits to Explore the Social Dynamics of the Eastern Democratic Republic of the Congo'. *Visual Methodologies* 4 (1): 10–29. https://doi.org/10.7331/vm.v4i1.59.

Haaland, Torunn. 2012. *Italian Neorealist Cinema*. Edinburgh: Edinburgh University Press.

Hafstein, Valdimar Tr. 2018. 'Intangible Heritage as a Festival; or, Folklorization Revisited'. *Journal of American Folklore* 131 (520): 127–49. https://doi.org/10.5406/jamerfolk.131.520.0127.

Halbwachs, Maurice. 1992. *On Collective Memory*. Chicago: University of Chicago Press.

Harlov, Melinda. 2016. 'The Intangible World Heritage Carnival of Hungary and Other Winter Closing Traditions of the Region'. Conference held in Florence and Viareggio, 3–7 February.

Harper, Douglas. 2002. 'Talking about Pictures: A Case for Photo Elicitation'. *Visual Studies* 17: 13–26.

Harrison, Rodney. 2013. *Heritage: Critical Approaches*. Abingdon: Routledge.

Hastrup, Kirsten. 1992. 'Anthropological Vision: Some Notes on Visual and Textual Authority'. In *Film As Ethnography*, edited by Peter I. Crawford and David Turton, 8–25. Manchester and New York: Manchester University Press.

Henley, Paul. 2007. 'Seeing, Hearing, Feeling: Sound and the Despotism of the Eye in "Visual" Anthropology'. *Visual Anthropology Review* 23 (1): 54–63. https://doi.org/10.1525/var.2007.23.1.54.

Heuson, Jennifer L., and Kevin T. Allen. 2014. 'Asynchronicity: Rethinking the Relation of Ear and Eye in Ethnographic Practice'. In *Experimental Film and Anthropology*, edited by Arnd Schneider and Caterina Pasqualino, 113–30. London and New York: Bloomsbury Academic.

Hirschkind, Charles. 2001. 'The Ethics of Listening: Cassette-Sermon Audition in Contemporary Egypt'. *American Ethnologist* 28 (3): 623–49.

——. 2006. *The Ethical Soundscape: Cassette Sermons and Islamic Counterpublics*. New York: Columbia University Press.

——. 2015. 'Religion'. In *Keywords in Sound*, edited by David Novak and Matt Sakakeeny, 164–74. Durham and London: Duke University Press.

Hoffman, Danny. 2017. *Monrovia Modern: Urban Form and Political Imagination in Liberia*. Durham and London: Duke University Press.

Hood, Mantle. 1960. 'The Challenge of "Bi-musicality"'. *Ethnomusicology* 4 (2): 55–59. https://doi.org/10.2307/924263.

Imbriani, Eugenio. 2016. 'Un autentico falso: la fattucchiera di Colobraro'. *Nuovo Meridionalismo Studi* II (3): 201–7.

Inserra, Incoronata. 2017. *Global Tarantella: Reinventing Southern Italian Folk Music and Dances*. Champaign: University of Illinois Press.

Johnson, James H. 1995. *Listening in Paris: A Cultural History*. Berkeley, Los Angeles and London: University of California Press.

Jones, Simon C., and Thomas G. Schumacher. 1992. 'Muzak: On Functional Music and Power'. *Critical Studies in Mass Communication* 9 (2): 156–69. https://doi.org/10.1080/15295039209366822.

Kalantzis, Konstantinos. 2019. *Tradition in the Frame: Photography, Power, and Imagination in Sfakia, Crete*. Bloomington: Indiana University Press.

Kane, Brian. 2014. *Sound Unseen: Acousmatic Sound in Theory and Practice*. Oxford and New York: Oxford University Press.

Kapchan, Deborah A. 1995. 'Performance'. *Journal of American Folklore* 108 (430): 479–508. https://doi.org/10.2307/541657.

Katz, Mark. 2004. *Capturing Sound: How Technology Has Changed Music.* Berkeley: University of California Press. With CD.

Keil, Charles, Dick Blau, Angeliki V. Keil and Steven Feld. 2002. *Bright Balkan Morning: Romani Lives and the Power of Music in Greek Macedonia.* Middletown: Wesleyan University Press. With CD.

Keller, Corey. 2018. 'Exchange Rates: 20 Dirhams or 1 Photo?' In *Mediations*, by Susan Meiselas, 135–43. Barcelona, Paris and Bologna: Fundació Antoni Tàpies, Jeu de Paume and Damiani.

Kelly, Alan. 1988. *His Master's Voice/La Voce Del Padrone: The Italian Catalogue – A Complete Numerical Catalogue of Italian Gramophone Recordings Made from 1898 to 1929.* 1st ed. New York: Greenwood.

Kenney, William Howland. 2003. *Recorded Music in American Life: The Phonograph and Popular Memory, 1890–1945.* New York and Oxford: Oxford University Press.

Khan, Naveeda. 2011. 'The Acoustics of Muslim Striving: Loudspeaker Use in Ritual Practice in Pakistan'. *Comparative Studies in Society and History* 53 (3): 571–94.

Koch, Ludwig, and D. W. E. Broch. 1937. *Hunting by Ear: The Sound-Book of Fox-Hunting.* London: H. F. & G. Witherby Ltd.

Kockel, Ullrich, Cristina Clopot, Baiba Tjarve and Máiréad Nic Craith, eds. 2019. *Heritage and Festivals in Europe: Performing Identities.* London and New York: Routledge.

Konewko, Simonetta Milli. 2016. *Neorealism and the 'New' Italy: Compassion in the Development of Italian Identity.* New York: Palgrave Macmillan.

Kun, Josh. 2005. *Audiotopia: Music, Race, and America.* Berkeley: University of California Press.

Kytö, Meri, Nicolas Rémy, Heikki Uimonen, Françoise Acquier, Gabriel Bérubé, Grégoire Chelkoff, Noha Gamal Saïd, et al. 2012. 'European Acoustic Heritage'. Research Report 83. Tampere University of Applied Sciences; Phonogrammarchiv, the Austrian Academy of Sciences; The multidisciplinary collective Escoitar; The Isle of San Simón Foundation; CRESSON. https://hal.archives-ouvertes.fr/hal-00993848 (accessed 31 March 2020).

La Sala, Serafino. 2019. Interview with Nicola Scaldaferri, Episcopia, Italy.

Lanternari, Vittorio. 1977. *Crisi e ricerca di identità. Folklore e dinamica culturale.* Napoli: Liguori.

Lee, Tong Soon. 1999. 'Technology and the Production of Islamic Space: The Call to Prayer in Singapore'. *Ethnomusicology* 43 (1): 86–100. https://doi.org/10.2307/852695.

Levin, Thomas Y. 2010. 'Before the Beep: A Short History of Voice Mail'. In *Voice: Vocal Aesthetics in Digital Arts and Media*, edited by Norie Neumark, Ross Gibson and Theo van Leeuwen, 17–32. Cambridge, MA: MIT Press.

Leydi, Roberto. 1991. *L'altra musica. Etnomusicologia: come abbiamo incontrato e creduto di conoscere le musiche delle tradizioni popolari ed etniche.* Firenze and Milano: Giunti and Ricordi.

Loguercio, Canio. 2006. *Miserere. Preghiera d'amore al netto di indulgenze e per appuntamento*. Roma: Squilibri. With CD and DVD.

Lomax, Alan. 1956. 'Nuova ipotesi sul canto folcloristico italiano nel quadro della musica mondiale'. *Nuovi Argomenti* 17–18: 109–35.

———. 2008. *L'anno più felice della mia vita. Un viaggio in Italia 1954–1955*. Edited by Goffredo Plastino. Milano: Il saggiatore.

Lomax, Alan, and Diego Carpitella. 1957a. *Northern and Central Italy*. KL 5173. World Library of Folk and Primitive Music. Columbia Masterworks.

———. 1957b. *Southern Italy and the Islands*. KL 5174. World Library of Folk and Primitive Music. Columbia Masterworks.

Lortat-Jacob, Bernard. 1984. 'L'arbre mange. Variations sur la chèvre qui sonne (Calabre, Italie)'. *Canadian University Music Review / Revue de musique des universités canadiennes*, no. 5: 242–68. https://doi.org/10.7202/1013942ar.

Lüdtke, Karen. 2009. *Dances with Spiders: Crisis, Celebrity and Celebration in Southern Italy*. New York: Berghahn Books.

Lule sheshi. Dalla viva voce dei bambini. 2016. CD. Roma: Squilibri.

Lutz, Catherine, and Jane Collins. 1991. 'The Photograph as an Intersection of Gazes: The Example of National Geographic'. *Visual Anthropology Review* 7 (1): 134–49. https://doi.org/10.1525/var.1991.7.1.134.

Macdonald, Sharon. 2013. *Memorylands: Heritage and Identity in Europe Today*. London and New York: Routledge.

MacDougall, David. 1999. 'Social Aesthetics and The Doon School'. *Visual Anthropology Review* 15 (1): 3–20. https://doi.org/10.1525/var.1999.15.1.3.

Magrini, Tullia. 1994. 'The Contribution of Ernesto de Martino to the Anthropology of Italian Music'. *Yearbook for Traditional Music* 26: 66–80. https://doi.org/10.2307/768244.

Manning, Peter. 2013. *Electronic and Computer Music*. Oxford and New York: Oxford University Press.

Marano, Francesco. 1999. 'Maiali per i discendenti. Simboli e relazioni nella "festa del maiale."' *Archivio di Etnografia* 1: 31–46.

———. 2001. 'La Mietitura: Video between Imagined Community and Auto-ethnography'. *Visual Anthropology* 14 (2): 185–202. https://doi.org/10.1080/08949468.2001.9966825.

———. 2007. *Camera etnografica. Storie e teorie di antropologia visuale*. Milano: Franco Angeli.

Marcus, George E. 2010. 'Contemporary Fieldwork Aesthetics in Art and Anthropology: Experiments in Collaboration and Intervention'. *Visual Anthropology* 23 (4): 263–77. https://doi.org/10.1080/08949468.2010.484988.

Maxia, Carlo. 2011. 'Coiài su ferru (sposare i campanacci). L'estetica dei suoni nel pastoralismo sardo'. In *Saperi antropologici, media e società civile nell'Italia contemporanea*, edited by Luisa Faldini and Eliana Pili, 587–94. Roma: CISU.

———. 2013. '"Cumprendi su ferru". Costruzione, funzioni ed estetiche dei campanacci in Sardegna'. In *Metalli. Storia, linguaggio e innovazione in Sardegna*, 343–61. Nuoro: Ilisso.

McMurray, Peter. 2015. 'Archival Excess: Sensational Histories Beyond the Audiovisual'. *Fontes Artis Musicae* 62 (3): 262–75.

Meintjes, Louise. 2017. *Dust of the Zulu: Ngoma Aesthetics after Apartheid*. Durham and London: Duke University Press. Photographs by T. J. Lemon.

Meiselas, Susan. 1976. *Carnival Strippers*. New York: Farrar, Straus & Giroux.

——. 1997. *Kurdistan: In the Shadow of History*. New York: Random House.

——. 2003. *Encounters with the Dani*. Göttingen: Steidl.

Meiselas, Susan, Richard P. Rogers and Alfred Guzzetti. 1991. *Pictures from a Revolution*. Docurama. 93 mins.

Merriam, Alan P. 1964. *The Anthropology of Music*. Evanston: Northwestern University Press.

Meyer, Birgit. 2009. *Aesthetic Formations: Media, Religion, and the Senses*. New York: Palgrave Macmillan.

Mirizzi, Ferdinando. 2000. 'La Basilicata dopo Levi, laboratorio e centro propulsivo di studi demoetnoantropologici'. *Annali della Facoltà di Lettere e Filosofia* X: 177–207.

——. 2005. 'Gli sguardi e la scrittura'. In *Santi, animali e suoni. Feste dei campanacci a Tricarico e San Mauro Forte*, edited by Nicola Scaldaferri, 6–18. Udine: Nota.

——, ed. 2010. *Da vicino e da lontano. Fotografi e fotografia in Lucania*. Imagines. Milano: Franco Angeli.

——. 2019. 'Notes on the Writing of the Maggio'. In *When the Trees Resound: Collaborative Media Research on an Italian Festival*, edited by Nicola Scaldaferri and Steven Feld, 38–44. Udine: Nota.

Mitchell, W. J. T. 1994. *Picture Theory: Essays on Verbal and Visual Representation*. Chicago and London: University of Chicago Press.

Mjaaland, Thera. 2017. 'Co-photographing in North-Western Tigray, Ethiopia'. *Anthrovision. Vaneasa Online Journal*, no. 5.2 (December). https://doi.org/10.4000/anthrovision.2617.

Moore, Paul. 2003. 'Sectarian Sound and Cultural Identity in Northern Ireland'. In *The Auditory Culture Reader*, edited by Michael Bull and Les Back, 1–18. Oxford: Berg.

Morton, Christopher, and Elizabeth Edwards, eds. 2009. *Photography, Anthropology and History: Expanding the Frame*. Farnham: Ashgate Publishing.

Murphy, John W. 1996. 'There Is Nothing Virtual about Virtual Reality'. *ETC.: A Review of General Semantics* 53 (4): 458–64.

Musca, Giosuè. 1969. *Il 'Maggio' di Accettura*. 8mm. Facoltà di Lettere e Filosofia dell'Università di Bari. 50 mins.

Nancy, Jean-Luc. 2007. *Listening*. Translated by Charlotte Mandell. New York: Fordham University Press.

Nannyonga-Tamusuza, Sylvia, and Andrew N. Weintraub. 2012. 'The Audible Future: Reimagining the Role of Sound Archives and Sound Repatriation in Uganda'. *Ethnomusicology* 56 (2): 206–33. https://doi.org/10.5406/ethnomusicology.56.2.0206.

Narayan, Kirin. 1993. 'How Native Is a "Native" Anthropologist?' *American Anthropologist* 95 (3): 671–86.

Nelson, Jimmy. 2013. *Before They Pass Away*. Kempen: teNeues.

Nikolskaya, Alexandra, and Nicola Scaldaferri, eds. 2010. *Lule sheshi. Omaggio all'arte poetica di Enza Scutari*. Roma: Squilibri. With CD.

Ochoa Gautier, Ana María. 2006. 'Sonic Transculturation, Epistemologies of Purification and the Aural Public Sphere in Latin America'. *Social Identities* 12 (6): 803–25. https://doi.org/10.1080/13504630601031022.

———. 2014. *Aurality: Listening and Knowledge in Nineteenth-Century Colombia*. Durham and London: Duke University Press.

Ong, Walter J. 1982. *Orality and Literacy: The Technologizing of the Word*. London and New York: Methuen.

Orrantia, Juan. 2012. 'Where the Air Feels Heavy: Boredom and the Textures of the Aftermath'. *Visual Anthropology Review* 28 (1): 50–69. https://doi.org/10.1111/j.1548–7458.2012.01110.x.

Panagakos, Anastasia. 2003. 'Downloading New Identities: Ethnicity, Technology, and Media in the Global Greek Village'. *Identities* 10 (2): 201–19. https://doi.org/10.1080/10702890304326.

Panopoulos, Panayotis. 2003. 'Animal Bells as Symbols: Sound and Hearing in a Greek Island Village'. *Journal of the Royal Anthropological Institute* 9 (4): 639–56. https://doi.org/10.1111/j.1467–9655.2003.00167.x.

———. 2011. 'Noisy Images, Colorful Sounds: Representing the Senses of the Carnival Body'. In *Audiovisual Media and Identity Issues in Southeastern Europe*, edited by Eckehard Pistrick, Nicola Scaldaferri and Gretel Schwörer, 37–50. Newcastle Upon Tyne: Cambridge Scholar Publishing.

———. 2015. 'Homeland as Sound and Sound as Homeland: Cultural and Personal Soundscapes in Christos Christovasilis's Short Stories'. Translated by Vasiliki Chatzopoulou. *Ethnomusicology Translations*, no. 1 (November): 1–19. https://doi.org/10.14434/emt.v0i1.20266.

———. 2018. 'Vocal Letters: A Migrant's Family Records from the 1950s and the Phonographic Production and Reproduction of Memory'. *Entanglements: Experiments in Multimodal Ethnography* 1 (2). https://entanglementsjournal.org/ (accessed 31 March 2020).

Parr, Martin, and Gerry Badger. 2004. *The Photobook: A History*. Vol. 1. 2 vols. London: Phaidon.

Pasolini, Pier Paolo. 1964. *Il vangelo secondo Matteo*. Titanus. 137 mins.

Peckham, Robert Shannan, ed. 2003. *Rethinking Heritage: Cultures and Politics in Europe*. London and New York: Bloomsbury Academic.

Perrone, Camillo. 1983. *San Severino Lucano tra presente e passato*. Lagonegro: Zaccara.

Pettan, Svanibor, and Jeff Todd Titon, eds. 2015. *The Oxford Handbook of Applied Ethnomusicology*. Oxford and New York: Oxford University Press.

Picker, John M. 2003. *Victorian Soundscapes*. Oxford and New York: Oxford University Press.

Pickering, Hugh, and Tom Rice. 2017. 'Noise as "Sound out of Place": Investigating the Links between Mary Douglas' Work on Dirt and Sound Studies Research'. *Journal of Sonic Studies*, no. 14 (July). www.researchcatalogue.net/view/374514/374515/0/0 (accessed 31 March 2020).

Pinelli, Carlo Alberto. 1971. *Il matrimonio degli alberi*. 16mm. Moana. 17 mins.

Pinney, Christopher. 1992. 'The Common Histories of Anthropology and

Photography'. In *Anthropology and Photography, 1860–1920*, edited by Elizabeth Edwards, 74–91. New Haven: Yale University Press.

———. 1997. *Camera Indica: The Social Life of Indian Photographs*. Chicago: University of Chicago Press.

———. 2011. *Photography and Anthropology*. London: Reaktion Books.

Pistrick, Eckehard. 2015. *Performing Nostalgia: Migration Culture and Creativity in South Albania*. Farnham and Burlington: Ashgate. With DVD.

Pitt-Rivers, Julian A. 1954. *The People of the Sierra*. New York: Criterion Books.

Pizza, Giovanni. 2004. 'Tarantism and the Politics of Tradition in Contemporary Salento'. In *Memory, Politics and Religion: The Past Meets the Present in Europe*, edited by Frances Pine, Deema Kaneff and Haldis Haukanes, 199–233. Halle Studies in the Anthropology of Eurasia. Münster: LIT Verlag.

Poole, Deborah. 1997. *Vision, Race, and Modernity: A Visual Economy of the Andean Image World*. Princeton: Princeton University Press.

Price, Percival. 1983. *Bells and Man*. Oxford: Oxford University Press.

Rennie, Tullis. 2014. 'Socio-sonic: An Ethnographic Methodology for Electroacoustic Composition'. *Organised Sound* 19 (2): 117–24. https://doi.org/10.1017/S1355771814000053.

Renoff, Richard, Angela Danzi and Joseph A. Varacalli. 1989. 'The Albanese and Italian Community of Inwood, Long Island'. In *Italian Americans: The Search for a Usable Past*, edited by Richard N. Juliani and Philip V. Cannistraro, 106–32. Philadelphia: IASA Italian American Studies Association.

Ricci, Antonello. 2007. *I suoni e lo sguardo. Etnografia visiva e musica popolare nell'Italia centrale e meridionale*. Imagines. Milano: Franco Angeli.

———. 2012. *Il paese dei suoni. Antropologia dell'ascolto a Mesoraca (1991–2011)*. Roma: Squilibri. With DVD.

Ricci, Antonello, and Roberta Tucci. 2004. *La capra che suona. Immagini e suoni della musica popolare in Calabria*. Sinestesie. Roma: Squilibri. With CD.

Rice, Timothy. 1994. *May It Fill Your Soul: Experiencing Bulgarian Music*. Chicago: University of Chicago Press. With CD.

Rice, Tom. 2003. 'Soundselves: An Acoustemology of Sound and Self in the Edinburgh Royal Infirmary'. *Anthropology Today* 19 (4): 4–9. https://doi.org/10.1111/1467–8322.00201.

———. 2013. *Hearing the Hospital: Sound, Listening, Knowledge and Experience*. Canon Pyon: Sean Kingston Publishing.

Richards, Greg. 2007. 'The Festivalization of Society or the Socialization of Festivals? The Case of Catalunya'. In *Cultural Tourism: Global and Local Perspectives*, edited by Greg Richards, 257–80. New York, London and Oxford: The Haworth Press.

Rizzo, Chiara. 2010. *I documentari sulla Basilicata della cineteca lucana*. Potenza: Consiglio Regionale della Basilicata.

Roseman, Marina. 1991. *Healing Sounds from the Malaysian Rainforest: Temiar Music and Medicine*. Berkeley: University of California Press.

Rossi, Annabella. 1969. *Le feste dei poveri*. Bari: Laterza.

Rouget, Gilbert. [1980] 1985. *Music and Trance: A Theory of the Relations Between Music and Possession*. Chicago and London: University of Chicago Press.

Rowlands, Michael. 2007. 'The Sound of Witchcraft: Noise as Mediation in

Religious Transmission'. In *Learning Religion: Anthropological Approaches*, edited by David Berliner and Ramon Sarró, 191–207. New York and Oxford: Berghahn Books.

Ruby, Jay. 1996. 'Visual Anthropology'. In *Encyclopedia of Cultural Anthropology*, edited by David Levinson and Melvin Ember, 4: 1345–51. New York: Henry Holt.

Rutten, Kris, An van Dienderen and Ronald Soetaert. 2013. 'Revisiting the Ethnographic Turn in Contemporary Art'. *Critical Arts* 27 (5): 459–73. https://doi.org/10.1080/02560046.2013.855513.

Sachs, Curt. 1961. *The Wellsprings of Music*. The Hague: Martinus Njihoff.

Sakakeeny, Matt. 2010. '"Under the Bridge": An Orientation to Soundscapes in New Orleans'. *Ethnomusicology* 54 (1): 1–27. https://doi.org/10.5406/ethnomusicology.54.1.0001.

——. 2015. 'Music'. In *Keywords in Sound*, edited by David Novak and Matt Sakakeeny, 111–24. Durham and London: Duke University Press.

Salgado, Sebastião. 2013. *Genesis*. Cologne: Taschen.

Samuels, David W., Louise Meintjes, Ana Maria Ochoa and Thomas Porcello. 2010. 'Soundscapes: Toward a Sounded Anthropology'. *Annual Review of Anthropology* 39 (1): 329–45. https://doi.org/10.1146/annurev-anthro-022510–132230.

Scaldaferri, Nicola. 1994. *Musica arbëreshe in Basilicata*. Lecce: Adriatica Editrice Salentina. With audio tape.

——, ed. 2005. *Santi, animali e suoni. Feste dei campanacci a Tricarico e San Mauro Forte*. Udine: Nota. With CD.

——. 2006. 'Mezzo secolo di etnomusicologia in Basilicata'. In *Nel paese dei cupa-cupa. Suoni e immagini della tradizione lucana*, by Nicola Scaldaferri and Stefano Vaja, 9–39. Sinestesie. Roma: Squilibri.

——. 2009. 'I "campanacci organizzati" di San Mauro Forte, fra tradizione e patrimonializzazione'. *Archivio di Etnografia* 1–2: 59–68.

——. 2013. 'Multipart Singing, Multilingualism and Mediatization: Identity Issues of the Arbëresh Minority of Southern Italy at the Beginning of a New Century'. In *Local and Global Understandings of Creativities: Multipart Music Making and the Construction of Ideas, Contexts and Contents*, edited by Ardian Ahmedaja, 89–100. Newcastle Upon Tyne: Cambridge Scholar Publishing.

——. 2014a. 'The Voice and the Tape: Aesthetic and Technological Interactions in European Studios during the 1950s'. In *Crosscurrents: American and European Music in Interaction, 1900–2000*, edited by Felix Meyer, Carol J. Oja, Wolfgang Rathert and Anne Chatoney Shreffler, 335–49. Woodbridge: Boydell Press.

——. 2014b. 'Voice, Body, Technologies: Tales from an Arbëresh Village'. *Trans – Revista Transcultural de Música*, no. 18: 2–21.

——. 2015. 'Audiovisual Ethnography: New Paths for Research and Representation in Ethnomusicology'. In *Musical Listening in the Age of Technological Reproduction*, edited by Gianmario Borio, 373–92. Farnham: Ashgate.

——. 2018. '(Absent) Authors, Texts and Composition Technologies: Ethnographic Pathways and Compositional Practices'. In *Live-Electronic Music:*

Composition, Performance, Study, edited by Friedemann Sallis, Valentina Bertolani, Jan Burle and Laura Zattra, 217–29. London and New York: Routledge.

——. 2019a. 'Back in the Field (2004): Three Interviews about "When the Trees Resound"'. In *When the Trees Resound: Collaborative Media Research on an Italian Festival*, edited by Nicola Scaldaferri and Steven Feld, 94–103. Udine: Nota.

——. 2019b. 'Music and Sounds: New Perspectives on the Maggio Festival'. In *When the Trees Resound: Collaborative Media Research on an Italian Festival*, edited by Nicola Scaldaferri and Steven Feld, 12–27. Udine: Nota.

——. 2020. 'Ricerca etnografica in Basilicata e creazione artistica. Le esperienze materane di Steven Feld e Yuval Avital'. *Archivio di Etnografia* 1–2 (2018): 71–82.

Scaldaferri, Nicola, and Steven Feld, eds. 2012. *I suoni dell'albero. Il Maggio di San Giuliano ad Accettura*. Musica e cultura tradizionale della Basilicata 6. Udine: Nota.

——, eds. 2019. *When the Trees Resound: Collaborative Media Research on an Italian Festival*. Udine: Nota. With photographs by Stefano Vaja and Lorenzo Ferrarini. With 2 CDs.

Scaldaferri, Nicola, and Stefano Vaja. 2006. *Nel paese dei cupa-cupa. Suoni e immagini della tradizione lucana*. Sinestesie. Roma: Squilibri. With CD.

Schafer, R. Murray. 1977. *The Tuning of the World*. 1st ed. New York: Knopf.

Schäuble, Michaela. 2018. 'Visual Anthropology'. In *Anthropology Beyond Text*, ed. Hilary Callan and Rupert Cox, 1–21. The International Encyclopedia of Anthropology. New York: Wiley-Blackwell. https://onlinelibrary.wiley.com/doi/abs/10.1002/9781118924396.wbiea1969 (accessed 31 March 2020).

——. 2019. 'Ecstasy, Choreography and Re-enactment: Aesthetic and Political Dimensions of Filming States of Trance and Spirit Possession in Postwar Southern Italy'. *Visual Anthropology* 32 (1): 33–55. https://doi.org/10.1080/08949468.2019.1568112.

Schechner, Richard. 1985. *Between Theater and Anthropology*. Philadelphia: University of Pennsylvania Press.

Schillaci, Rossella. 2005. *Pratica e Maestria*. Digibeta. Nota. 46 mins.

Schneider, Arnd. 2014. 'Stills That Move: Photofilm and Anthropology'. In *Experimental Film and Anthropology*, edited by Arnd Schneider and Caterina Pasqualino, 25–43. London and New York: Bloomsbury Academic.

Schneider, Arnd, and Christopher Wright, eds. 2010. *Between Art and Anthropology: Contemporary Ethnographic Practice*. Oxford and New York: Berg Publishers.

Scianna, Ferdinando. 1965. *Feste religiose in Sicilia*. Bari: Leonardo da Vinci Editrice. With texts by Leonardo Sciascia.

Seeger, Anthony. 1987. *Why Suya Sing: A Musical Anthropology of an Amazonian People*. Cambridge and New York: Cambridge University Press.

Seymour, David. 1949. *Children of Europe*. Paris: UNESCO.

Shelemay, Kay Kaufman. 1996. 'The Ethnomusicologist and the

Transmission of Tradition'. *Journal of Musicology* 14 (1): 35–51. https://doi. org/10.2307/763956.

——. 1998. *Let Jasmine Rain Down: Song and Remembrance Among Syrian Jews.* Chicago and London: University of Chicago Press. With CD.

——. 2011. 'Musical Communities: Rethinking the Collective in Music'. *Journal of the American Musicological Society* 64 (2): 349–90. https://doi. org/10.1525/jams.2011.64.2.349.

——. 2013. 'The Ethics of Ethnomusicology in a Cosmopolitan Age'. In *The Cambridge History of World Music*, edited by Philip V. Bohlman, 786–806. Cambridge and New York: Cambridge University Press.

Shiel, Mark. 2006. *Italian Neorealism: Rebuilding the Cinematic City.* London and New York: Wallflower – Columbia University Press.

Siisiänen, Lauri. 2010. 'Foucault's Voices: Toward the Political Genealogy of the Auditory-Sonorous'. PhD, Jyväskylä: University of Jyväskylä.

Silverman, Rena. 2018. 'A Marriage of Two Trees: An Unusual Wedding in a Small Italian Town'. *New York Times*, October 9, 2018, sec. Lens. www. nytimes.com/2018/10/09/lens/tree-wedding-italy-town.html (accessed 31 March 2020). With photographs by Gianluca De Bartolo.

Singer, Milton. 1972. *When a Great Tradition Modernizes: An Anthropological Approach to Modern Civilization.* New York, Washington and London: Praeger Publishers.

Small, Christopher. 1998. *Musicking: The Meanings of Performing and Listening.* Middletown: Wesleyan University Press.

Smith, Laurajane. 2006. *Uses of Heritage.* London and New York: Routledge.

Sontag, Susan. 1977. *On Photography.* New York: Farrar, Straus & Giroux.

Spanu, Gian Nicola. 2014. *Strumenti e suoni nella musica sarda.* Nuoro: Ilisso. With DVD.

Spera, Vincenzo. 1982. 'Inizio del carnevale a Tricarico'. *Quaderni dell'università degli studi di Bari* 2: 318–43.

——. 2014. 'L'ambigüe et séduisante "inventio" de l'origine archaïque des fêtes populaires. Le cas du Mai d'Accettura'. In *Les traditions en Europe: modification, invention et instrumentalisation des traditions.* Vol. 7. Problemes d'ethnologie et d'anthropologie – Monographies numériques. Belgrade: Université de Belgrade, Faculté de philosophie Département d'ethnologie et d'anthropologie.

Spottswood, Richard K. 1992. *Ethnic Music on Records: A Discography of Ethnic Recordings Produced in the United States, 1893–1942.* 7 vols. Urbana and Chicago: University of Illinois Press.

Stella, Maria Carmela, ed. 2005. *Tradizioni musicali del materano.* Musica e cultura tradizionale della Basilicata 2. Udine: Nota. With CD.

Sterne, Jonathan. 2003. *The Audible Past: Cultural Origins of Sound Reproduction.* Durhamand London: Duke University Press.

Stewart, Kathleen. 1996. *A Space on the Side of the Road: Cultural Poetics in an 'Other' America.* Princeton: Princeton University Press.

Stocker, Michael. 2013. *Hear Where We Are: Sound, Ecology, and Sense of Place.* New York, Heidelberg, Dordrecht and London: Springer.

Stokes, Martin, ed. 1994. 'Introduction: Ethnicity, Identity, and Music'. In

Ethnicity, Identity, and Music: The Musical Construction of Place, 1–27. Oxford and Providence: Berg.

Stoller, Paul. 1984. 'Sound in Songhay Cultural Experience'. *American Ethnologist* 11 (3): 559–70. https://doi.org/10.1525/ae.1984.11.3.02a00090.

Suhr, Christian, and Rane Willerslev. 2012. 'Can Film Show the Invisible? The Work of Montage in Ethnographic Filmmaking'. *Current Anthropology* 53 (3): 282–301. https://doi.org/10.1086/664920.

Sutherland, Patrick. 2016a. 'Spiti: Some Notes on the Practice of Documentary Photography'. In *Beyond Text?: Critical Practice and Sensory Anthropology*, edited by Rupert Cox, Andrew Irving and Christopher Wright, 33–57. Manchester: Manchester University Press.

——. 2016b. 'The Photo Essay'. *Visual Anthropology Review* 32 (2): 115–21. https://doi.org/10.1111/var.12103.

——. 2016c. 'VAR SUPPLEMENTS: Patrick Sutherland on Learning Documentary Photography and Constructing Photo Essays from Groups of Photographs'. *Society for Visual Anthropology* (blog). November 1, 2016. http://societyforvisualanthropology.org/2016/11/var-supplements-patrick-sutherland-learning-documentary-photography-constructing-photo-essays-groups-photographs/ (accessed 31 March 2020).

Szendy, Peter. 2008. *Listen: A History of Our Ears*. New York: Fordham University Press.

Tedlock, Dennis. 1979. 'The Analogical Tradition and the Emergence of a Dialogical Anthropology'. *Journal of Anthropological Research* 35 (4): 387–400.

The Talking Machine News. 1905. 'The Talking Post Card'. *Talking Machine World*, April 15, 1905.

Truax, Barry. 1984. *Acoustic Communication*. Norwood: Ablex.

——. 2008. 'Soundscape Composition as Global Music: Electroacoustic Music as Soundscape'. *Organised Sound* 13 (2): 103–9. https://doi.org/10.1017/S1355771808000149.

Turino, Thomas. 2008. *Music as Social Life: The Politics of Participation*. Chicago: University of Chicago Press.

Turner, Victor W. 1986. *The Anthropology of Performance*. New York: PAJ Publications.

Vaja, Stefano. 2006. 'Appunti per un "lungo viaggio" nella fotografia del Sud'. In *Nel paese dei cupa-cupa. Suoni e immagini della tradizione lucana*, by Nicola Scaldaferri and Stefano Vaja, 40–46. Sinestesie. Roma: Squilibri.

Visconti, Luchino. 1960. *Rocco e i suoi fratelli*. Astor Pictures. 177 mins.

Walsh, Kevin. 1992. *The Representation of the Past: Museums and Heritage in the Post-Modern World*. London and New York: Routledge.

Werbner, Richard. 2011. *Holy Hustlers, Schism, and Prophecy: Apostolic Reformation in Botswana*. Berkeley, Los Angeles and London: University of California Press.

Wilson, Dave. 2017. 'Commoning in Sonic Ethnography (or, the Sound of Ethnography to Come)'. *Commoning Ethnography* 1 (1): 125–36. https://doi.org/10.26686/ce.v1i1.4134.

Wright, Christopher. 2013. *The Echo of Things: The Lives of Photographs in the Solomon Islands*. Durham: Duke University Press.

——. 2018. 'Photo-ethnography'. In *Anthropology Beyond Text*, ed. Hilary Callan and Rupert Cox, 1–5. The International Encyclopedia of Anthropology. New York: Wiley-Blackwell. https://onlinelibrary.wiley.com/doi/abs/10.1002/9781118924396.wbiea2017 (accessed 31 March 2020).

Yelmi, Pinar. 2016. 'Protecting Contemporary Cultural Soundscapes as Intangible Cultural Heritage: Sounds of Istanbul'. *International Journal of Heritage Studies* 22 (4): 302–11. https://doi.org/10.1080/13527258.2016.1138237.

Yung, Bell. 2019. 'Exploring Creativity in Traditional Music'. *Yearbook for Traditional Music* 51: 1–15. https://doi.org/10.1017/ytm.2019.46.

Zinn, Dorothy Louise. 2015. 'An Introduction to Ernesto de Martino's Relevance for the Study of Folklore'. *Journal of American Folklore* 128 (507): 3–17. https://doi.org/10.5406/jamerfolk.128.507.0003.

——. 2019. *Raccomandazione: Clientelism and Connections in Italy*. New York and Oxford: Berghahn.

INDEX

Abitante, Antonio 195

Abitante, Dorina ('*Dhurana*') 138–40, 196

Abitante, Piero 195

Accettura 21, 23–26, 160, 191–92

 a zampogna singing style 30, 159

 see also *Maggio* festival in Accettura

Accra Trane Station 155

Acerenza 4

acoustemology 6, 16

aesthesis 4

African polyphonies, Arom's study of 155

agricultural ways of life, decline 107, 124–25

Albano di Lucania 12

Alessandria del Carretto, tree ritual 29

Aliano Carlo Levi confinement 7

Anderson, Benedict 131

Another Way of Telling (Berger, J. and Mohr, J.) 185

anthropology

 anthropological knowledge, reuse of 12, 14–15, 125

 anthropological knowledge, institutionalisation of 15, 25–26, 172

 anthropology of sound 2, 5, 8, 21–22

 and colonialism 170, 177

 Italian anthropology 8, 11

 photography in, uses of 181, 185

 photography in Basilicata and 171–77

 sensory anthropology 16, 18

see also photo-ethnography; photography

Arbëresh 115, 131, 135–36, 137, 141, 142–43, 144, 157–58, 161–62, 165

Arom, Simha 155

asynchronicity 18

Attali, Jacques 95, 97

audiotopia 5

authenticity, validation 4–5, 15, 19, 26, 113, 175

Avital, Yuval 55, 163–66, 197–98

Bakhtin, Mikhail M. 179–80

Balinese Character (Bateson, G. and Mead, M.) 169

Banfield, Edward G. 8

Barbarito, Berardino 192

Bartiluccio, Filomena 192

Bartók, Béla, 154

Basilicata 6–7

 cultural and heritage policies 11–15

 DGR 1198 (2014) 13

 'discovery' by Ernesto De Martino 8

 documentary photography and anthropology 171–77

 ethnographic and media imaginaries 6–11

 European Union (EU), funding by 13–14

bassa musica ensembles 28–29, 191–92

Before They Pass Away (Nelson, J.) 170

bells 54, 61

 apotropaic and propitiatory function 56, 61–62

bells (*continued*)
gendered identities 56–57
marking time and space 100
parades of people playing bells in
Basilicata 54
as soundmarks 142
Ben-Hur (Timur Bekmambetov film)
10
Bentham, Jeremy 99–100
Berio, Luciano 155
bimusicality 153
Blacking, John 58
Bronzini, Giovanni Battista 24–26, 61
Buccolo, Andreana 197

Cage, John 162
Calimano, Fiorina and Nicodemo
140–41, 196
Caluori, Domenica 197
Calzia, Fabio 32
Campanaccio festival in San Mauro
Forte 53, 54–56
apotropaic and propitiatory
function 60–62
bell carriers 4, 55, 57–58, 59, 62,
63–64, 164–65
bells, lack of gendered identity
56–57
darkness 57–59
heritagisation, campaign of 62–64
identity value for community of
55, 64–65
listening by participants 59, 64
pigs, connection with killing of
61–62
sound and soundwaves, role of
58–60
St Anthony the Abbot 54, 55, 62,
64, 193
synchronised clanking of bells in
Campanaccio 58
team research on 55
see also network of festivals,
Campanaccio as part of network
of Lucanian Carnivals;
soundmask
candle offerings 23, 105, 121, 195
Canosa, Agostino 196
Capossela, Vinicio 113
Carbone, Vincenzo 196

Cardone, Attilio 196
Carlomagno, Agostino 159
Carnival in Europe 53–54
bell festivals 58
parades and ritual actions during 54
rituals of, classic interpretations 57
Carnival Strippers (Meiselas, S.) 180
Carpitella, Diego 7, 8, 10, 141, 143,
158, 163, 173, 183, 188
Cartier-Bresson, Henri 171, 176
Caruso, Enrico 131
Casa Italiana choir (*Coro d'Italia*) at
Columbia University 130, 150
Chiaffitella, Domenico 196
Chiaffitella, Giuseppe 5, 129–51, 182,
195–97
photographs by 148–51
Chiaromonte 121–23
Chronis, Kostantinos 130–31
Ciancia, Pasquale 156
Ciminelli, Pina 197
Cohen, Anthony Paul 131
Colclough, Nevill 8, 23, 25
collaboration 155, 170, 180
between artists and scholars 93,
154, 164–66, 172–74, 187–88
Collier, John 169, 180
Colobraro 12, 174–75
Columbia World Library of Folk and
Primitive Music series 141
community 4, 131
acoustic community 3, 100
sound, role in creation of
community 56, 97, 137, 142
temporary communities of
musicians 30, 90, 160
wheat offerings and community-
making 120–21, 125
Corbin, Alain 100
Corleto Perticara *see* Tempa Rossa oil
and gas extraction site
Cox, Rupert 97
Craco 11
cultural performance 2–3
cultural survival 24–26, 113
Curtis, Edward S. 170

D'Amato, Michelino 196
De Gasperi, Alcide 7
Del Fra, Lino 10, 113

De Martino, Ernesto 8–9, 10, 11–12,
14, 64, 93–94, 163, 188, 197
 Demartinian anthropology 87, 94
 Demartinian documentary 9–10, 93
 and photography 8–9, 171–77
De Palma, Vittoria 8, 174
Derrida, Jacques 132
Deufemia, Mimì 54
devotion
 embodied 27, 86, 90, 92
 restrictions 94–95
 see also sonic devotion
dialogic 179–80
 research practices 22, 33, 155, 164,
 180–81
Di Gianni, Luigi 10, 93–94
Diluca, Francesco 54
Dimensional Stereo Microphones
 (DSM) 32, 55
Di Zenzo, Adolfo 192
Douglas, Norman 90

Edison, Thomas A. 132
emigrants
 returning 5, 23–24, 55, 115–16,
 121, 161
 Italian emigrants in the USA 130,
 196
 recordings by 130–31
Episcopia
 Madonna del Piano festival 101–3,
 107, 110
 see also Manca di Sopra
Espresso Mese 171
ethnography *see* photo-ethnography;
 sonic ethnography
ethnomusicology 154
 applied ethnomusicology 161
 CNSMP ethnomusicological
 archive 8, 141
 Italian ethnomusicology,
 foundations of 11
 sonic ethnography and 188
Ethnomusicology and Visual
 Anthropology Lab (LEAV) at
 the University of Milan 154
European Union (EU), funding by 13

Fanuele, Antonio 192
Fanuele, Domenico 191, 192

Feld, Steven 6, 8, 16–17, 19, 32, 54–55,
 154–55, 160, 185
Fellini, Federico 9
Ferrari, Luc 17
fieldwork 21–22, 146–47, 153–54,
 155–56
Filardi, Don Giuseppe 32, 51, 160,
 192
Foucault, Michel 96, 98, 99–100
Frazer, Sir James George 24
Friedmann, Frederick G. 8

'game of the sickle'
 wheat festivals and 110–13, 115
 De Martino's interpretation of 113
Gardens of War (Gardner, R. and
 Heider, K.G.) 169
Geertz, Clifford 189
Genesis (Salgado, S.) 170
Ghirardini, Cristina 32, 192
Giammetta, Rocco 54–55
Giannattasio, Francesco 157, 197
Gilardi, Ando 8–9, 173
Gorgoglione 194
Gospel According to St Matthew, The
 (Pier Paolo Pasolini film) 10
Gramsci, Antonio 7, 93, 94
Granada Centre for Visual
 Anthropology 18
Greco, Gerardo 197
Griaule, Marcel 172
Guaccero, Domenico 10

Henley, Paul 18
heritage
 cultural and heritage policies in
 Basilicata 11–15
 'demoethnoanthropological' 11
 insider repatriation of 161
 photography and 175–77
 wheat festivals as representations
 of 125
heritagisation 12–13, 115
 Campanaccio and campaign of
 62–64
 Maggio festival in Accettura 25–26
 St John the Baptist festival in
 Chiaromonte 123
Hirschkind, Charles 99
Hood, Mantle 153

Hunting by Ear (Koch, L. and Broch, D.W.E. sound-book) 16–17

Iannibelli, Dina 197
identity 4–5
 Arbëresh identity in USA 135–37
 local identities 3–6
 music and diasporic identity 131–32
 sonic identity 59, 153
 value of *Campanaccio* festival 55, 64–65
 value of *Maggio* festival 24
Ihde, Don 132
insider repatriation 160–62
inter-mediality 187–88, 189

Jodice, Mimmo 174

Kostandin, song of the *vallja* of 141–44
Kun, Josh 5

Laguardia, Francesco 54
Laico, Pietro 196
Lamento funebre (Michele Gandin documentary) 10
Land of Cockaigne, The (exhibition) 163
Lanternari, Vittorio 24–25
Larato, Alberico 31, 159, 191, 192
La Rocca, Maddalena, 'enchantress' of Colobraro 174–75
La Sala, Don Serafino 101–3
Levi, Carlo 7–8, 10, 171
 Christ Stopped at Eboli 7–8
Leydi, Roberto 27
Ligeti, György 155
listening 6, 16, 56, 147
 acousmatic 129, 132
 control, role in forms of 99
 during *Campanaccio* in San Mauro Forte 59–60, 64
 group recording and listening sessions, ritual value of 137
 histories of listening and recorded memories 129
 images and 183–85, 188
 recording as 136–37, 139
 skilled listening at *Maggio* festival in Accettura 30–31

sonic ethnography and 21–22
Loguercio, Canio 58
Lomax, Alan 8, 141
loudspeakers 98, 100, 163
 use during religious festivals 94–95, 100–1, 102–3
Lule sheshi (wildflowers) project 161–62

Macchi, Egisto 10, 93
La Madonna del Pollino (Luigi Di Gianni documentary) 93, 94, 174
Madonna del Pollino pilgrimage 88–89
 Fraternita Madonna di Pollino 88–90
 loudspeakers in, use of 100–1
 modes of devotion 91–92
 pilgrim participation, sonorous forms of 90
 restrictions on pilgrims 94–95
 San Severino Lucano, role of 89–90
 song of the Madonna del Pollino 85–86
 zampogna players 85–86, 91–92
Maggio festival in Accettura 4, 12, 22–24, 93
 ancestral symbol, as 24–27
 bonfire of leftover logs from 54
 Bronzini's interpretation of 25–27
 community, importance for 23–24
 debates on meaning 26–27
 exceptionality, validation of 33
 listening, examples of skilled listening 30–31
 'marriage of trees,' ancestral fertility ritual based on 25
 media interest in 24–25
 pagan fertility ritual, as survival of 26
 photographers of 27
 sonic ethnography of 27–31, 31–32
 sounds, institutionalised 28
 sounds, spontaneous 29–30
Magic: A Theory from the South (De Martino, E.) 12, 174
Magnocavallo, Pina 197
Manca di Sopra 120–21
Mangini, Cecilia 10

Matera 6, 7, 197
 Sassi area as backdrop for movies
 10
 European capital of culture 63, 162,
 164
 Open Sound Festival 64
 UNESCO World Heritage site 7
Il matrimonio degli alberi (Carlo Alberto
 Pinelli documentary) 25
Meiselas, Susan 180
Merriam, Alan P. 166
Mezzana 94
Mingozzi, Gianfranco 10
Mirizzi, Ferdinando 24
Mobilio, Andrea 123
Moles, Giuliano 191, 192
Il Mondo 171
Monrovia Modern (Hoffman, D.) 169
Musca, Giosuè 24–25
music
 catholic Church and 95–96
 electroacoustic 17, 22, 93, 133
 folk music 64, 90, 101, 154, 195
 functional music 98
 identity value 4–5 131–32
 mode of research, music-making as
 31, 154–62, 188
 'musicants' and 'musicated'
 (Rouget) 60
 as noise 97
 as organised sound 3, 58
 pop music 28
 as sonic devotion 86, 89, 90
 spontaneous 29–30, 90
 at wheat festivals 107

Narayan, Kirin 160–61, 162
networks of festivals 14
 Accettura heading network of tree
 festivals 26
 Campanaccio as part of network of
 Lucanian Carnivals 63
 wheat festivals 123
New York Times 25
*Nights of Magic, The – a Journey in the
 Footsteps of De Martino* (festival
 in Albano di Lucania) 12
Nikolskaya, Alexandra 197
Noepoli, Madonna di Costantinopoli
 festival 107, 110, 195

noise 5, 27, 96–97
 insubordination and revolt,
 association with 97
 noise abatement 97
 noise pollution 3
 social boundaries and definition 97
nostalgia 4–5, 12, 124, 129, 131, 144,
 196

Osnato, Caterina 197
Osnato, Costantino 161

'panaudicism' (Foucault) 99
Pasolini, Pier Paolo 10
La passione del grano (Lino Del Fra
 film) 113
Passion of the Christ, The (Mel Gibson
 film) 10
Peck, George 8
Pedali, wheat festival 120–21, 163, 195
performance-based research 153
 see also music, mode of research,
 music-making as
phonography 131, 132–33
photo-ethnography 169–71
 ecosystems of circulation of images
 178
 relational photographic practice
 177–81
 as sensory ethnography 183–85
photography
 and anthropology in Basilicata
 171–77
 within ethnographic monographs
 169
 interpretive problems with 170
 problematic gaze of 170
 text and photographs 15–16,
 181–83
On Photography (Sontag, S.) 170
Pictures from a Revolution (Susan
 Meiselas, Richard P. Rogers and
 Alfred Guzzetti documentary)
 180
Pietrapertosa 173, 176
pigs
 killing of 61–62, 148
 symbolic value 62
pilgrimage *see* Madonna del Pollino
 pilgrimage

Piliero, Vito 192
Pinna, Franco 9, 12, 172–73, 176–77, 183
Piria, Elisa 32, 154, 197
Pitt-Rivers, Julian A. 97
Plato 99
polyphonic
 songs 155, 165
 strategies of representation 154, 180
'popular piety' 94
postmodern theory 4
power, control of sound and 96–100
Pratica e maestria (Rossella Schillaci documentary) 163

Quasimodo, Salvatore 10

Radiocorriere 171
Ragone, Pietro 115, 161, 179
Raschieri, Guido 32
relational photographic practice 177–81
research in sound
 as creative practice 161–66
 early examples 154–55
 as provocation 157–60
 see also music, mode of research, music-making as
reverberation 59–60, 156
Riccardi, Leonardo 159
Rice, Timothy 157
Riefenstahl, Leni 170
Ripullone, Leonardo 197
Rocco, Giuseppe 192
Rocco and His Brothers (Luchino Visconti film) 10
Rossi, Annabella 93, 94
Rotonda, tree ritual 29
rurality 124–25

Salandra 54
Salgado, Sebastião 170
Samaritans (Yuval Avital icon/sonic opera) 164
San Costantino Albanese 136, 194, 195–96
 community repatriation 161
 musical traditions 141, 142–44
 musicians from 117, 161, 165
 memories of Giuseppe Chiaffitella 130–31

San Giorgio Lucano 14, 123
 heritage policies 113
 land ownership 113
 mural paintings 9, 177
 St Roch, festival of 113
 wheat harvest ritual in 110–13
San Mauro Forte 53, 193
 see also Campanaccio festival in San Mauro Forte
San Paolo Albanese
 dances of the sickle for festival of St Roch 115, 116, 118–19, 161, 179
 himunea offering 115–17, 118–19
 land ownership 115
San Severino Lucano 88, 193
 role in Madonna del Pollino pilgrimage 89–90
Scaldaferri, Pasquale 196
Scarano, Nicola 25, 27, 29
Schafer, R. Murray 3, 56, 133, 142, 156
Schillaci, Rossella 156, 163
Schillizzi, Andrea and Franco 138, 140
Schillizzi, Michele 196
Scianna, Ferdinando 174
Scotellaro, Rocco 171
Scutari, Antonio 196
Scutari, Enza 161–62, 197
Scutari, Stella 144–46
Senise, St Roch festival 195
sensory anthropology 16, 18–19
Sensory Ethnography Laboratory at Harvard 18
Seymour, David 171
Shelemay, Kay Kaufman 131–32, 160
Sicilian Mafia 132
Singer, Milton 2
sonic branding of space 98
sonic devotion 86–87, 103, 107
 Madonna del Pollino pilgrimage 88–95
sonic ethnography 21–22, 188
 archival sonic ethnography 129–31, 146–47
 listeners, positionalities of 22
 of *Maggio* festival Accettura 27–31, 31–32
 ocularcentric bias, re-balancing of 21–22

poetic representation 32
representational component 22
as research practice 31–33
sound recordings as forms of
 ethnographic representation
 31–32
Sontag, Susan 170
sound 2, 3–6
Sound and Sentiment (Feld, S.) 185
sound-chapter 2, 17–18
soundmask 53, 60
sound memories 130–31
sound monuments 142, 165
sound recorder
 anthropomorphisation of 136–40
 Chiaffitella's Recordio tape
 recorder 130, 134–35
 tape recorder as commodity 133–35
sound recording
 ethnic record catalogues 131–32
 playback as research method 155,
 158
 relationship with images 183–85
 resonant tomb 146
 vocal mail 130–31
 see also sound memories; sound
 monuments; sound souvenirs
soundscape 5, 22, 56
 composition 17–18, 32, 55, 64,
 160–61, 163, 191
 control 95–101, 103
 zampogna within festival soundscape
 156, 159–60
sound souvenirs 132–35, 142–44
space
 defining noise 97
 marked by the sound of bells
 59–60, 142
 sound and control of space
 91–92, 94, 98–100, 158–59,
 193–94
A Space on the Side of the Road
 (Stewart, K.) 169
Spera, Vincenzo 25, 26, 61, 62
Stella, Maria Carmela 192, 197
Sterne, Jonathan 100
Stigliano 197
Strand, Paul 172
Sutherland, Patrick 178

Tajoli, Luciano 196
tarantella 28, 64, 115, 194–95, 197
 Lucanian wheat festivals 107, 115
 Madonna del Pollino pilgrimage
 85–86
Tarantism in Apulia 64, 93
 De Martino's research on 9, 14–15
Teana 107, 194–95
Tempa Rossa oil and gas extraction
 site 127
La terra del rimorso (De Martino, E.)
 172
Terranova di Pollino, reaping
 competition 117–20, 194
Togliatti, Palmiro 7
tradition, invention of 62–63, 121–23
transnationality 129, 137–40
Tricarico 8, 171, 172, 176
 carnival 54, 57
 Gathering of Anthropological Masks
 festival in 14, 53
Trimarco, Carmine 158, 197
Truax, Barry 17
Trupo, Nicola 196
Turino, Thomas 131
Turner, Victor W. 2, 153
Tylor, Edward Burnett 24

UNESCO 7, 26

Vaja, Stefano 19, 55, 163
Valvano, Quirino 31, 159, 191, 195,
 197
Varimezov, Kostadin 157
Verdi, Giuseppe 192
Viggianello, Sanctuary of the
 Madonna 107, 160
 see also Pedali, wheat festival
Villa, Claudio 196
Visual Anthropology Review 169
Vitali, Tommaso 154
voice
 of photographic subjects 185
 recorded 132–34, 136–37, 146
 transnational circulation 137–38
Voices of the Rainforest (Steven Feld
 soundscape composition and
 Steven Feld and Jeremiah Ra
 Richards sound film) 17, 155

Westerkamp, Hildegard 17
wheat
 festivals 15, 105–27, 177, 194–95
 harvest 4, 105, 110–13, 117, 163
 offerings 105–7, 115–23, 163
 varieties 117
When the Trees Resound (Scaldaferri, N.
 and Feld, S.) 51, 162, 185, 191

zampogna 156, 158, 164, 191, 192,
 194–98
 learning 156–57
 players 12, 29, 85–61, 91–92, 93,
 163, 197–98
Zavattini, Arturo 8–9, 172, 173
Zavattini, Cesare 172
Zinn, Dorothy Louise 8
Zumthor, Paul 132